REACH FOR THE CROWN

THE DAY-DATE

SHAPING SPACES

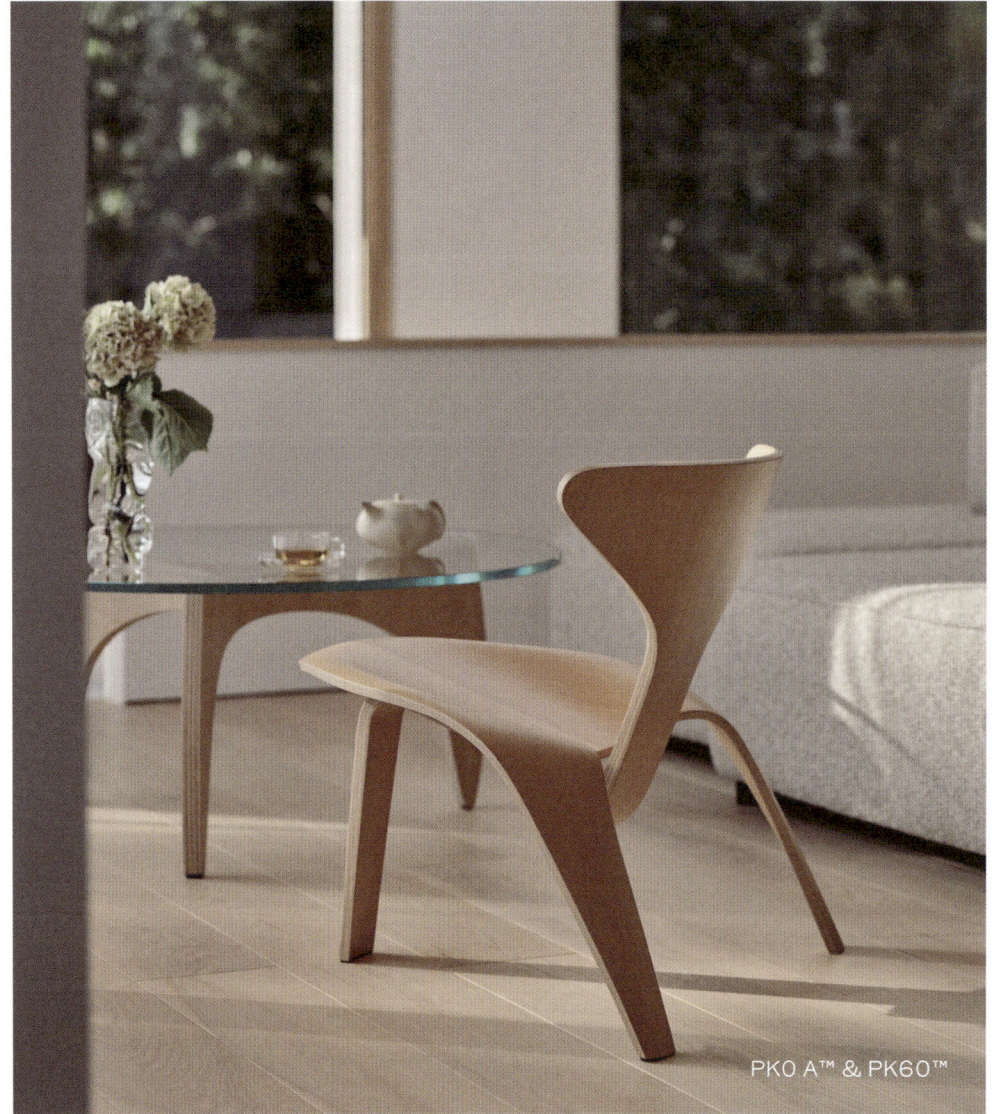

When design endures, it transforms spaces and the way we experience them. Beautiful materials, timeless forms—crafted to last, designed to inspire.

See more at **fritzhansen.com**

FRITZ HANSEN

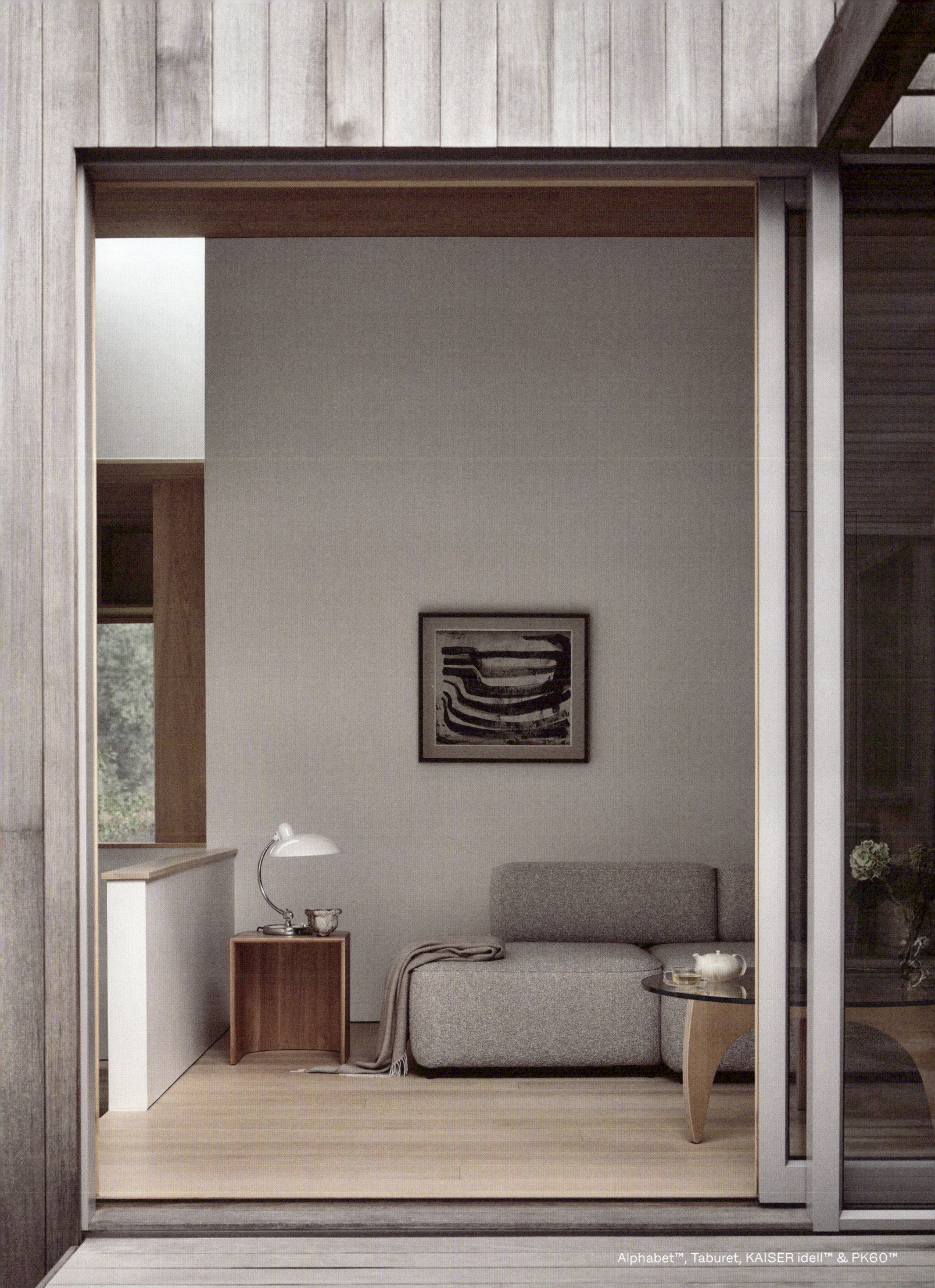

Alphabet™, Taburet, KAISER idell™ & PK60™

Boxes

Handcrafted Designs in Resin
Boxes for your Goodies

Exlore the collection at
tf.design

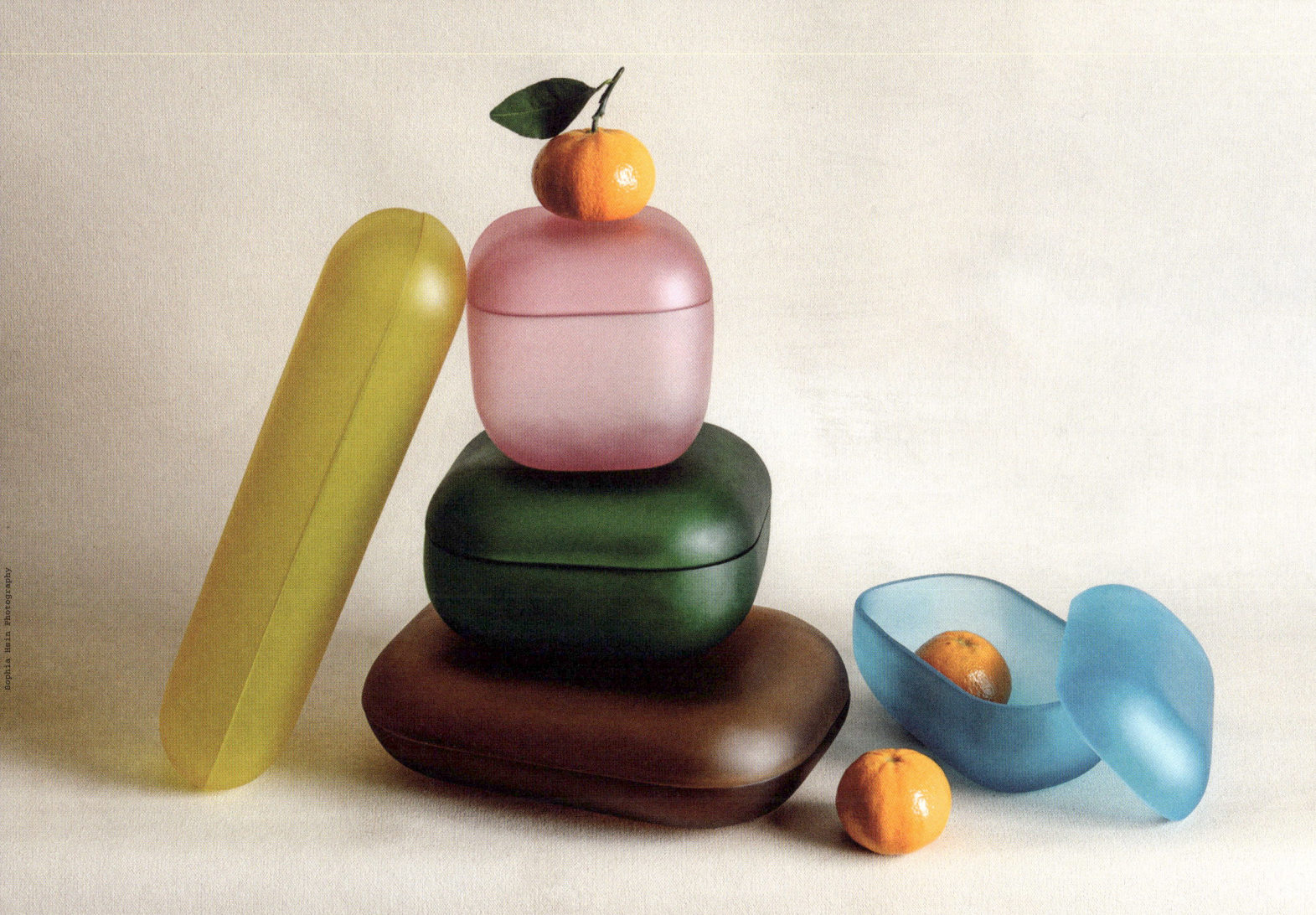

MASTHEAD

KINFOLK

MAGAZINE

EDITOR IN CHIEF — John Burns
DEPUTY EDITOR — George Upton
ART DIRECTOR — Mario Depicolzuane
DESIGN DIRECTOR — Alex Hunting
COPY EDITOR — Rachel Holzman

STUDIO

PUBLISHING DIRECTOR — Edward Mannering
STUDIO MANAGER — Vilma Rosenblad
DESIGN & ART DIRECTION — Studio8585
DIGITAL MANAGER — Cecilie Jegsen
ENGAGEMENT EDITOR — Rachel Ellison

CROSSWORD — Mark Halpin
PUBLICATION DESIGN — Alex Hunting Studio
COVER PHOTOGRAPHS — Daria Kobayashi Ritch
Katie McCurdy

The views expressed in *Kinfolk* magazine are those of the respective contributors and are not necessarily shared by the company or its staff. *Kinfolk* (ISSN 2596-6154) is published quarterly by Ouur ApS, Amagertorv 14B, 2, 1160 Copenhagen, Denmark. Printed by Park Communications Ltd in London, United Kingdom. Color reproduction by Park Communications Ltd in London, United Kingdom. All rights reserved. No part of this publication may be reproduced, distributed or transmitted in any form or by any means, including photocopying or other electronic or mechanical methods, without prior written permission of the editor in chief, except in the case of brief quotations embodied in critical reviews and certain other noncommercial uses permitted by copyright law. The US annual subscription price is $80 USD. Airfreight and mailing in the USA by agent named World Container Inc., c/o BBT 150-15, 183rd St, Jamaica, NY 11413, USA. Periodicals postage paid at Brooklyn, NY 11256. POSTMASTER: Send address changes to Kinfolk, World Container Inc., c/o BBT 150-15, 183rd St, Jamaica, NY 11413, USA. Subscription records are maintained at Ouur ApS, Amagertorv 14B, 2, 1160 Copenhagen, Denmark. SUBSCRIBE: To subscribe, visit www.kinfolk.com/subscribe or email us at info@kinfolk.com. CONTACT US: If you have questions or comments, please write to us at info@kinfolk.com. For advertising and partnership inquiries, get in touch at advertising@kinfolk.com.

WORDS

Precious Adesina
Ed Cumming
Benjamin Dane
Daphnée Denis
James Greig
Simran Hans
Elle Hunt
Robert Ito
Rosalind Jana
Brandon Jew
Lyra Kilston
Francis Martin
Emily May
Conor McTernan
Shonquis Moreno
Ali Morris
Kabelo Sandile Motsoeneng
Celine Nguyen
Okechukwu Nzelu
Sala Elise Patterson
Rebekah Peppler
Caitlin Quinlan
Nicolaia Rips
Rhian Sasseen
Emma Silvers
Amanda Thomson
Alice Vincent
Annick Weber
Tom Whyman

STYLING, SET DESIGN, HAIR & MAKEUP

Ashley Abtahie
Dana Boyer
Nehemiah Davidson
Gemma Ferri
Von Ford
Gia Harris
Bebe LaMonica
Risha Rox
Emma Sandral
Mr. Sarah
Stephanie Stamatis
Maranda Widlund
Elaine Winter

ARTWORK & PHOTOGRAPHY

Julie Adams
Lauren Bamford
Elizabeth Carabacas
Christian Cassiel
Justin Chung
John Dolan
Jessica Ellis
Trinity Ellis
Cecilie Jegsen
Annika Kafcaloudis
Daria Kobayashi Ritch
Arianna Lago
Romain Laprade
Alixe Lay
David van der Leeuw
Inès Manai
Molly Mandell & James Burke
Faustine Martin
Steph Martyniuk
Katie McCurdy
Chris Mottalini
James Pearson-Howes
Julien Sage
Cédrine Scheidig
Yosigo

PUBLISHER

Chul-Joon Park

RICHARD MILLE

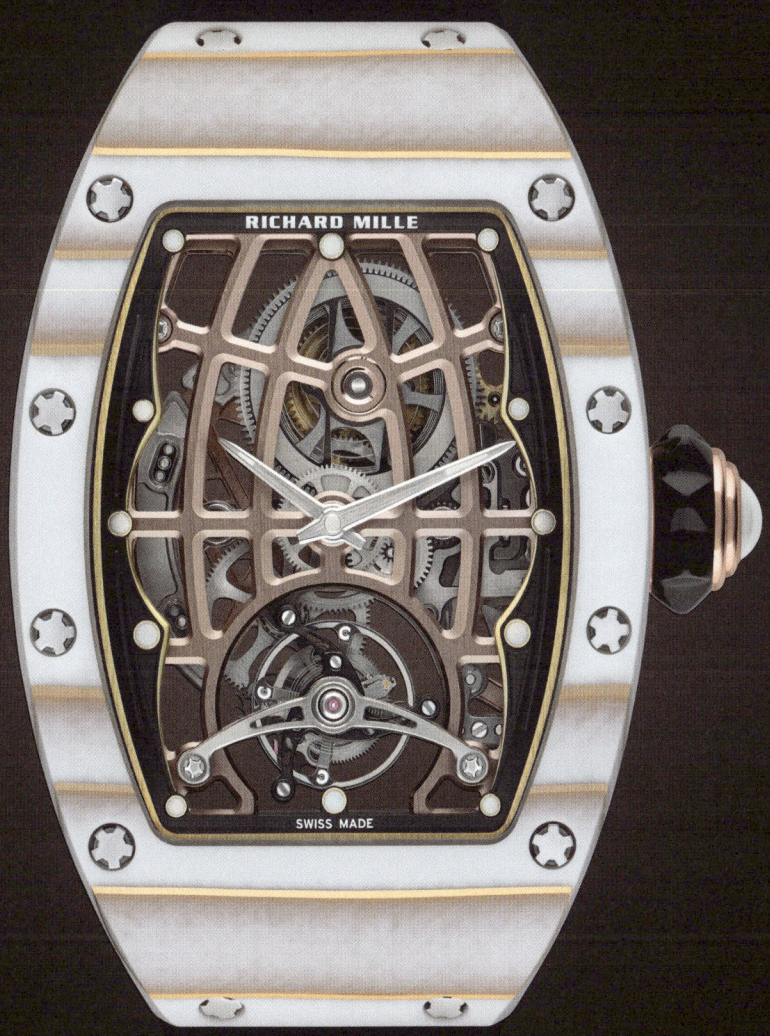

RM 74-02

In-house skeletonised automatic winding tourbillon calibre
50-hour power reserve (± 10%)
Baseplate and bridges in 18K 3N and 5N red gold
Variable-geometry rotor
Fast-rotating barrel
Case in Gold Quartz TPT® and 5N red gold

A Racing Machine
On The Wrist

WELCOME
The California Issue

When Wim Wenders sets out to make a film, he first finds a location that speaks to him. "Only then do I try to find the story that belongs there," the celebrated director tells Simran Hans on page 42. And so it is with this issue of *Kinfolk*, which started with an idea of a destination: California.

The Golden State has long been synonymous with living well—an effortless, sun-drenched ideal, where nature meets glamour and innovation shapes the way we live. But California is more than a lifestyle dreamscape: As the epicenter of the world's entertainment, wellness and tech industries, it is a proving ground for human potential—a place where counterculture and commerce have long intersected, and where aspiration is less an endgame than a moving target.

This issue is dedicated to the state's timeless allure. In Silver Lake, we join record producer Emile Haynie—known for his work with megastars such as Adele and Lana Del Rey—as he turns a private creative process into a shared experience: opening up his music studio for community dinners. Further north, we tour the iconic Blunk House, the handcrafted home of JB Blunk—a California artist through and through; his craft bound up not only with the state's landscape but also with its back-to-the-land ideology. We step into the kitchen with food writer Rebekah Peppler, who has created a menu infused with California's ease and ingredients on page 108. And we meet Betty Reid Soskin, who, at 103, has lived through more than a century of the state's history. Her secret to living well? "Always follow the questions," she says. "It's questions that lead to growth."

It's a philosophy that resonates throughout California's history, and will continue into its future. In San Francisco, AI researchers at Anthropic are led by questions that probe the nature of creativity. They ask how technology might be imbued with a "mark of the maker"—an idea that echoes the handcrafted traditions of artists like Blunk but within an entirely new paradigm. And in Venice Beach, we visit Raed Khawaja, co-founder of Open, to examine how the wellness industry—one of California's most successful cultural exports—continues to evolve in the space between ancient wisdom and modern consumerism.

Taking a cue from Reid Soskin, the rest of the issue examines what makes a life well-lived through asking questions: Does laziness really exist? How should we handle incompetent people? And what's the best way to roll down a hill? Wenders, who turns 80 this year, offers the following advice: "Walk! Be around trees! Take your time!"

WORDS
JOHN BURNS

HOUSE OF FINN JUHL

The Nyhavn Desk

Finn Juhl | 1945

Locate a retailer near you at finnjuhl.com

CONTENTS

15 — 40

STARTERS
On bananas, laziness and clowning.

16	LA Is Over There	28	What Are You Working On?
18	Village People	30	Weaponized Incompetence
20	Odd Jobs	32	What's In a Name?
21	Cult Rooms	33	Think On Your Feet
22	Oklou	34	Mariane Ibrahim
24	Low-Hanging Fruit	38	Word: Egérmozi
26	Counter Productive	40	How To: Roll Down a Hill
27	The Liking Gap	—	—

41 — 96

FEATURES
Designs for living.

42	Wim Wenders	68	Studio Visit: Industrial Facility
54	The Lonely State	76	Tree Hugging
58	Georgia Anne Muldrow	88	Home Tour: Frey House II

"They tell me to turn left, I turn right." (Wim Wenders – P. 50)

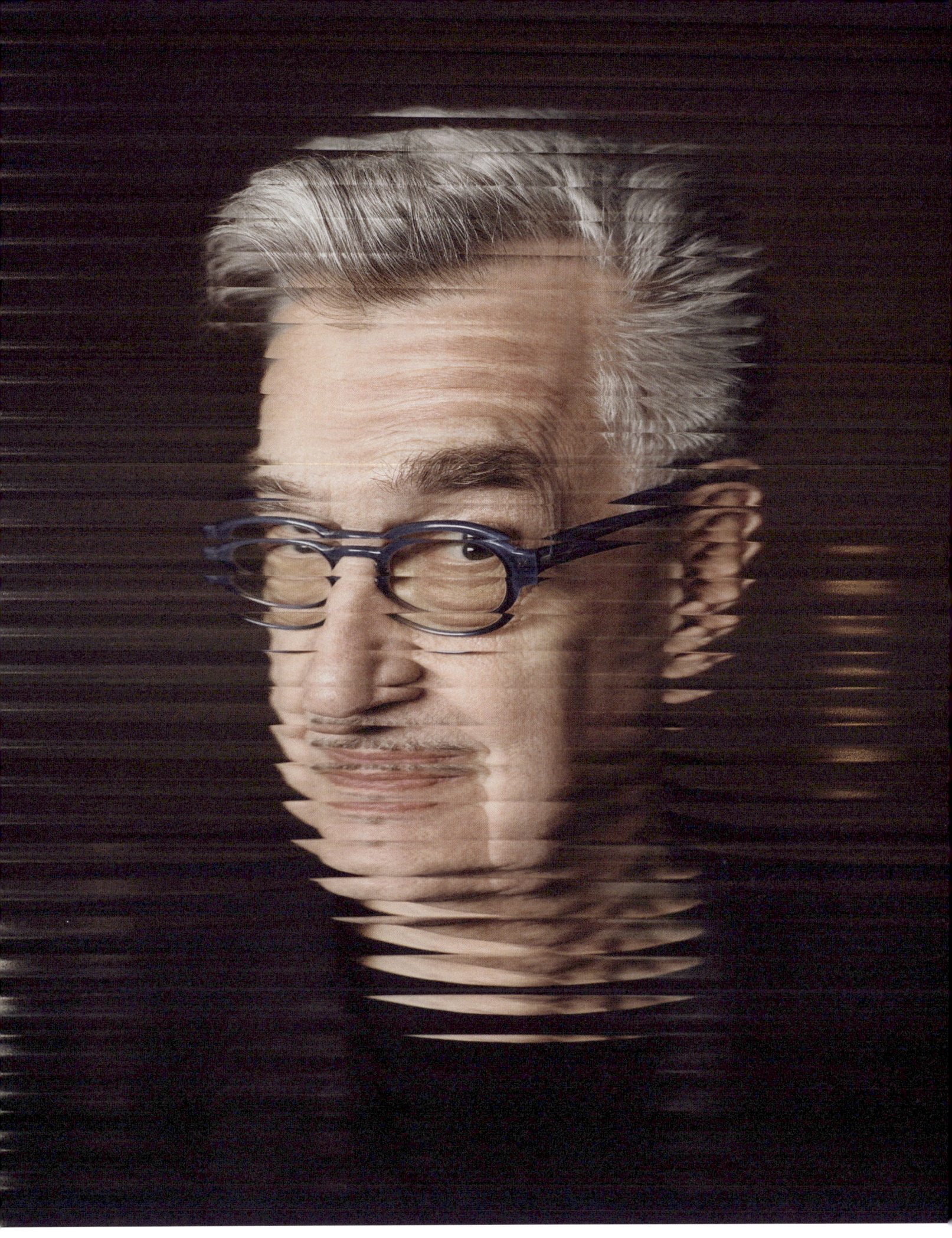

CONTENTS

97 — 160

CALIFORNIA
A window onto the West Coast.

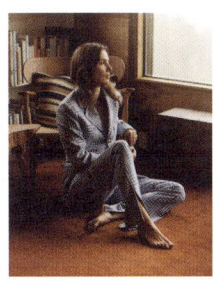

- 98 Raed Khawaja
- 108 West Coast Cooking
- 122 Betty Reid Soskin
- 130 Emile Haynie
- 140 The Artisans of AI
- 148 Blunk House

161 — 176

DIRECTORY
Old hands and novel ideas.

- 162 Field Notes
- 163 Power Tool
- 164 On the Shelf
- 166 Behind the Scenes
- 168 Crossword
- 169 Received Wisdom
- 171 Top Tip
- 172 Seasonal Produce
- 174 Credits
- 175 Stockists
- 176 Point of View

Photo: Daria Kobayashi Ritch

ORIGINAL BTC

STARERS

16	LA Is Over There
21	Cult Rooms
22	Oklou
30	Weaponized Incompetence
34	Mariane Ibrahim
40	How To: Roll Down a Hill

LA IS OVER THERE
A New Yorker considers Los Angeles.

"Would you ever live anywhere else?" To a lifelong New Yorker it feels like a stupid question but people still ask it, sometimes offering their opinion at the same time: "I could never see you anywhere else, you're SO New York."

What they mean is neurotic, caffeine-addled and busy. I am always ignoring someone's text or shooing away a pigeon, often at the same time. I'm constantly dashing from place to place, disappointing someone, running late, leaving early, being consumed with my own importance and lack thereof, ping-ponging between being robbed and beloved, stressed, unhappy and elated.

But if I were to live somewhere else, if I were to pack up and move, I would go to LA. Cut the pigeons, cue the doves.

I believe if you're someone who survives only because you're in a particular place, someone who requires *this* routine and *that* coffee blend, this exercise class and that bar; essentially, if you're a plant that can't live without the hard terra-cotta walls of a pot, you might be doomed to wither away and die. At the risk of sounding even more like Dr. Seuss: Building your identity around a location makes for a weak foundation. I like to think I could live anywhere for any amount of time. This is, of course, an unsubstantiated claim but I'd give living in a shipping container in the tundra a go if the rent was low enough and it had some southern exposure.

The first time I went to Los Angeles as a tax-paying adult I was shocked by how much I loved it—and how much I hated paying taxes. I love Hollywood Regency–style furniture. I love movies. I love people who have created a version of themselves that's far from who they were when they were born, who have forged a new identity from rough material. I love self-mythology. I love Eve Babitz, I love sunshine, I love beautiful girls and boys, and I love wellness.[1] (Oh, to be well!) In New York, everybody seems to be too busy to be well. Even your unemployed friends and those lonesome artist types (writers, musicians, painters, you know and have dated the sort) are suspended in this gelatin of anxiety—wildly windmilling, trying to get anywhere at all.

I love LA, but the thing I love most of all about LA is that LA is over there. What would I hold onto if it were over here? Would I dream of my ancestral home of Missouri? Yearn for the nightlife of Miami? Become besotted with Berlin? I know that if I were to move to LA, I could be just as unhappy there as anywhere else, and that's saying something. But I thank God that, for now, LA is still over there.

(1) Eve Babitz was a writer, artist and prominent member of the Los Angeles cultural scene in the 1960s, '70s and '80s. Bret Easton Ellis once wrote, "In every book she writes, Babitz's enthusiasm for L.A. and its subcultures is fully displayed."

WORDS
NICOLAIA RIPS
PHOTO
ROMAIN LAPRADE

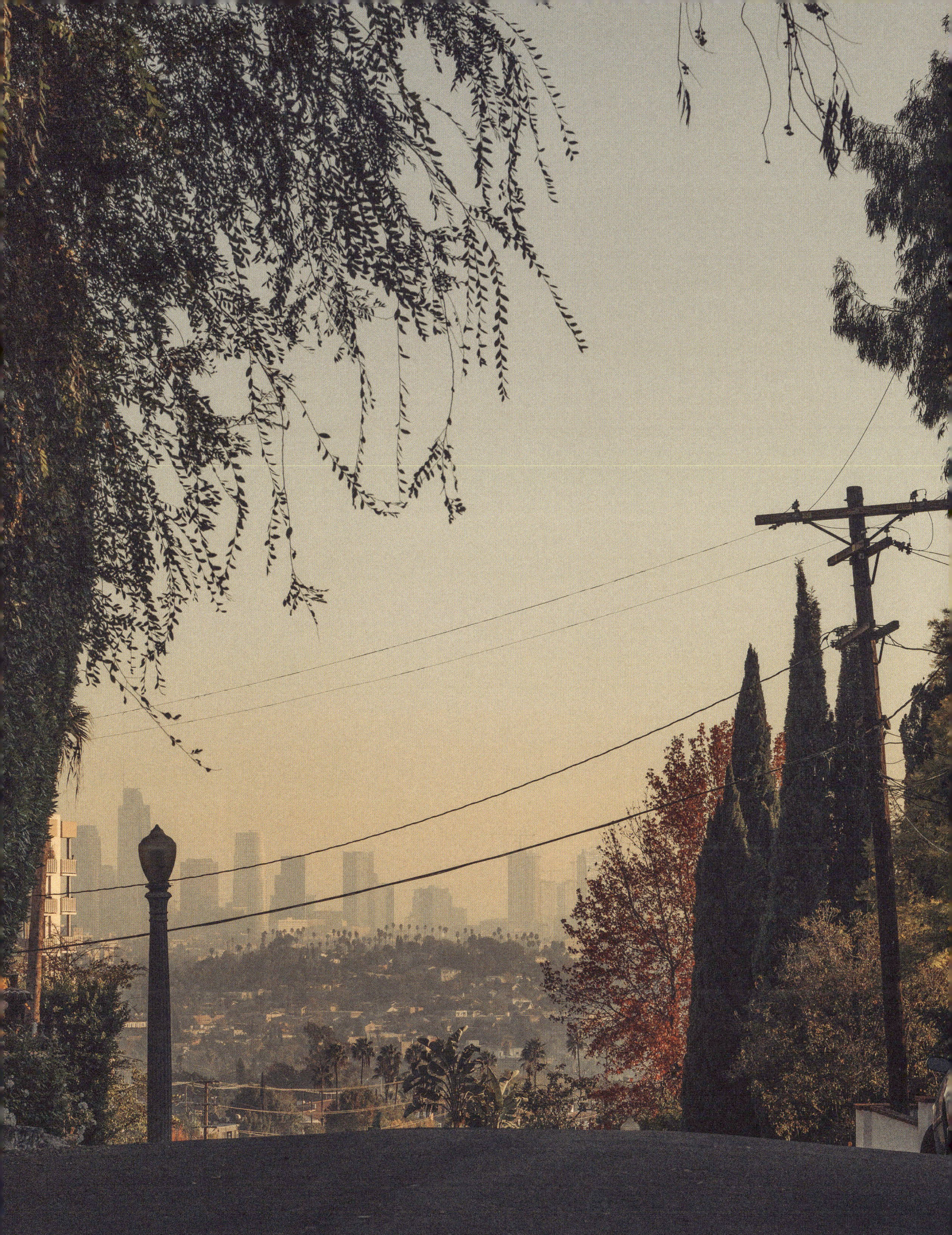

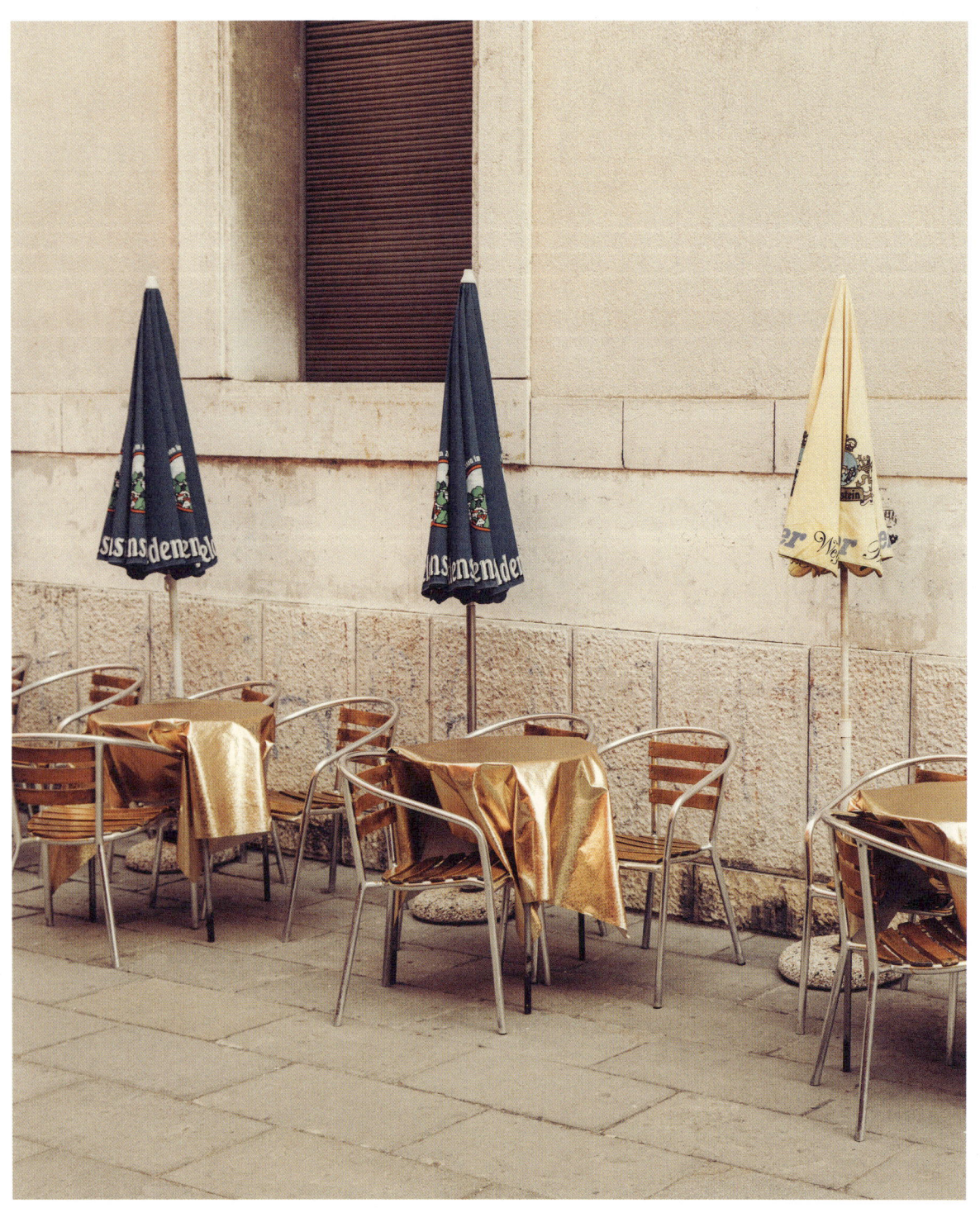

18

STARTERS

VILLAGE PEOPLE
Why is it so difficult to cultivate community?

WORDS
FRANCIS MARTIN
PHOTO
ROMAIN LAPRADE

The traveler's holy grail is a bar or restaurant frequented solely by locals. You know the place: the furniture mismatched, the radio on, there's at least one person reading a newspaper; there's a warmth, as well as a subtle guarantee of quality, that emanates from a place where everyone seems to know one another.

Such a close-knit way of life centered in a local community might be termed the "village mentality." Marked by a shared focus on the immediate locality, and the people who inhabit it, it's a mindset that can be cultivated in the neighborhoods of a city as well as in small towns and villages. Friendships are made, and maintained, within the community, growing organically from regular encounters; people come to see their home as the area itself, rather than just their house or apartment, and so life is lived more openly.

Encountered as a stranger, a community like this can feel like a low-key utopia, but establishing something similar back home can be a challenge. A village does not germinate overnight; it can take years, decades or generations, and the day-to-day reality might not be as straightforwardly delightful as what you experience when away from home. Always seeing the same faces can become tiresome—the old man reading a newspaper is picturesque on first encounter, but perhaps not when you see him every day and discover the topics that set him off.

Is it any wonder that so many of us, after a busy week of work, opt for a change of scene, as often as we can, rather than stay put and build the kind of community that we find so appealing elsewhere? The 17th-century French thinker Blaise Pascal suggested that this was down to humankind's "secret instinct which impels them to seek amusement and occupation abroad."[1] Alongside this urge, Pascal wrote, stood a contradictory pillar of self-knowledge: "That happiness in reality consists only of rest, and not in stir." In the case of the village mentality the contradiction is evident: We want the deep peace of belonging, but our itchy feet undermine our ability to put in the hours.

Yet what if the urge to wander wasn't originally incompatible with the village mentality? The travel writer Bruce Chatwin argued that we are preternaturally disposed to wandering, that "Natural Selection has designed us—from the structure of our braincells to the structure of our big toe—for a career of seasonal journeys." If Chatwin was right, and such a collective nomadism is our natural state, the competition between our desire for a stable community and the urge to wander is shown to be the product of our modern, static ways of living, rather than an inherent contradiction in our nature.

Given that the widespread readoption of a nomadic lifestyle isn't feasible, what can be done to neutralize this clash of impulses and approach something of the village mentality? For many people, this occurs when they consciously take a stake in the area. Often this is when they have children, but sprouting progeny is not the only way to do it. You could join a community group or a sports club, volunteer or get involved with local politics, and if just the thought of this is making you want to head straight to the airport, at least stop by your nearest bar or pub first, and have a chat with the man reading a newspaper: You might just find that there's a community there, ready and waiting for you to join the conversation.

(1) Pascal went on to suggest that an inability to rest can be blamed for everything from wanderlust to war: "A man who has enough to live on, if he knew how to stay with pleasure at home, would not leave it to go to sea or to besiege a town."

Philippe Gaulier may be the world's most famous clown. He's certainly the founder of the world's most famous clown school. Since 1980, École Philippe Gaulier in Étampes, France, has taught hundreds of students who come from around the world to learn *le jeu* (the game); a great actor, Gaulier has written, is "one who never lets the game die."

In January 2014, Gaulier was hospitalized for three months following a stroke and has since stopped teaching on the advice of his doctor. His wife, Michiko Miyazaki Gaulier, a former student, is now running the school in his stead. On the school's website, he reassures his well-wishers: "The funeral is still a long way off."

ELLE HUNT: Can anyone be a clown, or do you have to have particular skills or attributes?

PHILIPPE GAULIER: No. Not everyone can be a clown. You need to have a sense of humor. If you don't have a sense of humor, you will never be a clown.

EH: Why does the world need clowns?

PG: I don't know what the world needs to stay in good health. But for sure, if people laugh a lot, their health is better. I was sick, recently. A guy with a good sense of humor would ring me sometimes, and I'd laugh a lot. After three weeks I was not sick.

EH: What do people tend to get wrong about clowning?

PG: A clown doesn't make you laugh because he kicks his friend up the arse. He doesn't make people laugh because it *is* funny. He makes people laugh because *he* thinks it is funny.

EH: You have worked with many famous English and American actors and comedians, including Emma Thompson and Helena Bonham Carter. Who stands out in your memory, and why?

PG: Sacha Baron Cohen. We are friends. He was a normal student, but he was ready to take what I said, to use it—he was commercial. I like people who say, "I am going to steal your idea, to do something with it after."

EH: What can you do to remain childlike in adulthood?

PG: I don't know. Some people are children all their life, and some people, they want to be adults really quickly. They are quite boring. A child who is four or five years old, and who doesn't know how to read or walk so well—he is the image of a beautiful clown. That is what we are looking for in a student.

EH: How do you identify that?

PG: I have three pairs of glasses.

ODD JOBS
Philippe Gaulier, clown.

WORDS
ELLE HUNT
PHOTO
CÉDRINE SCHEIDIG

STARTERS

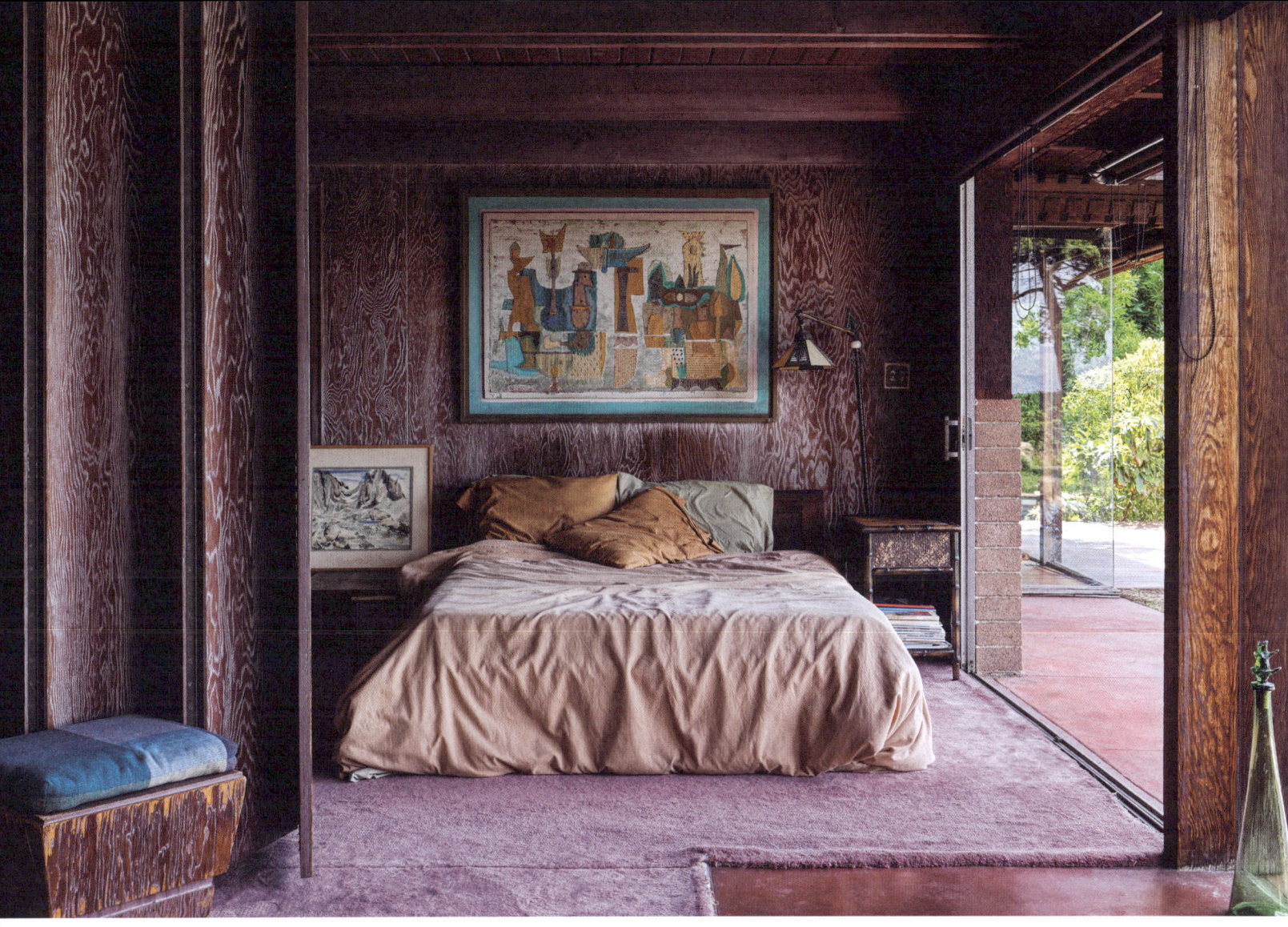

CULT ROOMS
Spying on the house of Anaïs Nin.

WORDS
KABELO SANDILE MOTSOENENG
PHOTO
CHRIS MOTTALINI

The story behind the Los Angeles home of the celebrated writer and eroticist Anaïs Nin (1903-1977) begins in 1947, when Nin met the actor and forest ranger Rupert Pole. Nin had been splitting her time between New York and California and so Pole, who would later become Nin's husband, commissioned a home in Silver Lake to anchor her on the West Coast.

Designed by Pole's half brother, Eric Lloyd Wright, the home expresses the philosophy of organic architecture that had been conceived by Lloyd Wright's pioneering grandfather, Frank—an approach that seeks to balance buildings with the environment, prioritizing natural materials, such as the stained redwood used at Nin and Pole's home, and sustainable design.

The Nin-Pole house, which was completed in 1962, is noted as much for its interior design as for its architecture, however, and is defined throughout by a prominent use of purple. There are mauve carpets and the walls are clad in wire-brushed purplish-brown plywood, a material that is also used for a folding divider that opens the living room onto the bedroom. The west wall has vast floor-to-ceiling windows opening onto a small pool with views over Silver Lake Reservoir, causing—as Tree Wright, the secretary of the Anais Nin Foundation, says—the entire space to be "warmed [by] the mauve interior [at] sunset."

Little has changed at the house since Nin and Pole lived there. Following Pole's death in 2006, Tree moved in with her husband, Devon, Lloyd Wright's son, and had the house designated as a historic-cultural monument. They sold the house in 2020, but as Tree remembers, "We spent hours watching incredible fires in the large fireplace, with the pool reflecting dancing light onto the interior walls and ceiling; the sky entering from the unobstructed picture windows, along with the abundant lush landscape planted by Rupert."

OKLOU

WORDS
CONOR MCTERNAN
PHOTO
JAMES PEARSON-HOWES

The classically trained, club-ready pop star.

For over a decade, French musician Oklou (pronounced "OK, Lou") has been quietly reshaping avant-pop with ethereal soundscapes and introspective lyrics. Her music blends ambient textures with club-oriented rhythms, an enchanting sound that has earned her a devoted following and a steady stream of cult remixes.

When we speak, Oklou—whose real name is Marylou Mayniel—is on the cusp of releasing her debut full-length album, *choke enough*, a record that features collaborations with Casey MQ, A.G. Cook, Danny L. Harle and Cecile Believe. Here she discusses balancing life and creativity, the influence of cinema and the natural world, and her definition of success.

CONOR MCTERNAN: What's been on your mind lately?
OKLOU: I'm pregnant right now, and that takes up a lot of my thoughts. It's intense balancing that and being creative, but I don't have time to be bored!
CM: Your music explores magical realism, loneliness and escapism. How do these themes play into your new album?
O: I wanted to balance the fairylike elements of my music with a more complex and truthful reflection of my experiences. My first language is the sound—then vocal lines, then lyrics.
CM: How did you find the process of writing *choke enough*?
O: The main thing I found was that I needed to decenter myself and pay more attention to the people, the environment and the world around me. I got closer to my family, friends and—how can I say—humanity in general. When it comes to lyrics, it's a bit crazy, but with the sound, the process is very simple. Using the crow sound [on track "Harvest Sky"], for example, was a great way for me to picture what I had in mind for the sonic landscape, to get in the mood of the fields, the countryside, the night. It's also a nod to "Crow," one of my favorite tracks by the band 18+.
CM: Another reference in *choke enough* is the 1982 animated film *The Plague Dogs*, which features in a track title and the music video for "obvious." How does film inspire you?
O: Animated films leave a mark on me—the aesthetics, characters, the use of music. *The Plague Dogs* resurfaced in my mind when I saw a video of a man running from the police into the sea which I used as an album reference. That imagery—seeking escape but heading toward something fatal—stayed with me.
CM: One fan noted a blue undertone to the album. Was that intentional?
O: Not consciously. When it came to visuals, I just went with what felt right. My designer, Kim Coussée, and I naturally leaned into blue with our mood boards, which also connects to late '90s and early 2000s sci-fi films like *The Matrix* and *Minority Report*.
CM: What's the busiest part of your job right now?
O: Promo. It forces me to articulate my thoughts, but reading my interviews later, I often think, "I talk so much bullshit!" I wish I had David Lynch's precision.
CM: What do you think defines success for an artist today?
O: For me, it's making choices without compromise. Success isn't about streams if I don't care about the song. It's about feeling completely in touch with what I create.

LOW-HANGING FRUIT
Banana peels: a slippery history.

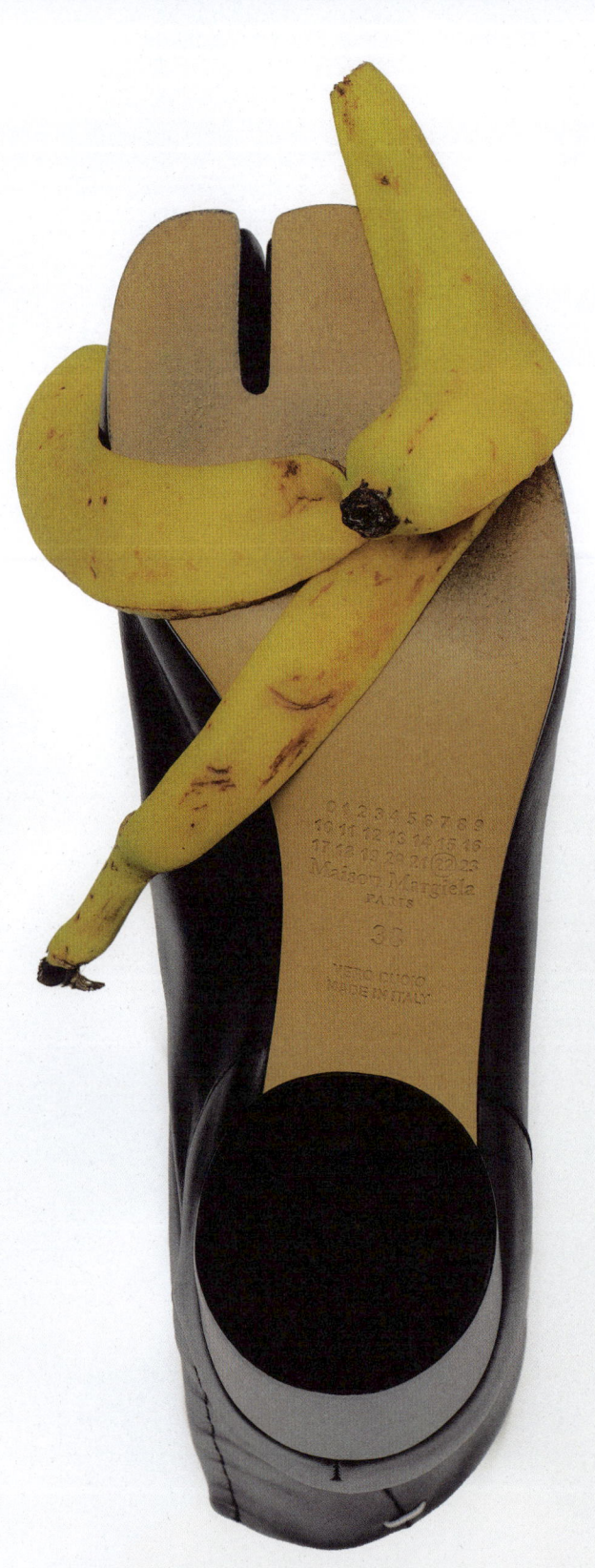

Set Designer: Emma Sandral

WORDS
JAMES GREIG
PHOTO
LAUREN BAMFORD

Slipping on a banana peel was already considered hackneyed at the beginning of the 20th century. One *Variety* writer dismissed the gag, in 1909, as having been "so done to death by the funny papers that it is tabooed now entirely as too old." It had become the kind of groan-inducing cliché that would have seen trembling hopefuls booed offstage at vaudeville open mic nights; the Edwardian era's equivalent of a sitcom character saying "...he's standing right behind me, isn't he?"

Played out or not, the trope went on to feature heavily in the golden age of silent comedy, where it was being subverted from early on: In *The High Sign* (1921), Buster Keaton casually saunters over a banana peel that an enemy has left out as a trap—the joke being that, contrary to the audience's expectations, he *doesn't* slip. Keaton returned to a more conventional version of the gag several years later in *The Cameraman* (1928), where he slips on a peel and slides flat onto his back with an almost balletic grace. Since then, successive generations of comedians have continued to strive to do something novel or surprising with the hoariest old cliché in the book.

But while the joke itself has endured, the context that first led to it becoming ubiquitous has not. Slipping on a banana peel was never simply an absurdist gag, but one rooted in a then-familiar social problem: litter. Bananas became a popular snack for the first time in the 1880s, when North American and European cities were growing at a rate that far outpaced their capacity to manage waste. After enjoying a banana, most people would toss the peel into the gutter, and so the streets really were lined with slimy, decomposing skins. Slipping on them was a fairly common hazard—which in some cases proved fatal—and could even be said to be a driver of modern urbanism: In 1903, the death of an elderly man in Bristol after slipping on a banana peel led to the introduction of some of Britain's first ever public trash cans.

Although accidents still happen today, banana peels are responsible for a far lower body count. Not only are city streets cleaner, but the variety of banana that we eat today (the Cavendish) has a less slippery skin than the kind that was popular at the time of Charlie Chaplin (the Gros Michel, now all but extinct).[1] But even if tossing away a banana peel is less likely to lead to a manslaughter charge or hip replacement surgery, it is a waste to discard such a versatile ingredient, capable of doing everything from flavoring curries and making teas to moisturizing skin, strengthening hair and whitening teeth. The banana peel, which has given us so many groans over the years as a comedy prop, deserves a second act as the next aspirational lifestyle accessory.

(1) Cavendish bananas have been the dominant variety since the Gros Michel was almost wiped out by Panama disease in the 1950s. Today, they represent 99% of all banana exports, but their days may be numbered: All Cavendishes are descended from a single plant cultivated at an English stately home in 1834, and their lack of genetic diversity makes them vulnerable to disease.

"I have the best advice for women in business: Get your fucking ass up and work," Kim Kardashian quipped during a *Variety* interview in 2022. "It seems like nobody wants to work these days," she continued, unaware of the bomb she had just dropped. People were fresh out of COVID lockdowns, still reeling from the financial hardship of society shutting down for months on end, and utterly *unwilling* to receive work advice from a billionaire reality star turned entrepreneur. The social media maelstrom that followed oscillated between the nonexistent merits of influencer "girlbossery," the tone deafness and privilege of the Kardashians and the unavoidable sexism that follows comments made by women online.

What was largely missed in the uproar, however, is how unoriginal Kardashian's comments were. Wealthy people have a long history of blaming those less fortunate for being lazy, and therefore casting them as unwilling—rather than unable—to pull themselves up and rise through the ranks of society. It ties into an almost universally held belief that laziness is a negative human trait, a demonstration of one's incapacity to contribute to society.

But what if "lazy" people just need a break—literally? That is the argument made by social psychologist Devon Price in his book *Laziness Does Not Exist*, which sets out to debunk the "laziness lie" permeating Western societies. "To this day, many of us believe that time spent in productivity is inherently better spent than time spent relaxing, connecting to other people, meditating or repairing the body's tissues with rest," says Price. This belief system, he argues, is inherited from Puritanism: the conviction that work has moral value, and that lethargy leads to damnation. Today, it is a convenient way to scapegoat individuals for their inability to be successful and an excuse to deny them a social safety net. As Price puts it: "If unemployment is merely caused by a personal lack of drive in applying for jobs, then there is no need for state intervention."

The inevitable result is an overworked, burned-out society where people feel guilty for their lack of motivation, rather than realizing they just need time off. Capitalism thrives on this state of affairs; humans not so much. To unlearn the "laziness lie," Price suggests giving money to those society deems the laziest of all: unhoused people. "It is easiest to start being patient towards others," he says, "and then begin to extend that same graciousness to oneself."

Destigmatizing the notion of "laziness" could be helpful too. That is what the French radical thinker Paul Lafargue—incidentally Karl Marx's son-in-law—proposed all the way back in 1883, in *The Right to Be Lazy*, a pamphlet against "the disastrous dogma of work." In it, Lafargue makes the case for a three-hour workday and a progressive shift toward idleness and universal income as machines become increasingly capable of replacing human labor. Laziness, per Lafargue, is not so much a state of inactivity, but rather time to focus on contemplative or communal activities outside of the vicious production-to-consumption cycle. By getting rid of work, and the notion that it makes our existence more valuable, laziness would instead allow us to give in fully to what matters most: life itself.

COUNTER PRODUCTIVE
The case for laziness.

WORDS
DAPHNÉE DENIS
PHOTO
YOSIGO

THE LIKING GAP
A soother for the socially awkward.

WORDS
OKECHUKWU NZELU
PHOTO
FAUSTINE MARTIN

Have you ever walked away from a conversation with someone new, cringing over how you might have come across? Did that joke really land? Do I still have some of my lunch in my teeth? Was that the right way to pronounce "Loewe"? Ugh.

The common message for overcoming such vigilance is to simply have more confidence. But in fairness, these conversations are a fundamental part of life. They have the power to turn strangers into friends, coffee dates into marriages, and interviews into jobs. The anxiety is rooted in something much more real: Will this person want to see me again? If either party is intimidated or afraid of rejection, then it's understandable that they might be guarded about how much they're enjoying a conversation, in case that enthusiasm is not reciprocated.

In 2018, *Psychological Science* published a study: "The Liking Gap in Conversations: Do People Like Us More Than We Think?" The answer to this question, it turned out, was almost always a resounding yes. The study observed strangers meeting in a range of scenarios and found that people will systematically underestimate the extent to which their interlocutor liked them and enjoyed their company—even if all signs to the contrary were present. The authors called this mistaken belief "the liking gap."

Looked at one way, *Psychological Science*'s study confirms something that is deeply frustrating: Most people know when they are worrying too much about how they are perceived, and yet still allow themselves to get caught up in thinking about it rather than being present with the other person. On the other hand, knowledge is power: Many studies attest to the phenomenon, and so the reassurance that it is a universal experience is particularly welcome. Perhaps all you need to bridge the liking gap is to just acknowledge that it happens to the best of us—and to always have a breath mint on hand, just in case.

WHAT ARE YOU WORKING ON?

WORDS
ANNICK WEBER
PHOTO
CHRISTIAN CASSIEL

TATJANA VON STEIN's latest designs.

"I used to go to school on a sleigh! I'm surprised I've become so urban," says the London-based designer Tatjana von Stein. Despite the dramatic shift in scenery, her resolutely European upbringing—moving between Germany, the Austrian Alps and Paris before settling in the British capital in her teens—is evident throughout her practice. Since founding her namesake firm in 2016, von Stein has completed hotels, restaurants, members' clubs and private residences—as well as design collectibles—that nod to the continent's design heritage, whether that's the Vienna Secession or Eurodisco.

ANNICK WEBER: European flair aside, how would you define your style?

TATJANA VON STEIN: I can't put an actual word to it, but there's a feeling of nostalgia running through everything we do. Certain projects are sexier than others, but they are always quite indulgent in that they create little worlds that envelop people. And my work is very intuitive; maybe it goes back to the fact that I never actually studied design. If I look at the bar I designed for our Mise en Scène furniture collection, for example, it's 90% true to the first sketch I ever did of it.

AW: Can you give an example of the worlds that your designs aim to evoke?

TVS: We're currently working on a 300-bedroom hotel in Munich. We did a lot of research on the city and it turns out it had a booming 1980s disco scene. Some of the biggest artists recorded there. We thought, Wow! Let's bring that narrative up and reference it in our design. It's how we differentiate our projects, though it's only ever about gentle nuances in form and materiality that cultivate the *essence* of an era—I don't want to create a themed hotel.

AW: Would you say your work focuses as much on creating experiences as it does on aesthetics?

TVS: I think a lot about the psychology of space: how people feel in a space or how they want to experience it. We've just completed a residential project in an Art Deco–inspired building in London, 60 Curzon, where we sought to echo the atmosphere associated with that era. When you think about Art Deco, you imagine people running around with martini glasses, being fabulous. So we brought this kind of theatricality throughout, in both our interior design and furniture. It's the first project where the two really come alive together.

AW: What inspires you right now?

TVS: Dance is very emotive to me. I think it's why I work a lot with reflective surfaces—glass, lacquered wood—as it's never bland; things are in constant movement. I'm also into symbolism. We just did a plaster sun [wall decoration] at 60 Curzon, and we're using suns and moons for the outdoor restaurant we're working on with local makers for Hotel Corazón in Majorca. Once I start being interested in a theme, it suddenly begins appearing in all kinds of places.

WEAPONIZED INCOMPETENCE
How to handle useless people.

WORDS
ALICE VINCENT
PHOTO
TRINITY ELLIS

One of the universal experiences of being an intern is realizing how many straightforward jobs people with far more experience are not only too busy to do but apparently incapable of actually doing—tasks such as arranging the return of precious designer samples or exporting a document as a PDF—and which manage to be simultaneously stultifying and fraught with anxiety. Yet, of course, there also comes a time when the once-harried intern has climbed far enough up the greasy pole that they develop their own performed ignorance of how things work: After all, it becomes easier to avoid doing tedious tasks by professing not to know how, rather than admitting you don't want to.[1]

The mindset has come to be known as weaponized incompetence—a term that gained popularity in 2021 in the midst of the pandemic, when women, on average, spent an extra working day per week doing domestic care, totally unpaid, while men's contributions to housework and childcare remained largely unchanged. It has since been feverishly applied to 18.5 million TikTok posts and become an increasingly familiar source of bickering for those in cohabiting or parenting couples. Rachel Yoder's novel *Nightbitch*, and its subsequent film adaptation, had many women sighing in recognition of the heroine's husband's supposed incapability to complete basic tasks around the home.

Social media and pop cultural conversations around weaponized incompetence center on the household, where domestic work is no longer expected to be divided along gender lines, but the term has its origins in the workplace. Coined as "skilled incompetence" by the *Harvard Business Review* in 1986 before being rebranded as "strategic incompetence" by *The Wall Street Journal* in 2007, the concept has stayed largely the same: being purposefully bad at something to avoid having to do it. Case in point, the subject of *The Wall Street Journal*'s landmark feature, who dodged organizing the company picnic for years.

Once you learn how to spot weaponized incompetence, you'll see it everywhere: On those customer service calls that ping you around to different departments in an Escher-like loop because nobody really wants to solve your problem. That one friend who never organizes the restaurant reservations, "because you know all the good places." The relative who is somehow perfectly able to transfer money for the shared gift, but is incapable of thinking about or buying it ("But you always know what they want!"). Turn that lens on yourself, and you might even find some instances where you're weaponizing your own incompetency.

How to fix it? Try these approaches. Solve the incompetency and it can no longer be weaponized—it takes a lot more courage for someone to profess ignorance of how something works if they've actively been shown how to do it. So show your partner how to program the thermostat. Give an impromptu demonstration of how to work the printer one quiet Tuesday morning. Or you could just ask them to do the thing they've assumed you'll do. It's a lot more difficult to shirk a direct request. And you can always rise above when you're feeling generous: "Do you know how the coffee machine works? Let me help you."

(1) The inverse of weaponized incompetence is "learned helplessness." Coined by researchers at the University of Pennsylvania in the 1960s, it describes feelings of powerlessness after repeated exposure to negative, uncontrollable situations and has been seen as a contributing factor to depression. More positively, the idea of "learned optimism"—that it is possible to cultivate feelings like joy—also exists.

The linguist Adam Aleksic, who maintains an entertaining social media presence as @etymologynerd, has noted that the way we save people's names in our phones with descriptive information—Bob Plumber; Jessica Tinder; Marina EX! DO NOT ANSWER!—is simply a rehashing of the way last names in the West came about in the first place. While there is evidence of family names and patronyms being used in the ancient world, they really took off in the Middle Ages in England when a population increase, and the need for accurate record-keeping, led people to distinguish one another by their place of origin, job or other notable personal traits.

If there were two Johns in the village, one might be from the wood and the other was the blacksmith—hence the proliferation of Hills, Smiths and Bakers. Only over time did these monikers become hereditary. Some surnames simply reflected the name of the father: Once upon a time all Johnsons were John's son. In Iceland, practically every name is made by adding the Icelandic spelling of "daughter" or "son" to the father's first name (Björk Jónsdóttir, for example).

As last names evolved, they became a way of distinguishing someone's class and status as well as their occupation or provenance. If a "von" in German or "de" in French preceded the surname it indicated noble lineage; the Napoleonic admiral Pierre-Charles Villeneuve shrewdly dropped his "de" when he took up with the revolutionaries. In English, a double-barreled last name was another indicator of status—a sign that the wife's maiden name was too important to lose when she married.

Today, however, it's increasingly hard to tell much from a last name. Hyphenated names now tend to reflect a feminist, rather than aristocratic, desire not to give the child only the father's name, and many newlyweds create a whole new family name in the quest for equality. There has also been so much intermingling and migration that a surname is no longer a reliable indicator of provenance or class. And—as is demonstrated every time a Western sports commentator tries to wrap their head around a Korean name—many cultures have entirely different conventions.

Besides, as language evolves, words can achieve completely new meanings. For most of the past few hundred years, "Cumming" has been a reliable indicator of Scottishness. Before that, its antecedent "Comines" would have let you know the individual had come over from Comines in Normandy, when William the Conqueror invaded England in 1066. Today, thanks to the internet, cumming has another, more recent connotation, and waking up to find someone saved as "Cumming" in your phone might give you pause for thought. Luckily, sometimes a name is just a name.

WHAT'S IN A NAME?
A medieval solution to a modern problem.

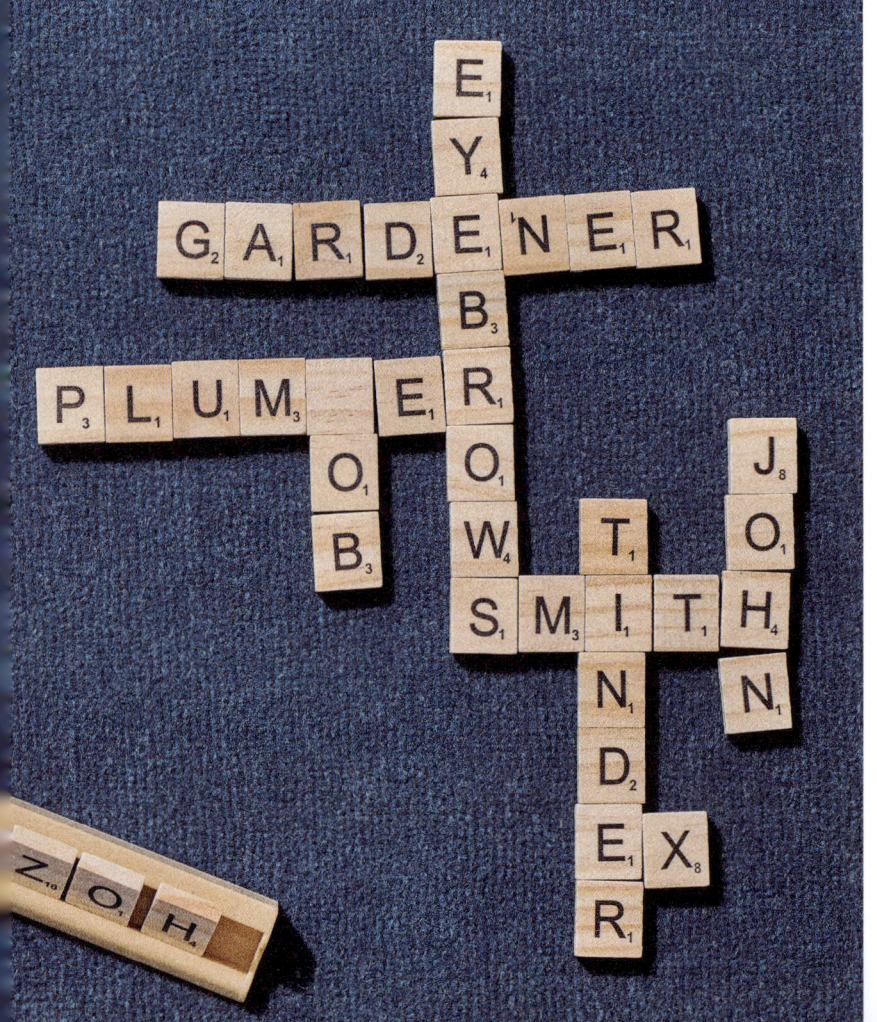

WORDS
ED CUMMING
PHOTO
LAUREN BAMFORD

STARTERS

In the popular imagination, philosophy is done "from the armchair." It's an image that suggests both comfort and detachment, and that makes philosophizing the preserve of those with sufficient time and repose to isolate themselves from the world and follow their intuitions.

Yet not all philosophers have been happy to stay seated. The empirical orientation of Aristotle's school in ancient Athens was symbolized in the members' nickname—"the Peripatetics"—a label they acquired from their habit of walking while discussing philosophical ideas. Hippocrates, also a physician, proclaimed that "walking is man's best medicine." Kant is known to have taken walks every day (with such an intense regularity that the housewives of Königsberg are said to have told time by them).

Meanwhile Nietzsche, whose mature works were the product of an itinerant lifestyle spent mostly in cheap Italian hotels, once advised, "Sit as little as possible; do not believe any idea that was not born in the open air and of free movement—in which the muscles do not also revel. All prejudices emanate from the bowels." Here we have one of the fiercest condemnations of the armchair imaginable: In Nietzsche's image, the idle posture of the proverbial "armchair philosopher" is quite literally allowing feces to rise to their brains.

But why *should* we think better thoughts when we are walking rather than seated? The armchair philosopher is isolated but so too is the lone wanderer, hiking in the hills above the clouds. Surely, it matters where we walk—and with whom. The armchair philosopher is comfortable, and so might fall prey to delusion, but this can be equally true of the philosopher whose ideas are formed while strolling with colleagues round an Oxford quad.

I can't speak to the quality of my own thoughts, but stepping outside surely helps them along. My walking is not idle—mostly, as an academic philosopher and writer, it is something that I need to do in order to materially sustain my family—and it can leave me in no delusions about the state of the world: The sidewalks near me are cracked and covered in trash. This, to me, is what seems necessary about philosophical walking: that it should connect thought with life—real life—in all its drudgery and dirt.

WORDS
TOM WHYMAN
PHOTO
DAVID VAN DER LEEUW

THINK ON YOUR FEET
On wandering and wondering.

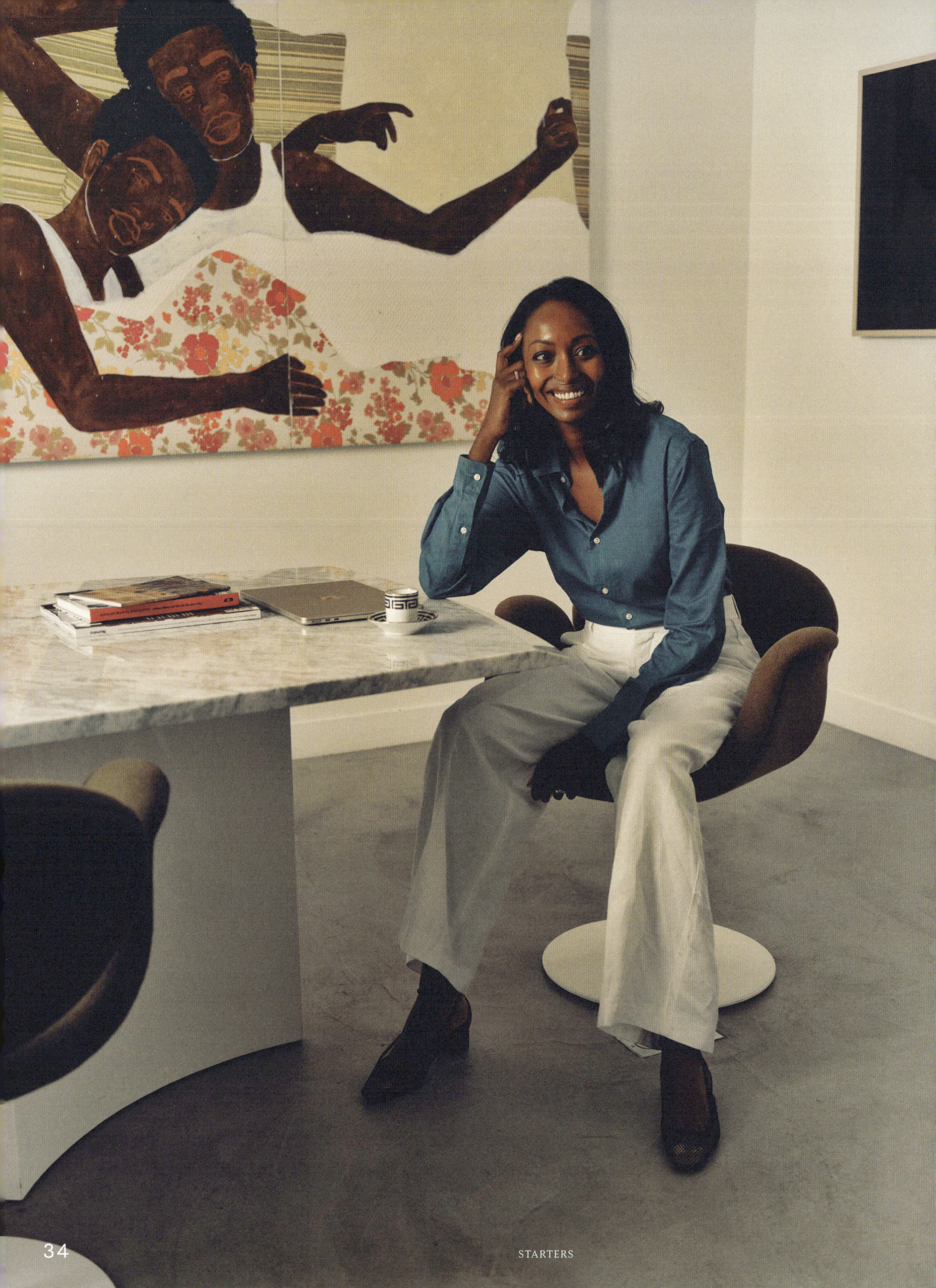

MARIANE IBRAHIM

WORDS
PRECIOUS ADESINA
PHOTO
INÈS MANAI

A quick check-in with the globe-trotting gallerist.

Many people advised Mariane Ibrahim against opening a gallery. "There's always these well-intentioned people saying, 'get to know how things work first,'" she says over the phone from Paris. The Somali French art dealer had previously worked in marketing and the skeptics assumed she had a lot to learn before opening a successful art space. "But I knew what I wanted," she says; in 2012, she founded M.I.A Gallery in Seattle, focusing on championing artists from countries in Africa and the Middle East.

Ibrahim has just landed at the airport and has little time to waste as she bundles herself into a taxi to head to a meeting. In 2019, she relocated the gallery to Chicago, renaming M.I.A (an acronym that stood for both "Missing in Art" and her maiden name, Mariane Ibrahim Abdi) to Mariane Ibrahim Gallery. In 2021, she opened a second spot in Paris and in 2023, her third in Mexico City. She now represents a roster of world-renowned artists, including the German-born Ghanaian textile artist Zohra Opoku, the Ghanaian painter Amoako Boafo, British Liberian visual artist Lina Iris Viktor and the Ethiopian photographer Girma Berta.

Ibrahim points out that Seattle "wasn't an easy place to start," but played an integral role in founding the gallery. "There was no art market, no diversity in that city. Everything was about tech—Microsoft, Amazon, industries like that," she explains. Seattle allowed her to focus on her goals without being "distracted by the art world": "I wouldn't say Seattle was the place where I found a community or success, but in some ways, that solitude was useful."

Ibrahim's approach to the industry has been shaped by her upbringing. Born to Somali parents in Nouméa, New Caledonia, a French territory in the South Pacific, her family returned to Somalia with her when she was five. In 1987, not long before the ongoing civil war broke out, her family moved to Bordeaux. She would later study communications at Middlesex University in London, remaining in the UK to work in marketing.

Spending her formative years hopping between continents has encouraged Ibrahim to look beyond national or regional identities. "When it comes to this profession, or creative work, there should be no borders," she says. "In my case, it was about caring for and bringing forward certain artists without marginalizing them—'marginalized' being a term I don't like." She points out that nobody should be forced to devalue themselves as a result of society's biases: "How others treat you is on them, but how we treat ourselves and connect with art is noble, not marginalized."

Today, opening a gallery that focuses on artists in Africa and the Middle East would not be groundbreaking, but it was a different story a decade ago. Museums like the Tate, MoMA and the Louvre primarily showcased Western artists, and if non-Western ones were shown, they were often lumped together in group exhibitions or particular sections of the institutions, furthering entrenched ideas of otherness. "I knew I wanted to build a gallery that focused on African and African diaspora artists, but I was often told, 'No, we don't work with artists from that heritage,'" she says. "There was resistance, but

I didn't care. It was a mission—something I had to do. It wasn't about being trendy or making a statement; it was just necessary."

Now artists from Africa, the Middle East and the diaspora are an integral part of the global art market. There are fairs focusing solely on African artists, such as 1-54 Contemporary African Art Fair, which travels to London, Marrakech and New York each year, and the past decade has also seen the rise of new art markets in places such as Lagos, Cairo and Dubai.

Ibrahim herself is a significant figure in this shift, having worked to build a bridge between the art fairs and institutions and the artists themselves. Her decision to open galleries in Chicago and Mexico City, rather than in cities with established art markets, such as London and New York, was a deliberate act of defiance and part of an effort to seek out places that were more relevant to her mission, both professionally and personally. "I know New York is very international—I've lived in London, I've lived in Paris, so I understand that energy. But I felt like… I'm the second child in my family, so maybe it made sense to go to a 'second city,'" she says of her decision to move to Chicago. "I received such an amazing welcome from the people. I've found the community I was looking for for a long time."

Ibrahim admires the Midwestern city "for its history, especially the presence and migration of Black Americans." Chicago has a long legacy of being a hub for Black creativity, from the Great Migration, which brought many African Americans from the South to the city between 1916 and 1970, and cultural movements such as the Chicago Black Renaissance that paralleled the famous Harlem Renaissance.

"I've always been fascinated by the level of excellence that Chicago has—without any pretension," she says.

Despite Paris being a well-established art capital, Ibrahim's decision to open a gallery there wasn't driven by prestige. After her success in Chicago, she felt she needed to bring what she had learned to one of her hometowns. "For me, going back to Paris felt like I'd been sent on a mission," she says. "I felt that the knowledge and progress I had made in the US was something to be shared in France."

Mexico City was perhaps the most unlikely location of the three spaces: Her desire to open shop stems from her experiences visiting the country on vacation. "Mexico was a place where I used to go out of frustration with Seattle not being a city of culture and antiquity," she says. "I was going there to enjoy the architecture, the culture, the art." It was only later that she recognized its potential. "I realized there were so many possibilities there," she says. "You have these spaces that are Baroque or Brutalist, and I thought, 'Wow, wouldn't it be amazing to use that decor, that space, to present art?'"

Today, Ibrahim is an established figure in the art world, but she hasn't forgotten how and why she got her start. She still feels that it has a long way to go before her industry is truly accepting of artists from Africa and the Middle East, and she has no intention of stopping or slowing down. "The question is: Can we focus on an artist's aesthetic and intellect rather than just their Blackness?" she says as her taxi pulls up to her meeting. "I want to do this for as long as possible," she says. "This isn't a trend for me—it's my life's work."

*"It was a mission—something I had to do.
It wasn't about being trendy or making a statement; it was just necessary."*

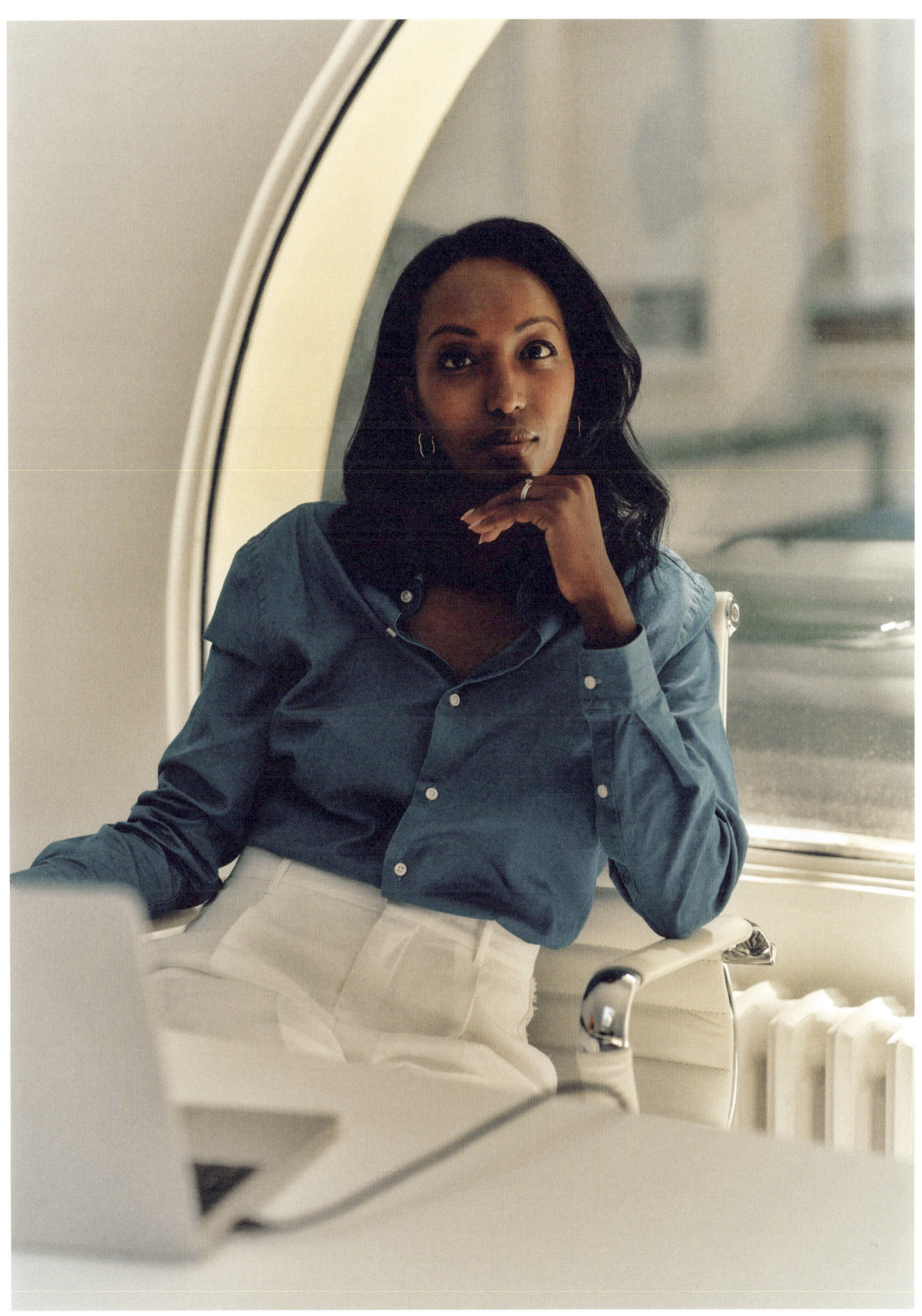

WORD: EGÉRMOZI
The silver screen is shrinking.

Etymology: Egérmozi, Hungarian, a modern slang term literally translating to "mouse cinema." *Mozi* derives from *mozgóképszínház*, an archaic term for a movie theater.

Meaning: This evocative phrase refers to the act of watching films or television on your phone, a habit increasingly adopted in our content-obsessed modern world. Morning commutes and late-night gym sessions would not be complete without the sight of several bleary-eyed people squinting into phones held sideways.

The environments that engender such behavior are typically spaces of boredom. Why shouldn't you make the time pass quicker by binge-watching episodes of the latest straight-to-streaming thriller or catching up on a movie from your watchlist? The convenience of your phone makes the decision a no-brainer, but it's had a curious effect on the content the streaming platforms produce. Eager to meet the burgeoning demand to fill those mindless moments, companies like Netflix have sought to optimize their offerings for small screens, including exploring the possibility of editing films differently—tightening up wide-angle shots, for example—to ensure maximum impact for those watching on their phones.[1]

The rise of mouse cinema has coicided with the decline of movie theaters, which are struggling to draw an active, cinema-going public and increasing their ticket prices as operating costs become untenable as a result. The sanctity of the cinema space has been rejected, but can a six-inch phone screen watched on a noisy train ever truly compare? At the release of his second *Avatar* film, James Cameron—a filmmaker firmly committed to big-screen action—said: "When you start looking at something on a phone, you're sort of missing the point. Going to a movie theater is less about the size of the screen and the perfection of the sound system. It's more about a decision to not multitask." In the theater, he continued, "you're making a deal between yourself and a piece of art to give it your full attention."

Depressing as it is, it's unlikely that this trend will change any time soon. With attention spans at an all-time low and brains addicted to the endless churn of online content, egérmozi, with all its distractions, may well become the only cinema space left available.

(1) Netflix has adapted to modern viewing habits in other ways, too. In an article for *n+1*, Will Tavlin writes that screenwriters are often told to make characters announce what they are doing so people who have Netflix on in the background can still follow along, leading to lines such as this from Lindsay Lohan in *Irish Wish*: "We spent a day together. I admit it was a beautiful day filled with dramatic vistas and romantic rain, but that doesn't give you the right to question my life choices. Tomorrow, I'm marrying Paul Kennedy."

WORDS
CAITLIN QUINLAN
PHOTO
LAUREN BAMFORD

Children have probably been rolling down hills as long as there have been hills and children to roll down them. All you need is a body, a hill (preferably grassy and without rocks) and gravity. You don't need gear, or strength, or athletic skill. You don't have to worry about doing it poorly—who, after all, rolls down hills *well*? Everybody looks foolish rolling down a hill.

Beyond the sheer unadulterated fun of it, rolling down hills has benefits for children and grown-ups alike. Communing with nature has long been shown to be beneficial for mental health and wellness, probably only more the case when you're literally rolling in it. According to the biophilia hypothesis, popularized by American sociobiologist E.O. Wilson, humans thrive in natural environments since our brains and bodies have evolved alongside nature.

Unlike other activities that were once done for fun and have since morphed into codified sports (surfing, skateboarding, pickleball), rolling down hills seems pretty resistant to co-optation by professional hill rollers. It's hard to imagine how one could score points, or become any more graceful or skilled at it than anybody else.

One of the few places one can see people rolling down hills in any sort of competitive setting is the Cooper's Hill Cheese-Rolling and Wake, an annual race in the UK in which contestants chase a wheel of cheese down a steep grassy slope. But all that rolling is more a consequence of the precipitousness of the hill than any requirement of the event (no rules prohibit you from just running the entire race upright, for example). Ironically, the rolling at Cooper's Hill is often the least fun part of the competition, resulting every year in scrapes, bruises, concussions and the occasional broken bone or two.

For would-be rollers interested in maximizing fun and minimizing Cooper's Hill–style injuries, there are a couple of things to keep in mind: Go for a steep, but not too steep, hill; wear clothing that you wouldn't mind getting grass stains on; check the slope for rocks, trees and deep holes larger than your body. But most of all, enjoy the ride, secure in the knowledge that nobody is judging your form (in rolling, there is none) or laughing at you, except perhaps to share in your childlike joy.

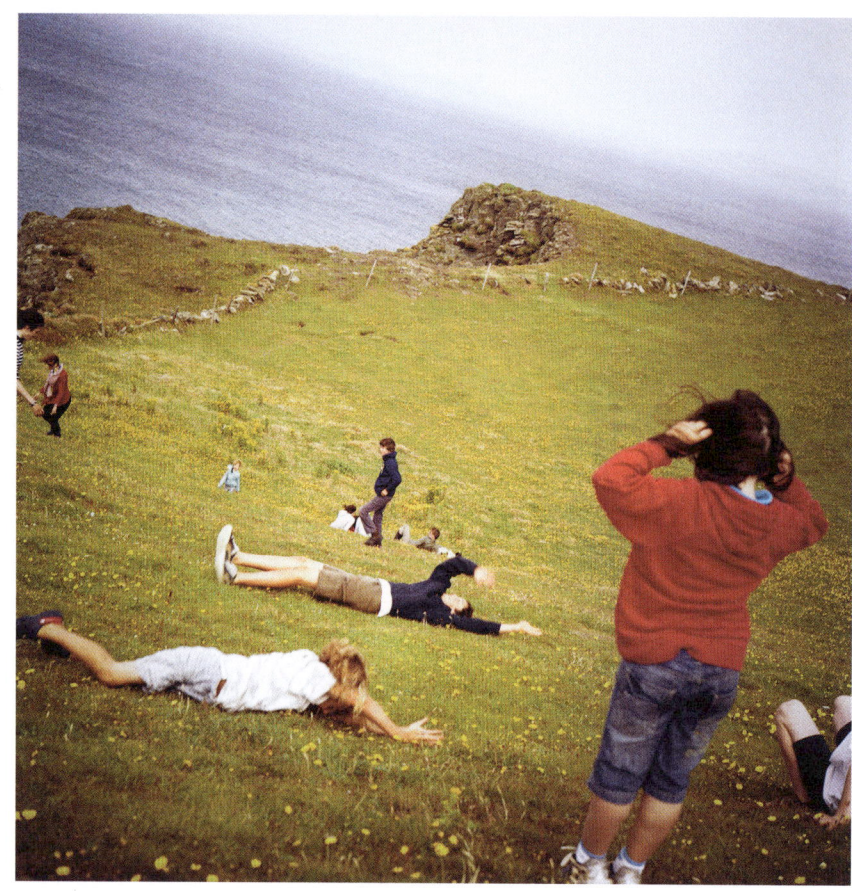

WORDS
ROBERT ITO
PHOTO
JOHN DOLAN

HOW TO: ROLL DOWN A HILL
A treatise for tumbling.

FEA
TUR
ES

42	Wim Wenders
54	The Lonely State
58	Georgia Anne Muldrow
68	Studio Visit: Industrial Facility
76	Tree Hugging
88	Home Tour: Frey House II

Whether in the US, Europe or Japan, or between feature films and documentaries, the director Wim

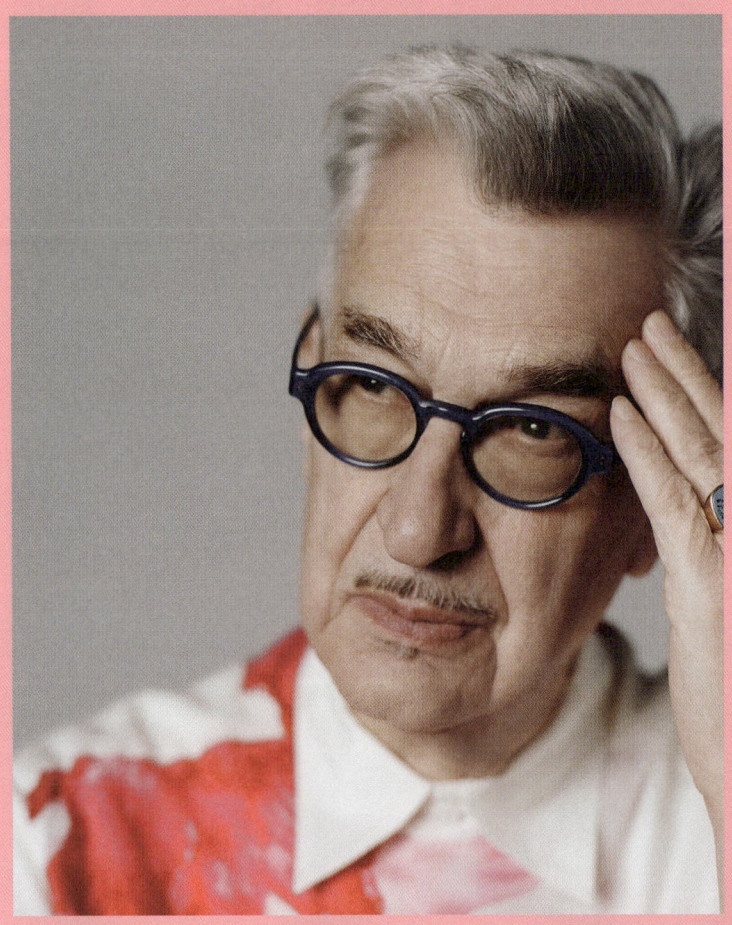

Words
Simran Hans
Photos
Katie McCurdy
Styling
Ashley Abtahie

WEN

WIM
Wenders has always been on the move. As he turns 80, he shows no signs of slowing down.

DERS

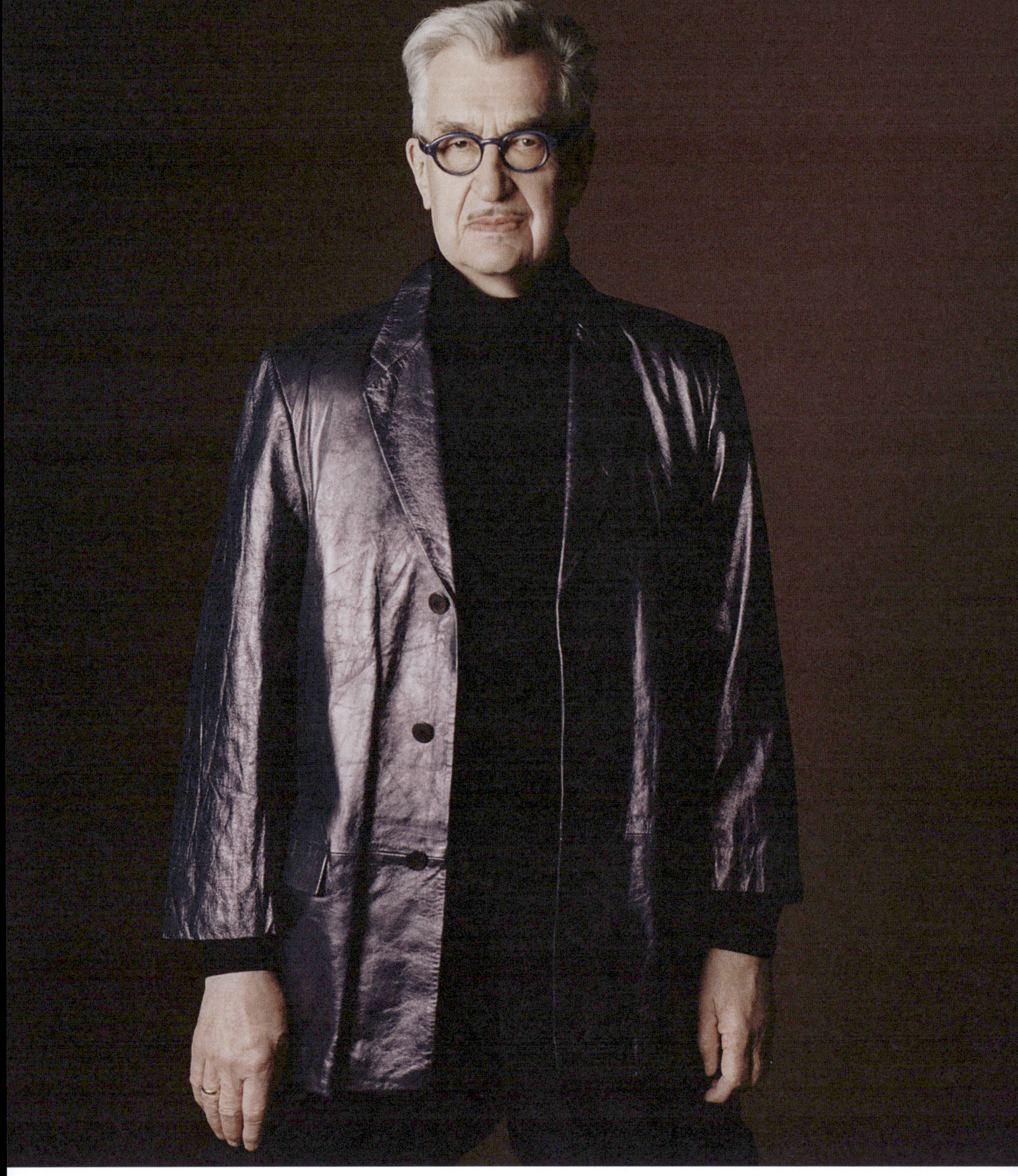

(opposite)
Wenders wears a vintage jacket by VERSACE from LARA KOLEJI, and his own sweater, eyewear and trousers by YOHJI YAMAMOTO.

(previous and overleaf)
He wears a shirt by YOHJI YAMAMOTO.

Wim Wenders loves to write on long-haul flights. "I never watch movies on planes," says the 79-year-old director of *Wings of Desire*, *Perfect Days* and *Paris, Texas*. On the few occasions that he has made use of the in-flight entertainment, he found himself "liking films that later on embarrassed me—I think they put something into the air."

Wenders is, appropriately enough, sharing all this in a long email, written en route to Mumbai. He's visiting the city for the first time: Over the next few weeks, he's presenting 18 of the more than 50 films he has made in five Indian cities. It's one of several major retrospectives celebrating the prolific career of an artist who says he sees himself, first and foremost, as a traveler.

"Usually, I am not good at home, sitting at my desk," he writes. For Wenders, creativity flows more freely when he is in motion, whether that's on a train ("my best 'setting'") or traveling via plane— "A journey really sets me free." Music, he says, is indispensable to his process: "I put on my headphones and I look out of the window. And then I start writing."[1]

This August, to celebrate his 80th birthday, the Bundeskunsthalle museum in Bonn is honoring Wenders' career with an immersive, large-scale exhibition, showcasing his photography as well as his films. But while the world might be looking back at a half century of his films, documentaries, photographs and writing, the artist himself is still working, still writing, and very much still dreaming of the future—specifically a science-fiction film that he is determined won't be dystopian. "I find that we have gotten used to accepting so many unbearable things, like wars and violence and dictatorship and severe poverty and inequality," he says. "Only a film, in which all this is gone, could open our minds."

Wenders is an eternal optimist, a German romantic who, many years ago, set out in search of the American dream. It started as a childhood thing. "My hometown of Düsseldorf was bombed severely at the end of World War II and largely destroyed," he says. Wenders was born in 1945, the year the war ended, and for as long as he can remember has yearned to travel. "I grew up in a city of ruins. As a kid you take it for granted that the world looks like that."[2]

Leafing through his grandfather's old encyclopedias, he was surprised to learn that "the rest of the world looked much more beautiful." He dragged his parents into museums and, in newspapers, he discovered skyscrapers and American cities, with shiny cars and wide, spacious avenues. His grandmother helped him decipher the names of the places he encountered studying atlases and maps. "I was longing to discover the world—as soon as possible."

(1) There is a long literary tradition of writing on the move, which includes Vladimir Nabokov, who wrote *Lolita* in the back seat of an Oldsmobile while his wife drove across the US, and Antoine de Saint-Exupéry, the author of *The Little Prince*, who would read and write on solo flights—sometimes circling the airport for an hour so he could finish a novel.

(2) Wenders was part of a generation of Germans who grew up in a country that was trying to rebuild itself after World War II while coming to terms with the atrocities of Nazism. Artist Anselm Kiefer, the subject of a 2023 documentary by Wenders, was also born in 1945 and explicitly confronts this history in his work.

KINFOLK

WALK! TAKE YOUR TIME! LOOK PEOPLE IN THE EYE WHEN YOU TALK TO THEM.

An image of America beckoned. It looked like the twilight-hour paintings of Edward Hopper, with lonely figures waiting in hotel rooms and desolate service stations and empty diners. It promised open roads and freedom, like those pursued by the disaffected outlaws in Dennis Hopper's classic 1969 road movie *Easy Rider*. It sounded like rock and roll. In 1977, Wenders moved to the US and spent nearly a decade there, trying to make his great American movie. In 1984, he released *Paris, Texas*.

But "traveling on my own, that started in the '60s," says Wenders. In 1966, Wenders set off on his first adventure—to Paris—to study painting. "My first journeys consisted of standing by the jukebox and hoping that somebody would push the right numbers for my favorite songs," he says. He wrote rock criticism and film reviews, and spent the rest of his free time in the city's Cinémathèque Française. "I had no idea if I was going to be able to make movies," he recalls.

A few years later, however, he enrolled at film school in Munich and became "the only one of the 20 guys and girls who graduated who made a film in the first year after film school." *Summer in the City*, which was released in 1970, was the start of a long collaboration with the late Dutch cinematographer Robby Müller, who died in 2018. Müller went on to become one of Wenders' most trusted comrades. "We were like twin brothers," he remembers. They made 12 films together and "taught each other everything."

Wenders says he thought calling himself a director seemed "very pretentious" and that a career as a filmmaker "was an idea just as likely as wanting to be an astronaut." His early films saw him modeling himself after the directors he admired—the loose, freewheeling spirit of Cassavetes (*Summer in the City*, 1970) and Hitchcock's taut, elastic band–snap of suspense (*The Goalie's Anxiety at the Penalty Kick*, 1972). He tried his hand at a costume drama (*The Scarlet Letter*, 1973), but, by his own admission, failed. ("I had to realize, painfully, that I was not gifted to shoot a period film.")

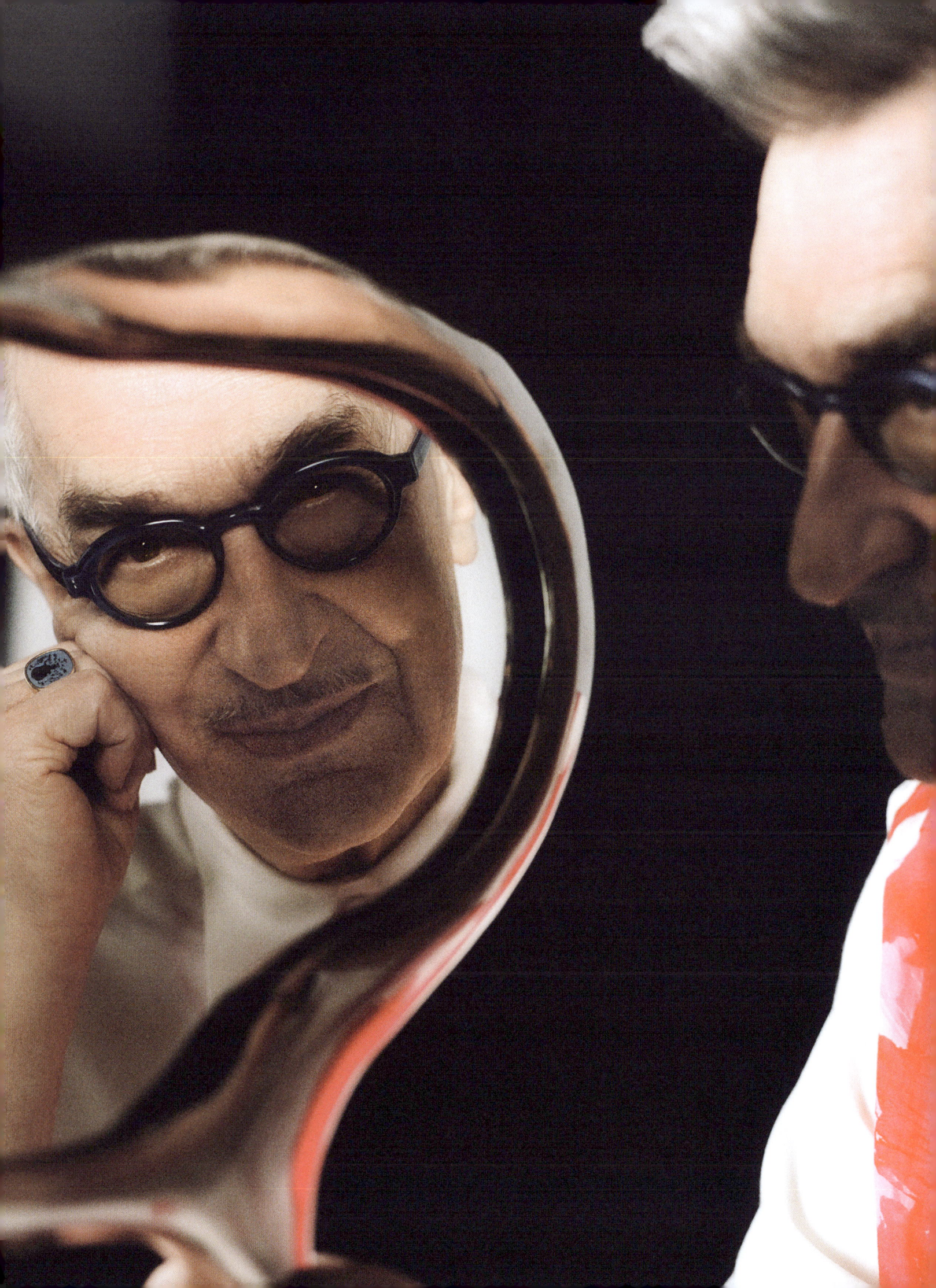

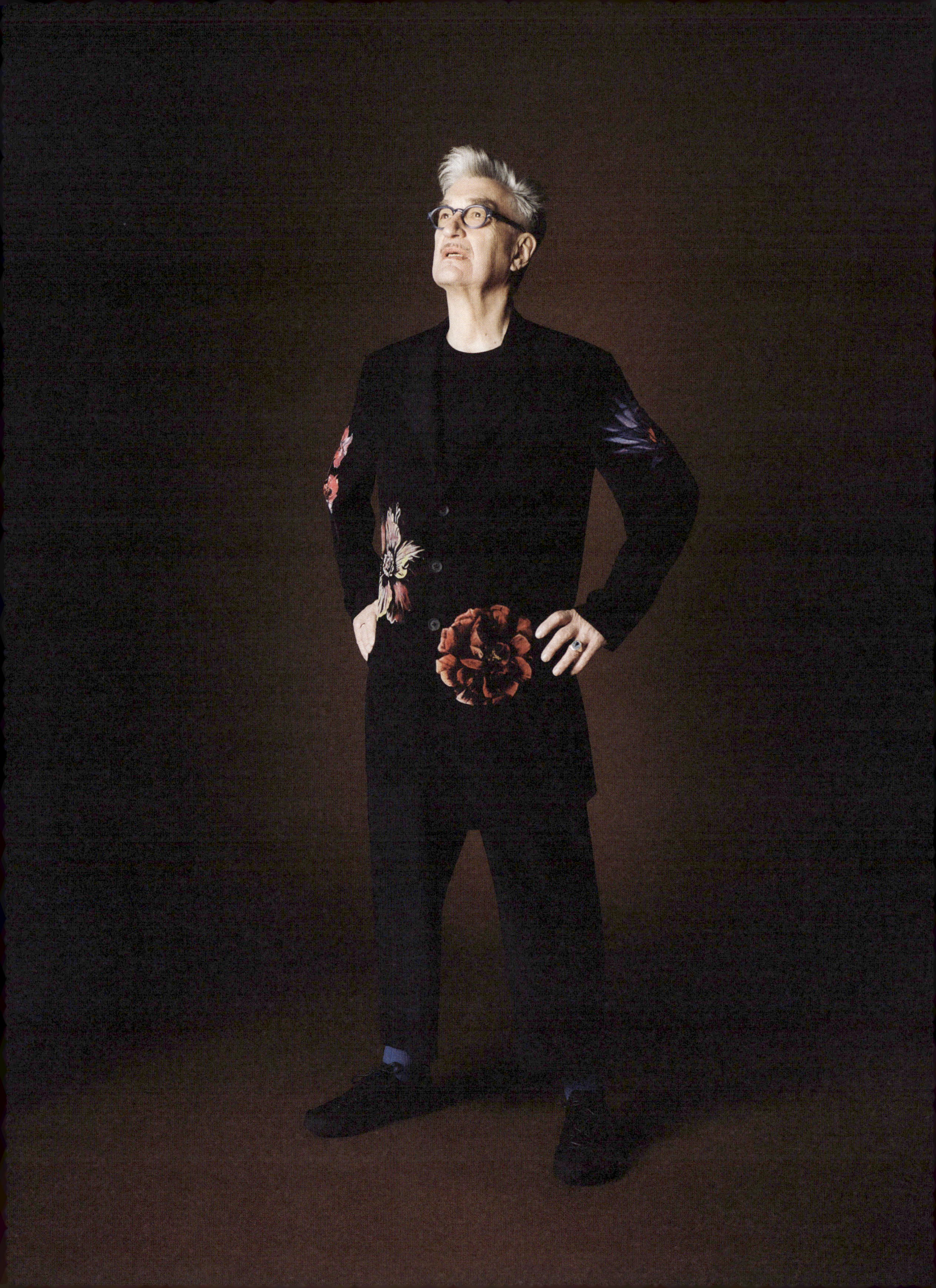

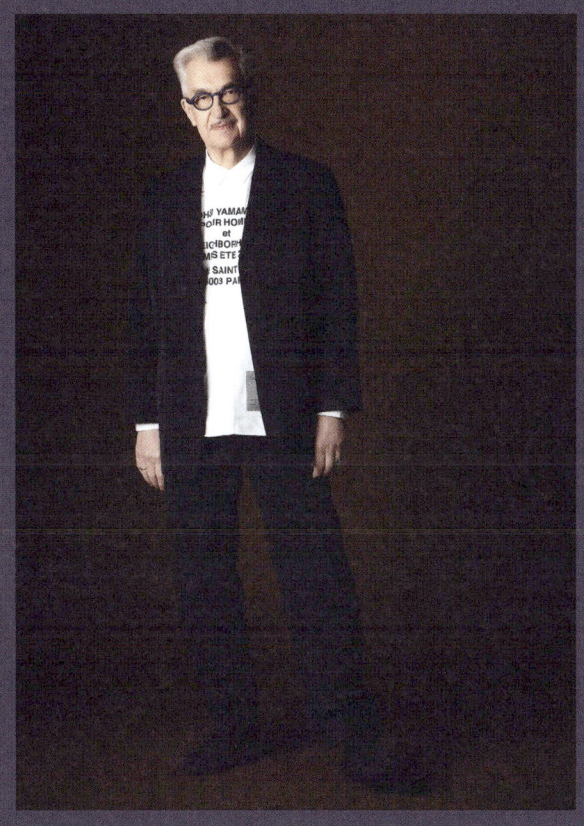
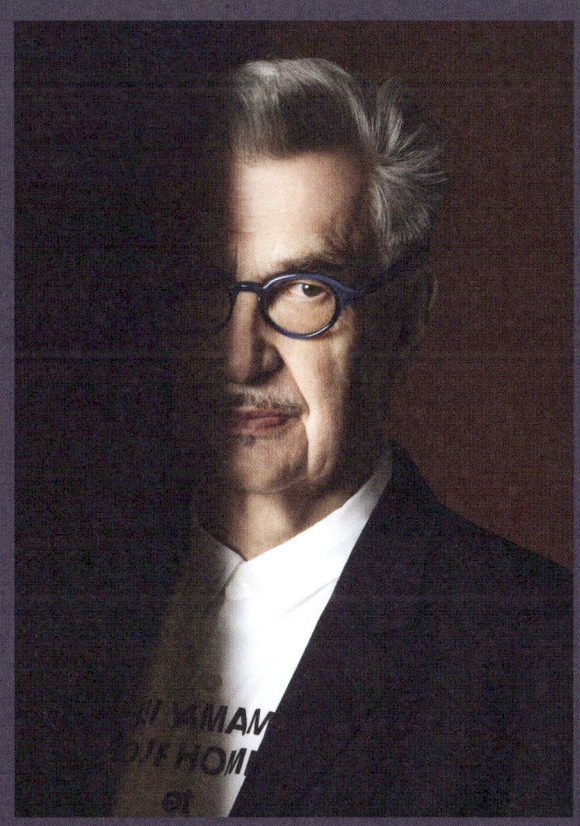

Wenders was fully prepared to return to writing criticism or painting. Then, in 1974, he made *Alice in the Cities*, a low-budget road movie about a journalist who finds himself looking after a bright nine-year-old girl. "I found my own voice," he says. "It was a great relief." The film brought Wenders new, critical success. "If you are searching for a fine, tightly controlled, intelligent and ultimately touching film, one will be shown tonight as part of the 12th New York Film Festival," wrote *The New York Times*. It was proof, Wenders says, that he could make a film "that owed nothing to anybody else."

In *Alice in the Cities*—the first in Wenders' "Road Movie" trilogy—a German journalist travels from New York to Munich, via Amsterdam and Wuppertal, Germany. Wenders' stories frequently unfold from the vantage point of outsiders; his characters are often "passing through" or else looking from a specific perspective. "I always thought that being a stranger was a privilege," Wenders says. "You see things differently, and you're paying more attention than locals, to all sorts of things." Another of Wenders' most romantic—and celebrated—films, *Wings of Desire* (1987), is a love letter to Berlin, as seen by two angels who eavesdrop on the city below.[3] He made the film after spending eight years living away, as a means of rediscovering the city where he has lived—on and off—since the mid-1970s.

*"If I understand the place,
I know where to put my camera, and I know my characters
and my story belong there."*

The director usually begins his projects with a location that interests him. "Only then do I try to find the story that belongs there," he says, explaining that he is "not at all interested in stories that can take place anywhere." It's a mindset that crystallized through his love of traveling, which has taught him to trust his instinct for "real" places rather than attractions aimed at foreign visitors. "In order to discover a city or a landscape I don't know yet, I avoid asking locals to show me 'interesting places,'" he says. "That's never what I'm after. They tell me to turn left, I turn right."

One of Wenders' recent films, *Perfect Days* (2023), follows a monastic bathroom attendant in Tokyo as he spends his free time in pursuit of modest, everyday pleasures. It's a different Tokyo from the chaotic, bustling metropolis usually depicted on screen: Instead

(3) *Wings of Desire* was one of several collaborations between Wenders and the Austrian writer Peter Handke, winner of the 2019 Nobel Prize in Literature. In 2022, *The New Yorker* described Handke as "literature's most controversial Nobel laureate" for his support of Serbian leader Slobodan Milošević, the first sitting head of state charged with war crimes for his role in the Yugoslav Wars.

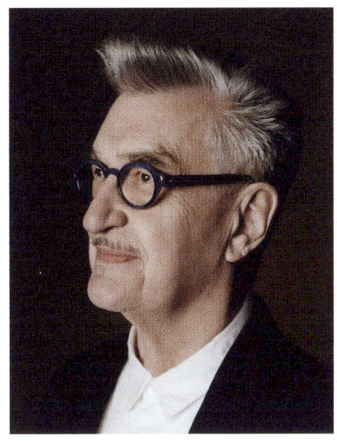

(above)
Wim wears a vintage jacket
by YOHJI YAMAMOTO from
LARA KOLEJI and a shirt by
YOHJI YAMAMOTO.

(previous, left)
He wears a jacket, trousers
and shoes by YOHJI
YAMAMOTO and a T-shirt
and socks by UNIQLO.

(previous, right)
He wears a vintage jacket by
YOHJI YAMAMOTO from
LARA KOLEJI, a shirt and shoes
by YOHJI YAMAMOTO and
trousers by A.P.C.

(overleaf)
He wears a jacket and trousers
by YOHJI YAMAMOTO, a
T-shirt and socks by UNIQLO
and shoes by CONVERSE.

of neon shopping malls and packed crosswalks, the film unfolds in a noodle shop, a secondhand bookstore and a public bathhouse. "Very ordinary, sometimes forgotten places can reveal a lot, if you're willing to notice the traces that history left behind," says Wenders.

Wenders has previously explored Tokyo in documentaries *Tokyo-Ga*, about filmmaking legend Yasujiro Ozu, and *Notebook on Cities and Clothes*, a profile of fashion designer Yohji Yamamoto. *Perfect Days* was supposed to be a documentary too, about the Tokyo Toilet, an art project in the district of Shibuya, but when Wenders landed in Tokyo after the pandemic, he was moved by how the city had put itself back together. The film's fictional protagonist, Hirayama (played by actor Koji Yakusho), would tell that story instead. "If I understand the place, I know where to put my camera, and I know my characters and my story belong there."

Though Wenders has worked extensively across both fiction and documentary, as he gets older, he has found "these divisions don't mean much to me anymore, and in my last two films [*Perfect Days* and *Anselm*] I pretty much discarded them." Over time, Wenders realized that in his fiction movies, he "had always tried to insert as much reality as possible, and that in my documentaries I had been keen to introduce fictional elements." *Anselm*, for example, is "a storytelling effort" about the painter and sculptor Anselm Kiefer in which sculptures of dresses whisper as though they have been inhabited by ghosts. And in Wenders' Oscar-nominated documentary *Pina*, the audience comes to know pioneering choreographer Pina Bausch through filmed performances of her neo-expressionist "dance theater" rendered in immersive 3D.[4] "Why did I find myself weeping watching her plays? Why could she show me more about the relation of men and women than in any movie ever before? I could only find out by making a film," he says. "Films are great ways to explore!"

Filmmakers, designers, dancers, painters and photographers: Many of Wenders' documentaries focus on singular creative figures. He explains that "they are all adventurers" and that "these films are more adventure stories." Wenders says the protagonists of his documentaries, like Ozu, Yamamoto, Bausch, Kiefer and Brazilian photographer Sebastião Salgado (*The Salt of the Earth*, 2014) "have all explored the human mind and the human condition, but instead of roaming the surface of planet Earth, they entered into our souls and discovered uncharted territories."

The next uncharted territory Wenders will explore is the minimalist world of Swiss "slow" architect Peter Zumthor, whose long-term project has been redesigning the Los Angeles County Museum of Art. Like he did with *Pina*, Wenders will shoot the forthcoming documentary, *The Secrets of Places*, in 3D, which he says is "the only

(4) Wenders is not the only auteur to have experimented with 3D filmmaking. In 2010, Werner Herzog used the technology to make *Cave of Forgotten Dreams*, a documentary about the world's oldest known paintings. French New Wave pioneer Jean-Luc Godard collaborated with cinematographer Fabrice Aragno to use 3D as a narrative tool, playing with traditional cinematic conventions in *Goodbye to Language* (2014).

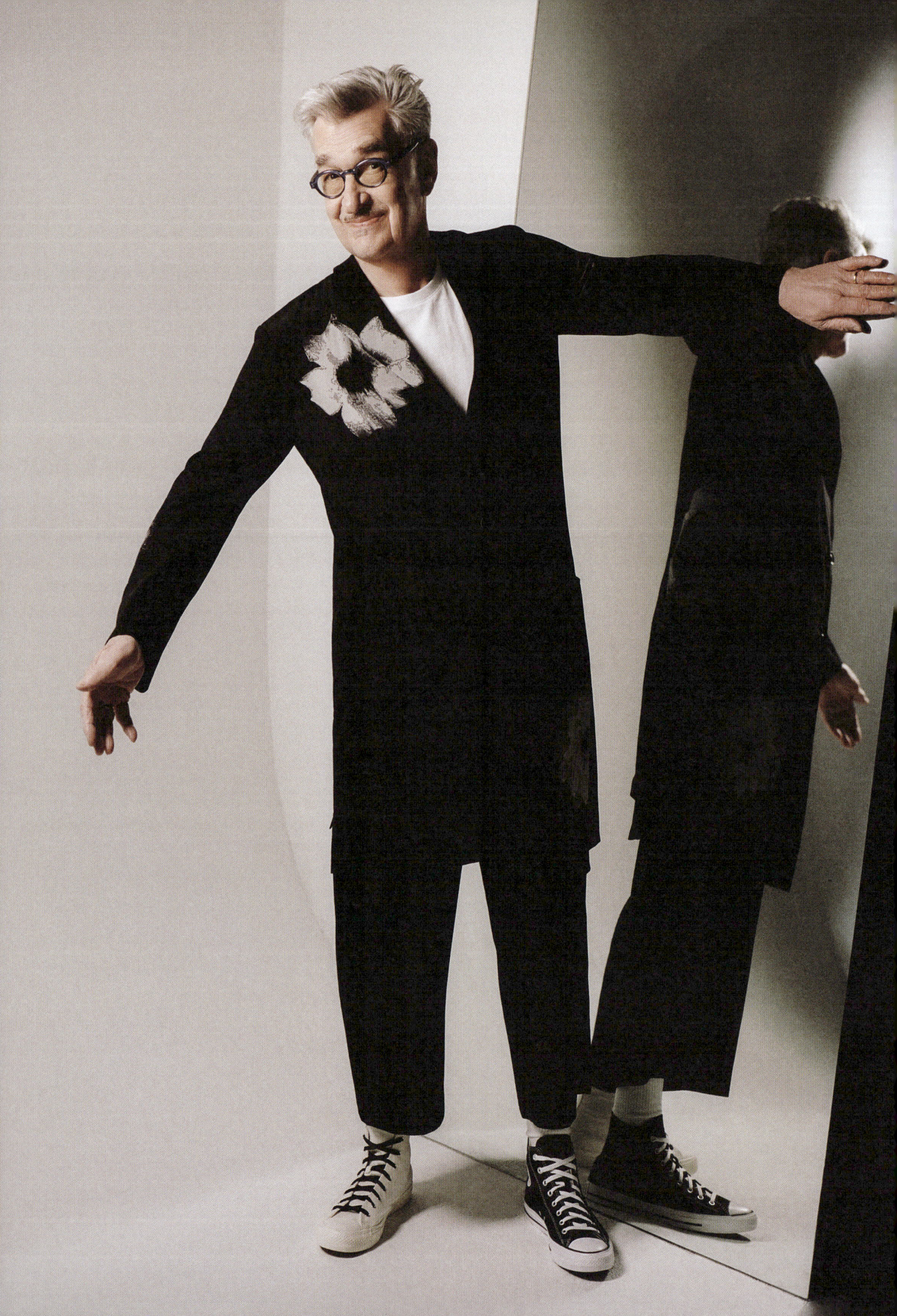

medium to help an audience experience architecture, not just see it like in a magazine." The architect has only created around 20 buildings, but Wenders describes each of them as a unique masterpiece. Even more unique is Zumthor's practice. "He has a small team, with very few employees, and he only builds what he esteems necessary," says Wenders. Patience, precision, mindfulness and utility—these are qualities that Wenders finds increasingly interesting; he says Zumthor's practice is "simply a different way of being and living inside architecture."

How best to live has been one of Wenders' lifelong obsessions. It's a question that animates his films, from his documentary studies of other artists, to the close attention paid to everyday details in his fiction. These days, "living well depends more and more on cutting myself off from distractions," he says, and offers a useful set of rules: "On a plane: Never look at a movie. At home: Never turn on the TV. Get off the internet. Use your phone only briefly during the day. Don't even think about using social media. Walk! Be around trees! Take your time! Look people in the eye when you talk to them. Go to bed early and sleep well. (What a luxury!) Ride a bicycle instead of driving a car."

In August, Wenders will turn 80. "I'm not interested in 'my legacy,'" he says, "but I hope my films can be seen when I'm gone." In 2012, he and his wife, Donata, created the Wim Wenders Foundation, a charitable body that owns the rights to the filmmaker's entire body of work and has the power to make that work permanently accessible to the public. "I don't own them anymore," he says of the films, but through the foundation they will "earn their own money and continue to exist independent of any archive or producer or film library." It is an act of preservation, as well as a gesture of generosity.[5]

As for his milestone birthday, he plans to celebrate simply, "with my loved ones, in the country," he says. "Under my big old tree friend."

"Very ordinary, sometimes forgotten places can reveal a lot, if you're willing to notice the traces that history left behind."

(5) The foundation's website quotes Wenders as saying, "People around the globe have seen my films, many have been influenced by them, and some of these films have become classics or cult films. In this sense, they no longer belong to me... but instead to a collective memory of cinema-goers of every age and many nationalities."

Essay: THE LONELY STATE

Why is California obsessed with loneliness?

Words
Robert Ito

The research is in: California is a hub for loneliness, or rather loneliness studies. In addition to leading the nation in the production of almonds, artichokes, citrus fruits and health clubs, California is leading the world in the search to figure out how we all got so lonely. In 1978, researchers at the University of California, Los Angeles, created the UCLA Loneliness Scale, a pioneering work that has become the gold standard for research in the field. Major studies in loneliness have been conducted at schools up and down the state, from UC Berkeley (is loneliness triggered by lousy sleep?) to UC San Diego (are mean people lonelier than compassionate ones?).

It's important work. According to UCLA's Letitia Anne Peplau, chronic loneliness has been associated with a greater risk of substance abuse, suicide attempts and depression. Researchers at UC San Diego showed that loneliness was also linked to increased risks for a host of major physical conditions, including high blood pressure, heart disease and stroke. Last year, justifiably alarmed by studies showing increased levels of loneliness among its citizens, Silicon Valley's San Mateo County (home to Meta, Visa and YouTube) became the first county in the US to declare loneliness a public health emergency, calling for yet more studies on ways to fight the "epidemic of loneliness and isolation."

*"For proponents of wellness,
it's no use being physically well if you are simultaneously
feeling isolated and blue."*

It's curious that a state with a reputation for sun and fun, and which is filled with people, and lots of them—has become a global center for loneliness research. In music, "all the lonely people" have always been somewhere else: in Liverpool, for example ("Eleanor Rigby"), or Texas (any number of country-western songs). In "California Dreamin'," LA is the antidote for the writer's East Coast blues. The Golden State is the most populous in the US—its 39 million residents make it larger than many small and not-so-small countries. Many people tend to flock here to escape grimmer, gloomier places where it would make sense to be lonely, places where your nearest neighbor might be 50 miles away, and where there isn't all that much to do, even if you had friends to do those things with.[1]

Perhaps much of California's focus on loneliness can be attributed to the state's interest in all things wellness. It's a fascination that goes back to at least the 1970s, when Dr. John Travis, a former commissioned officer with the United States Health Service, opened the world's first wellness center in Mill Valley. Even before that, however, pilgrims "doomed to death in the eastern climate" during the 19th century began flocking to the sanitariums and spas of Southern California in hopes of curing a host of medical maladies, tuberculosis foremost among them. It wasn't called wellness back then, but people certainly wanted to get well.

ONE CAN FEEL LONELY EVEN IN THE MOST CROWDED OF PLACES.

Since then, the state's health and wellness industry has grown to be worth around $5 billion, encompassing everything from spas and isolation tanks to sound therapy and goat yoga. And for proponents of wellness, it's no use being physically well if you are simultaneously feeling isolated and blue. Recently, advocates have tried to find ways to combat loneliness by promoting what they call "social wellness" through startups like Peoplehood, an online app that allows you to share stories and maybe do a bit of stretching and breathwork with a group of total strangers (although based in New York, the company chose to enlist 100 college students in LA for its pilot program).

Even if California is more aware of loneliness, and is offering solutions, it's not as if citizens of the Golden State are somehow immune to the feeling, then or now. Silicon Valley, for example, has particular cause for concern, given its massive concentration of tech workers and a growing number of studies showing links between loneliness and the use of various technologies developed there, key among them being social media apps. Tech workers are, no surprise, among the biggest users of tech, both because they have to use it to do their jobs, but also because, presumably, many of them are interested in it. Combine that with Silicon Valley's ultracompetitive atmosphere and it's an equation that compounds the problem: Tech makes you lonely when you're online instead of meeting up with friends, which pushes you onto your smartphone to ease the pain and/or boredom, which makes you even more isolated from friends and family, which makes you even more lonely.

Another reason loneliness studies have taken off in California is because of its wealth of fine psychology and sociology departments. According to a recent survey, three of the top five psychology departments in the country—Stanford, UC Berkeley and UCLA—are in the state. At the core of a vast number of the studies on loneliness is the UCLA Loneliness Scale, which measures loneliness by asking recipients to rate the accuracy of 20 statements ("I lack companionship," "No one really knows me well") and assigning a numerical score. Earlier scales were often unreliable or inconsistent, and the absence of one widely accepted measure made it difficult to compare the results of one study with another, which stymied research.

The widespread adoption of UCLA's scale allowed loneliness studies to flourish; today, an estimated 80% of empirical studies of loneliness use it, and loneliness studies have widened to include researchers in a variety of fields, from genome biology (in 2007, UCLA researchers identified a "molecular signature of loneliness" in immune cells) to gerontology (UCSF's Ashwin Kotwal's work on how the pandemic affected feelings of social isolation and loneliness among older adults).

By looking at studies based on the UCLA Loneliness Scale over time, researchers have found that "emerging adults" (18- to 29-year-olds) are lonelier now than their predecessors. The findings have led to a number of initiatives intended to alleviate loneliness not only in California but around the world. There are programs, like the Austin-based organization Big & Mini, that pair kids with socially isolated older folks (a particularly vulnerable group), and support groups for the chronically lonely. In 2018, UK Prime Minister Theresa May became the first world leader to appoint an official minister for loneliness to tackle the problem. In a recent interview, the current minister of loneliness, Stuart Andrew, opened up about some of the times he's felt pretty lonely, and the reasons for it (growing up gay in rural Wales; taking a job in Parliament). A few years later, the prime minister of Japan followed suit, appointing a minister of loneliness and isolation for his country.

Back in California, the Greater Good Science Center at UC Berkeley suggests a range of activities to help combat loneliness, from the obvious (go out more) to the "hmm, I could give that a try" (expressing gratitude for what you have) and the Zen (finding a quiet spot and embracing your solitude, rather than stewing about how lonely you feel).

Unfortunately, programs and initiatives that encourage the lonely to beat their loneliness by going out more and making friends might have limited efficacy, because isolation and loneliness are not the same thing, even if they're often lumped together (see: Japan's minister of loneliness and isolation). Put simply, social isolation is an objective measure of how many relationships you have; loneliness, on the other hand, is the subjective measure of feeling alone or isolated, whether or not one has a bunch of friends. One can feel lonely even in the most crowded of places—like, say, California—and studies have also found that feelings of loneliness can induce changes in the brain that cause us to behave in ways that lead to even more social isolation.

This conundrum might be yet another reason behind California's fascination with loneliness. Many of California's loneliness studies are conducted in the state's most populous areas, such as Los Angeles and the San Francisco Bay Area. Some, finding they feel lonely amid a sea of people, might figure there's something wrong with other people, but most will likely think there's something wrong with themselves. In a state filled with can-do people, Californians will often try to fix the problem themselves—hence, all those self-help groups and classes the state is famous for—and failing that, they at least try to understand it. How well any of this works, of course, may be the subject of yet another study.

(1) California's population growth has long been driven by people seeking better opportunities. In the 10 years after the state was founded in 1850, the population swelled from 92,000 to 380,000, thanks to the California Gold Rush. By 1930, industrial growth and the Great Depression had pushed the population past 5 million.

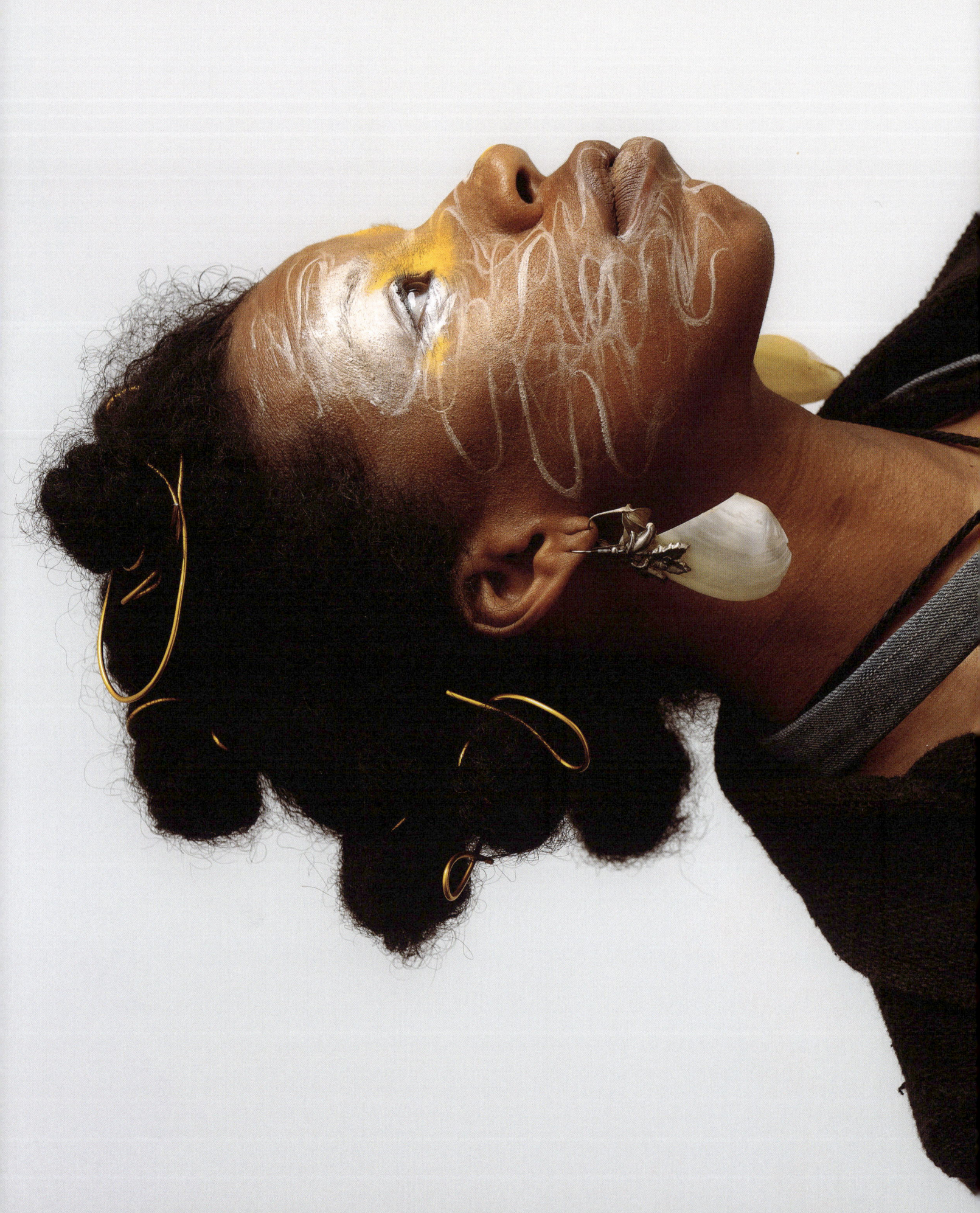

INTERVIEW: GEORGIA ANNE MULDROW

Some appreciation for a musical superpower.

Photos
Julien Sage

Styling
Bebe LaMonica

Words
Sala Elise Patterson

Even if you've never heard of vocalist and producer Georgia Anne Muldrow, you've probably heard her music. Perhaps on one of the collaborations she's done with Erykah Badu, Blood Orange, Robert Glasper or Mos Def; or maybe a track from one of the 21 albums released since her daring debut, *Olesi: Fragments of an Earth* in 2006; or else one of the many albums she produced for SomeOthaShip, the independent record label she created with her former husband, Dudley Perkins, in 2008.

Born and raised in 1980s Los Angeles, Muldrow is the daughter of vocalist Rickie Byars and guitarist Ronald Muldrow. Every morning as a child, she woke to her father interpreting John Coltrane's "Giant Steps" in a way that matched his mood that day. By the time she was a teenager, she was revered in LA's progressive underground scene for doing her version of the same: constructing vibes and whole universes with her music.

Since then, she has built a practice that glides between genres (soul, funk, R&B, hip-hop, free jazz) and roles (beatmaker, instrumentalist, singer, rapper, label owner, songwriter). Fellow musicians respect what's been called her "abstract production and writing style." Listeners love her heavy-hitting beats and zest for life. She has become a beacon of positivity in an often-dark industry, even more so after finding God and being, as she says, "saved and delivered onto the path of a surrendered life" in 2020.

Earlier this year, Muldrow took a break —surrounded by skeins of yarn, records and books—to talk about her beloved hometown, its Black community and the music that flows through her as a "child of God."

SALA ELISE PATTERSON: How did you become the creative force you are today?

GEORGIA ANNE MULDROW: Through my community. In my childhood, I was keyed into really hard by the Garveyites of LA. The first time I ever had honey-dew melon was sitting on Queen Mother Moore's lap. She was good friends with Sister Lola Coleman, the midwife who birthed me; I first heard rap music at a children's program she ran called African Minds United. I learned how to be a poet through the Anansi Writers Workshop in Leimert Park. And I learned how to be a confident performer from playing at church and going to jam sessions with my big brothers. That care and community is very potent.

SEP: Spiritually, you have talked about drawing on God's love. What do you draw on musically?

GAM: I am a diaspora nerd. I can go from singing a phrase from Larry Blackmon to one that is Celia Cruz and in the next bar I'm singing like Busta Rhymes: I can be inspired by loving all my people. It brings a new sound out of me. It's not me being in control, it's me being a hopeless romantic about our culture, about our institution, about our village.

SEP: Your parents are musicians—was it inevitable that you would become one?

GAM: It's got everything to do with them, even though I had to turn a certain age before my father and I could have a conversation about music. The same thing with my mom. I had to live some life first. I didn't get my first vocal lessons until I was 32. But because both of my parents are musicians, music is my first language.

SEP: Besides "Giant Steps," what music made up the soundtrack to your childhood?

GAM: At my mom's house, it was Salif Keita, Djavan, Dianne Reeves, James Brown, Mahalia Jackson, Curtis Mayfield's *The Anthology*, Quincy Jones' *Back on the Block*. That record made me say, *I want to do that*.

SEP: What was it like growing up in LA?

GAM: Beautiful. I am a big walker. I even hike up La Brea where it looks like a freeway, going to the music stores, buying local music, selling my music. But my favorite thing about LA is the trees and how vocal they are. I have lived in New York and Vegas, but I love LA because it's home.

SEP: What are you most excited about in the music scene there right now?

"I hope in my lifetime that my music sounds like people being fed, like shelter, like healing."

(previous) Muldrow wears a suit and trousers by NEHEMIAH DAVIDSON, a vintage kimono and bespoke boots by LONDYN KYLE.

(below) Muldrow wears a suit and trousers by NEHEMIAH DAVIDSON, a vintage kimono and bespoke boots by LONDYN KYLE.

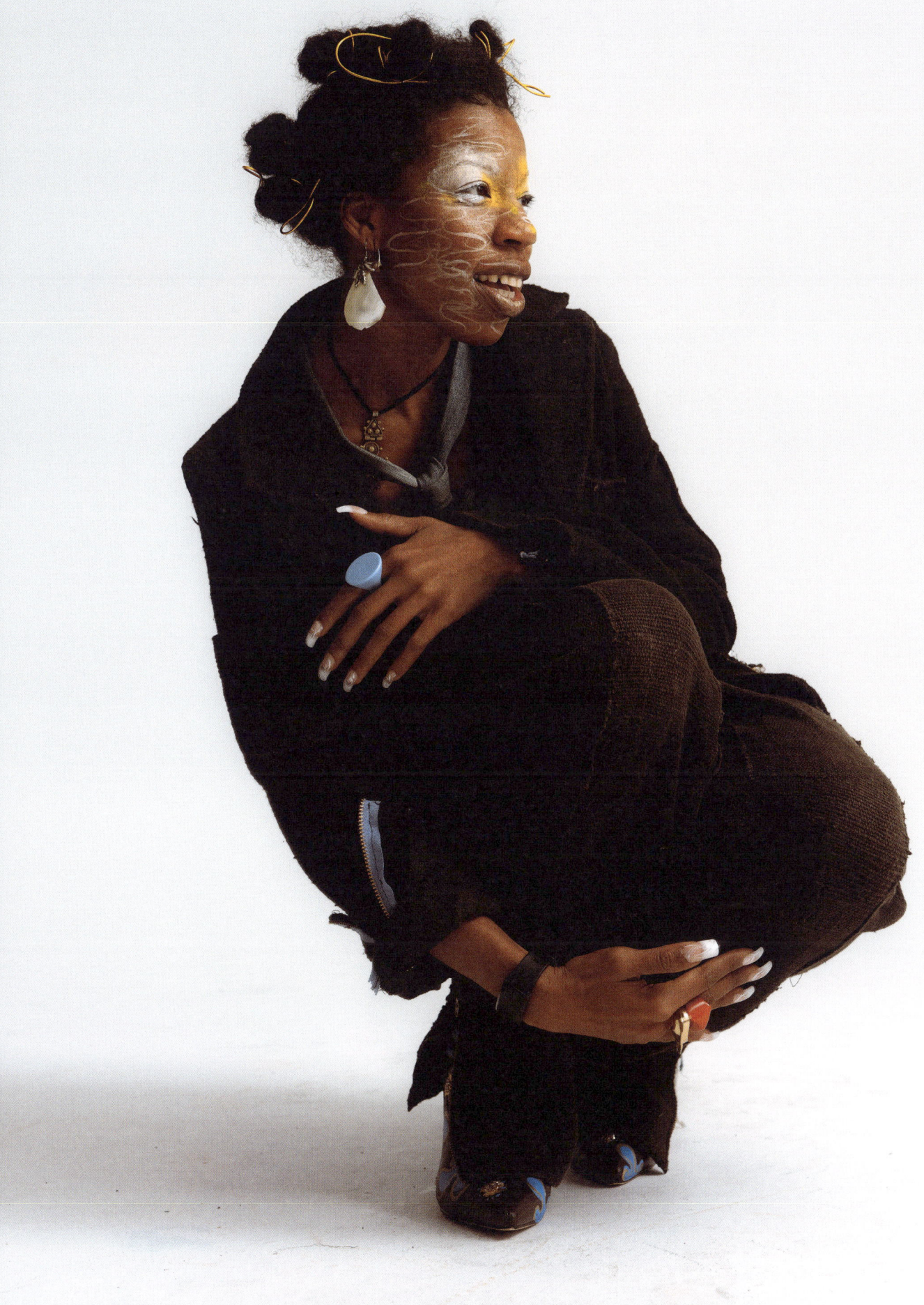

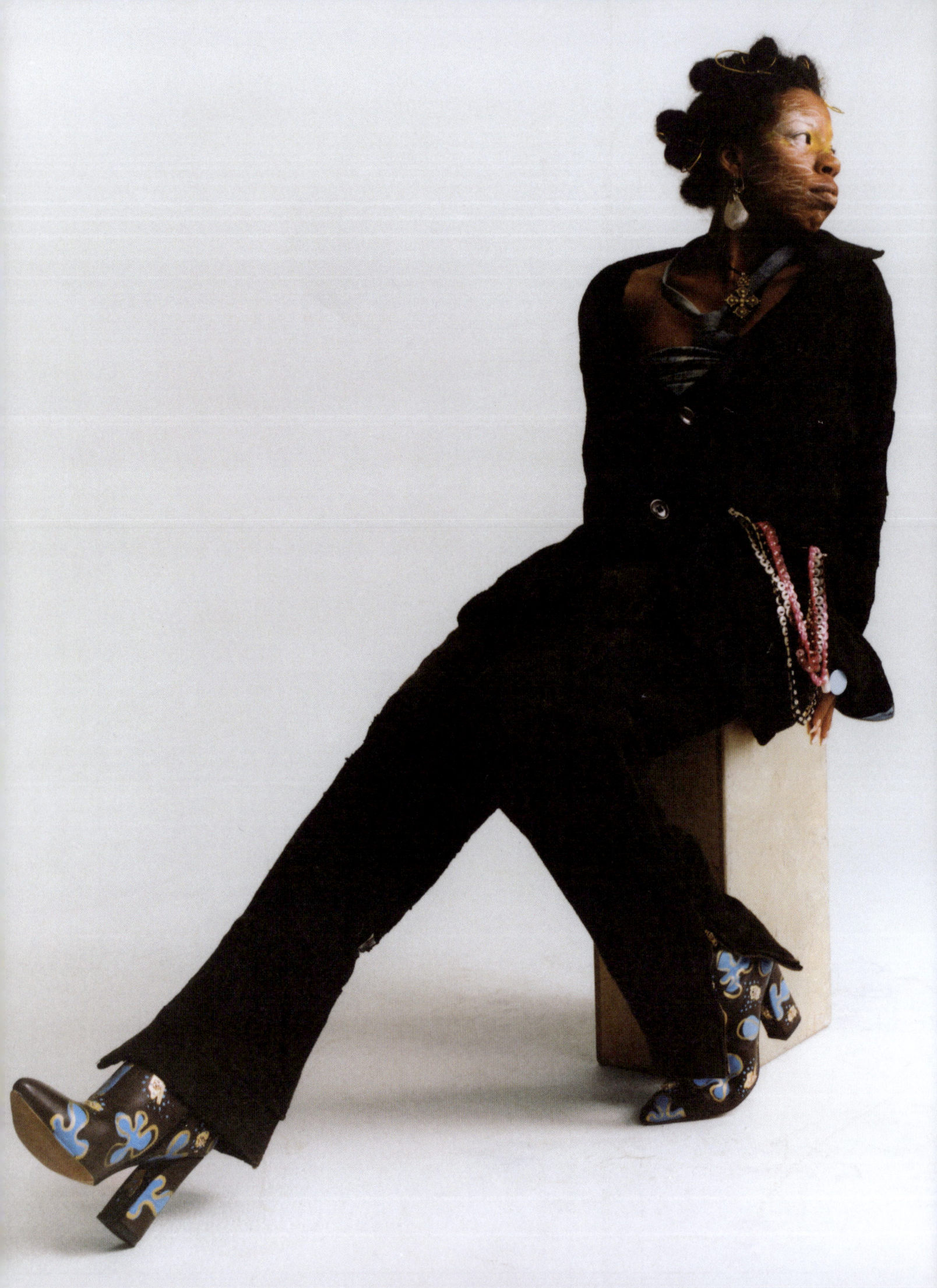

I'M STRETCHING TOWARDS A HIGHER STANDARD OF MUSICIANSHIP.

GAM: The best things are happening with those who understand that we've got to contend with our mastery as musicians, and one way to do that is by fiercely loving and spiritually supporting each other—cooking for one another, breaking bread, being in community, finding small excuses to get together and share ideas, and being in fellowship together. I've been able to enjoy the most earnest, heartfelt, sentimental discussions about what's actually still possible, about how it's not over till it's over.

SEP: It seems like collaboration is baked into your approach to making music even though that's not the norm in the music business.

GAM: I don't understand that. I'm like, *Ain't you ever heard Wu-Tang?* If you've ever heard a group of people float and dance over a song with their lyrics, it's because everybody's holding a piece of the thing. It makes the structure stronger. It makes the words more potent.

SEP: What is your creative process?

GAM: My whole relationship with music production is like tracing paper. The songs are complete, it's just God coming through me and my computer. It's me in a trance, looking at heaven, hearing finished music and then tracing it to the song. It's such a generous gift, and I feel blessed to be able to explore those terrains, to study what's coming through instead of thinking about what works commercially.

SEP: How do you know when a song is complete?

GAM: I know when I start to turn a knob and the music sounds worse. It's like, *Why did you turn that? Just stop before you oversalt the food.* The song is done when the toil introduces itself.

SEP: Which living musicians do you admire?

GAM: My mom is my number one inspiration. Saul Williams is an apostle—he helped me as a teenager to be confident in my punk rock. Meshell Ndegeocello. Marshall Allen, who put out his debut record at 100 years old. Bilal, another big brother of mine. Joan Armatrading—I love her latest record; there's stuff on there that's absolutely brilliant. She's always stretching towards something.

SEP: What are you stretching towards?

GAM: I'm stretching towards a higher standard of musicianship. If you are watering the seeds of potential within our community, then the music will have more in it than what capitalism has to offer. The reason I take breaks from the conventions of the music business is because the transactional aspect of it cheapens it. I love music. I love to perform music. But I don't want to just go play the concert and leave. I want to leverage that airplane ticket to go do something free in a city. I hope in my lifetime that my music sounds like people being fed, like shelter, like healing. Because that is what I belong to— the tone of the sum of life, with love as the navigational equipment. Ultimately, I am stretching for maturity.

—

(opposite) Muldrow wears a suit and trousers by NEHEMIAH DAVIDSON, a vintage kimono and bespoke boots by LONDYN KYLE.

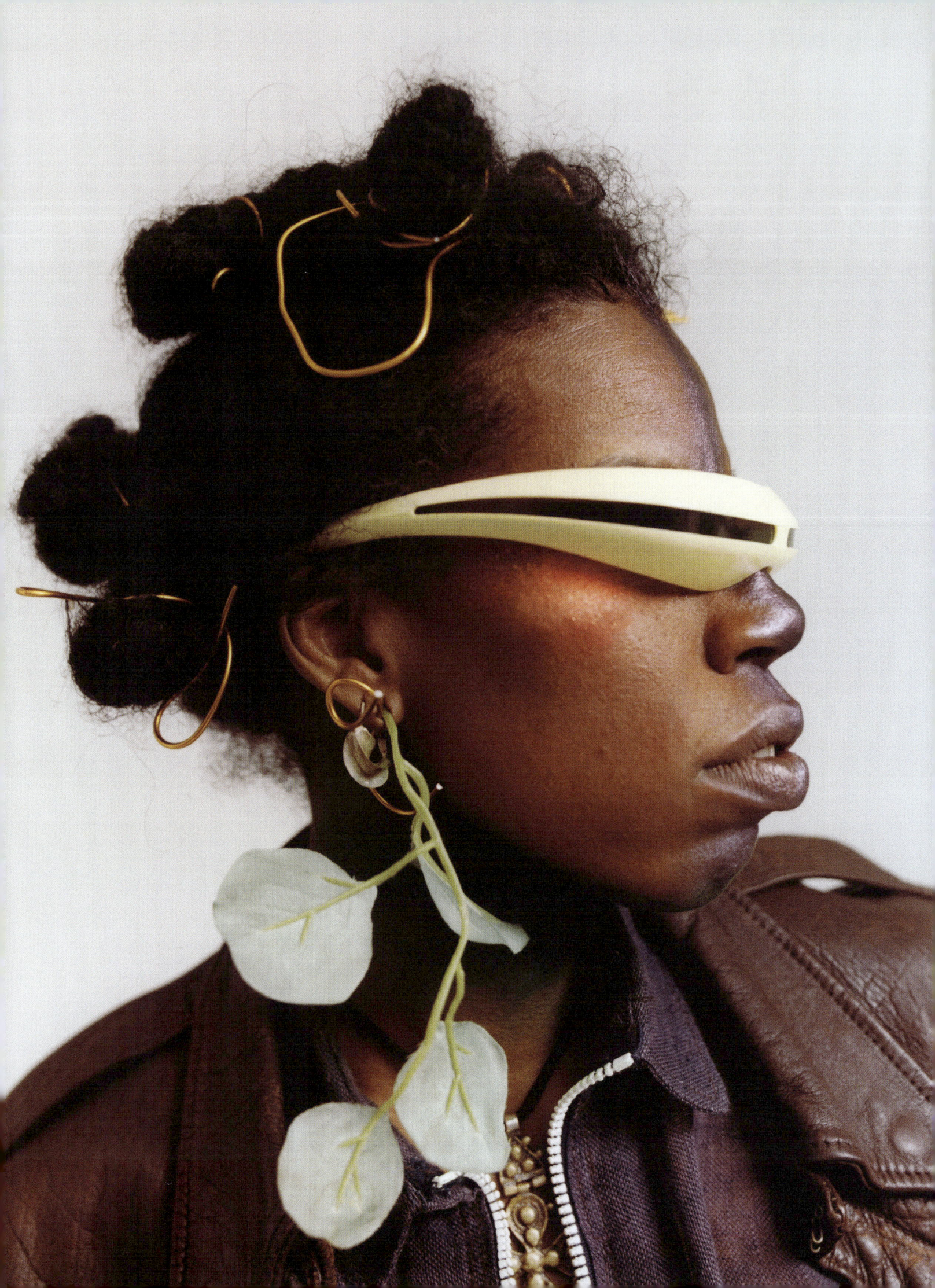

(below)　　Muldrow wears a vintage jacket, a shirt and trousers by NEHEMIAH DAVIDSON, boots by DOLLS KILL and vintage sunglasses.

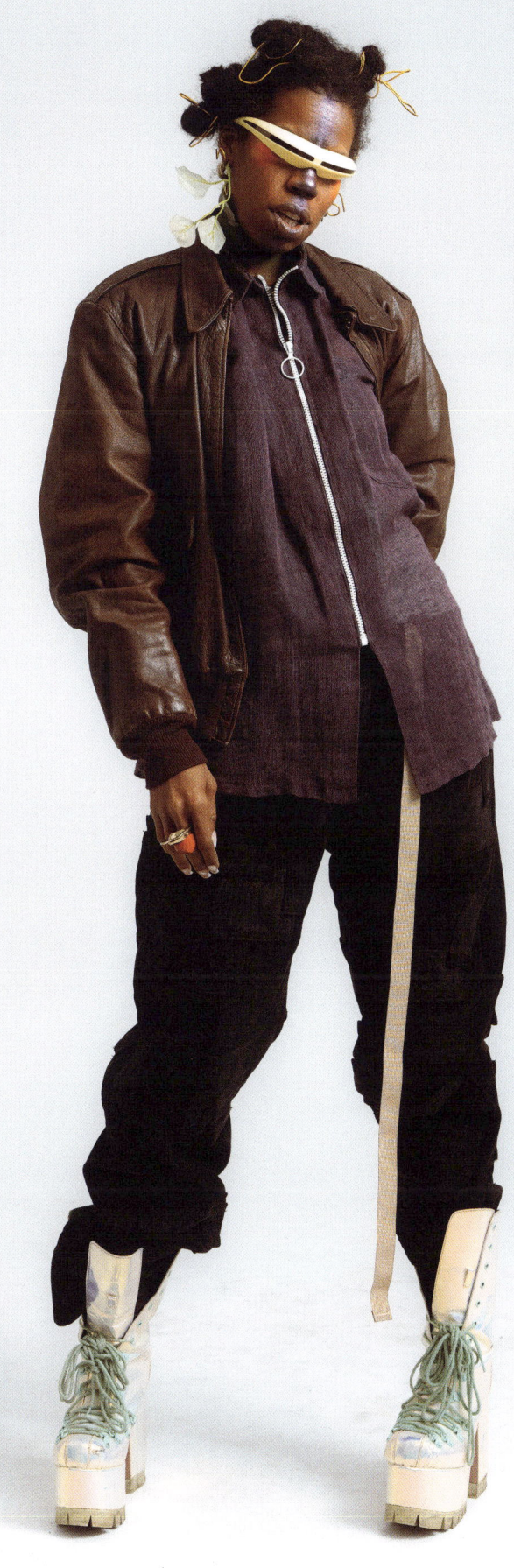

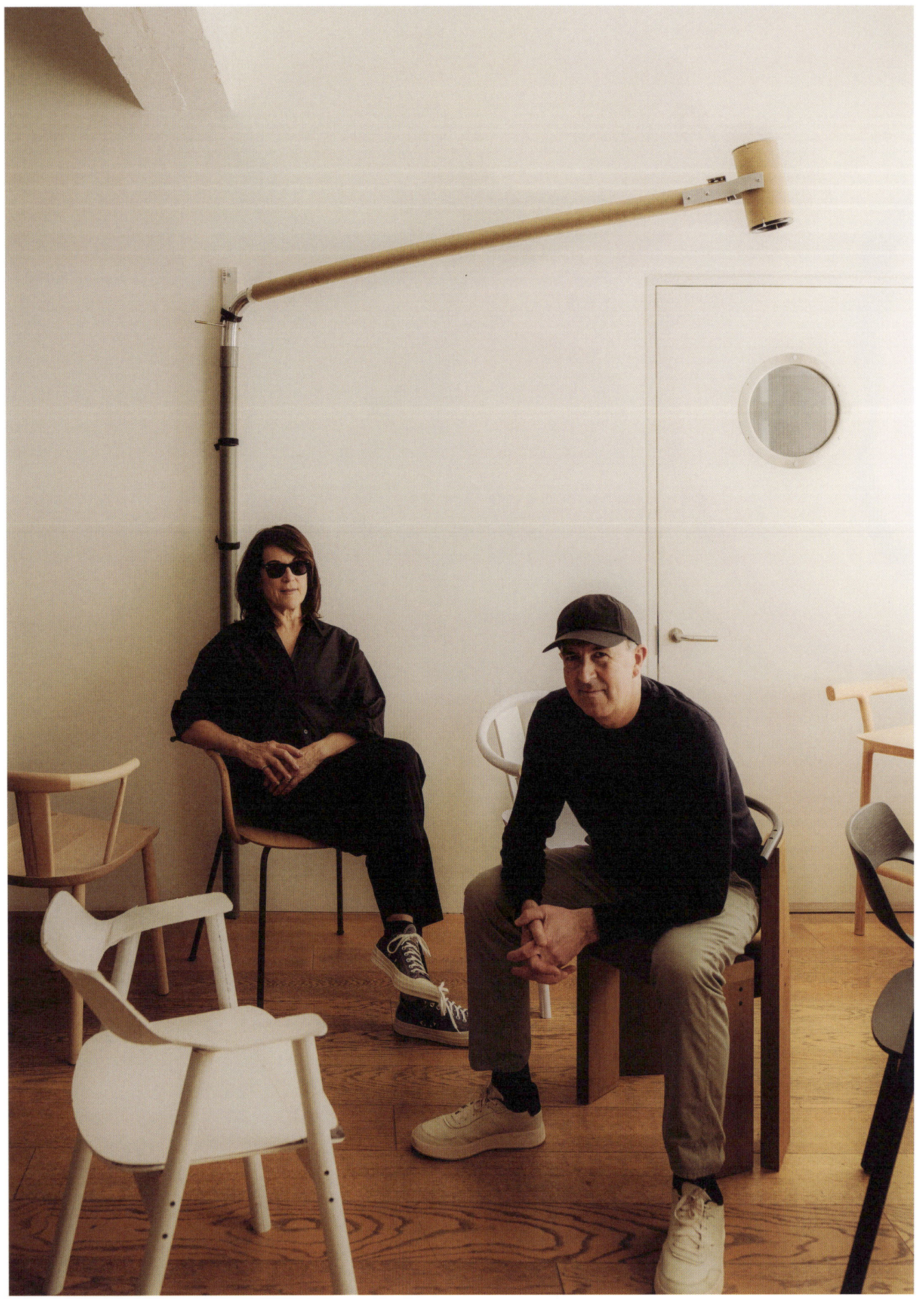

STUDIO VISIT: Industrial Facility

Words
Ali Morris
Photos
Alixe Lay

Seen from the neat, ordered meeting room of Industrial Facility's office, London's rooftops are a patchwork of eras and styles. "There are just so many layers of human habitation," says Sam Hecht, the studio's co-founder, surveying the Clerkenwell skyline. "We find that quite inspirational." It's a surprising statement, coming from a studio known for its clean, exacting approach to design, but one that reveals what is perhaps the essential motivation for the practice: "We're in a constant search for simplicity, for the good things in life—perhaps because we struggle to maintain them."

Turning away from the view and back into the meeting room, there's a glass-fronted display case with neatly arranged product and furniture prototypes—it's just a fraction of the studio's 23-year output. Hecht and Kim Colin—partners in both life and work—founded Industrial Facility in 2002, choosing a name that was intentionally anonymous and frustratingly difficult to Google. "Sorry about that," Colin laughs. "The name is kind of meaningless in one respect, but then, because of that, it becomes meaningful by the work that we're doing. We're judged by our work, not our personalities." The pair started out with a clear set of design principles and an approach that was more reactive than strategic. Colin, a native Angeleno who moved from California to London in 1999, had studied architecture and Hecht—a born and bred Londoner—had studied industrial design, a combination that, unlike other studios at the time, led them to consider a product's context, its spatial and cultural implications. "For us, it wasn't just about how persuasive something would look in a shop, but about what living with it was actually like," Colin says.

They began their practice in a modernist office building close to the Barbican, seeking out and working with manufacturers that shared their values—MUJI, Herman Miller and Mattiazzi are all long-term collaborators. They moved to Clerkenwell after their Barbican office was redeveloped, gradually expanding their footprint within a former optical factory. Today, they occupy two floors with a meeting room and workshop on the second floor, and an office and library above.

Their portfolio, they acknowledge, is a product of its time—enabled by their talents and determination but also by a specific set of circumstances that allowed them to flourish. Would they be able to thrive if they were just starting out today? "It's definitely harder for young designers now," they conclude. "It's more expensive and much more difficult for people to come to work here

(previous)
Kim Colin and Sam Hecht with
chairs they have designed for brands
including Ishinomaki Laboratory,
Thonet, TAKT and Mattiazzi.

(above) Hecht works on prototypes in the workshop.

from abroad, bringing different ideas and perspectives, which is very sad. London is not what it was, but culturally it's still the best in the world."

Colin and Hecht are fortunate to live just a 25-minute bike ride from their studio, a journey they make daily—though usually only after an hour spent walking in Regent's Park. In the studio, they work as a team of four. Keeping the staff small was a conscious decision. "It allows us the time to talk about things quite deeply," Hecht reflects. "There's not a lot of hierarchy, and there's not a lot of admin."

At any one time, they juggle up to 10 projects, each with its own pace, creating a sense of ease and flow that is reflected in their work. Browsing their neatly organized portfolio online or in their monograph, published by Phaidon, one gets the impression that everything they do is highly precise—a perception they find slightly bemusing. "That's the final image," laughs Hecht. "It's certainly not the process to get there." Problem-solving—their quest to find order in chaos—is something they find almost therapeutic. Hecht takes "great pleasure" in the design process, while Colin, a recovering perfectionist, has learned to let go and accept imperfections. "An object may look perfect, but it's never 100%," she says. "There's always something a little bit funny, a little unexpected. That openness is important."

An atmosphere of calm pervades the studio, but it is not the minimalist workspace one might anticipate from the practice's output. In the workshop—a testing ground for new work—prototypes made from paper, card, foam and plastic piping are stacked on shelves. An old Ping-Pong table serves as a workbench. "People are really surprised when they see this space and the models we make," Hecht says, holding what appears to be a steam-bent oak chairback before flipping it over to reveal a foam core and its sticky-back plastic "veneer." "The workshop is for building confidence in our ideas," Colin explains. "Design starts when an idea begins to be materialized—because then you can reflect on it, change it, question it."

Upstairs, their team member, creative director Leo Leitner, works in a light-filled space lined with bookshelves and a large communal desk. Leitner primarily handles tech projects under the studio's Future Facility department—essentially a label to signal to potential clients that they "do tech." A current prototype is Posting Card, a networked LCD screen that allows a close group of friends to send digital postcards and share their lives in a slower, more intentional way. The screen, using the same "e-paper" technology as a Kindle but with seven pigments instead of two, produces filmic, muted images. Similarly, SUSA, their AI-powered device for Taiwanese technology company ASUS, reduces the screen resolution and simplifies interactivity, blending analog elements with digital. "It's about slowing down, moving away from the addictive, fast-paced direction that screens are taking us," Hecht explains. "We don't want to be a part of that—we want to be part of the solution."

Industrial Facility exudes the confidence of a studio that knows exactly what it likes and what it does best. "We always say that when we choose a client, one of us has to be naive and one has to be an expert," Hecht says. "If both of us are naive, it ends in failure. If both of us are experts, you're trapped by your knowledge. One of each is the perfect balance."

Often, this involves bringing their naivety to niche areas of tech, lending imagination and a human touch to cold technology.

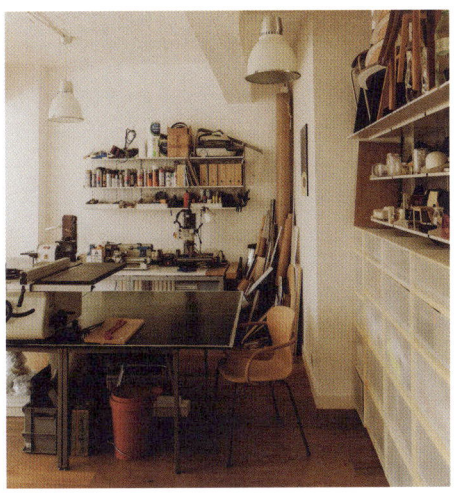

Other times, as with their upcoming Rombe shelves for &Tradition, they bring expertise. "We've been creating systemic furniture for Herman Miller for years, so we brought that knowledge to the table with &Tradition, which had never worked with system thinking before." The result is a system that balances utility and aesthetics, with hidden fixtures and rounded edges that soften the typical office-like rigidity of modular shelving.

As for what's next, Industrial Facility has several launches slated for 2025: the Stelo chair for Mattiazzi, their take on a Windsor chair; the tumbled aluminum Pastille Alu lamp for Wästberg; and a lightweight yet "almost indestructible" table for +Halle called Grid. There are early whispers of an exhibition, but no grand master plan. Instead, Hecht and Colin remain focused on their core values. "From the beginning, our ambition was not for bigger and bigger projects, but for better and better clients—ones who truly understand the value of design and are dedicated to producing the best thing they can, in line with our principles."

"We're in a constant search for simplicity, for the good things in life—perhaps because we struggle to maintain them."

(overleaf) Some of Industrial Facility's projects on display in the meeting room, including desk organizers and a portable battery designed for Herman Miller.

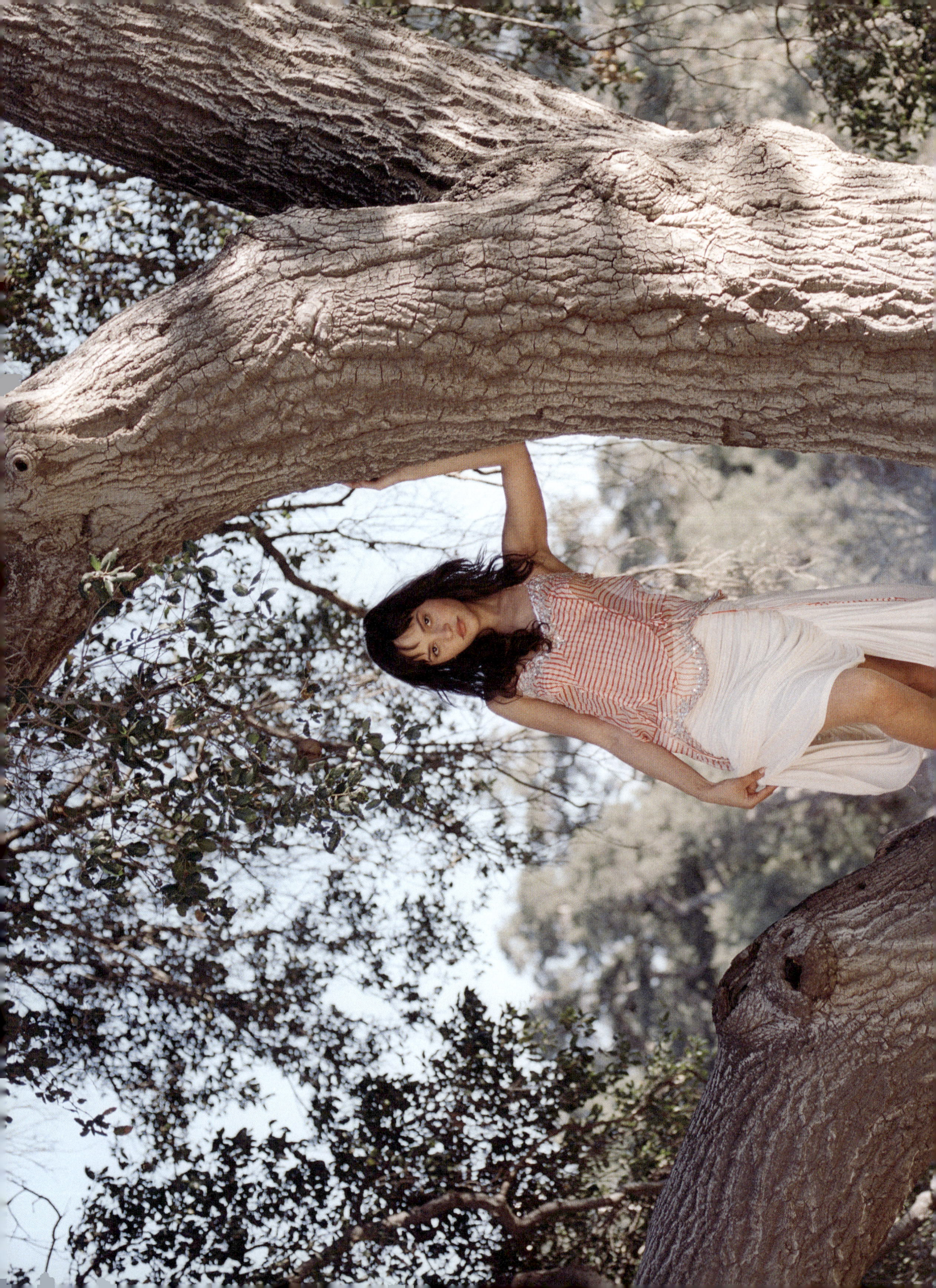

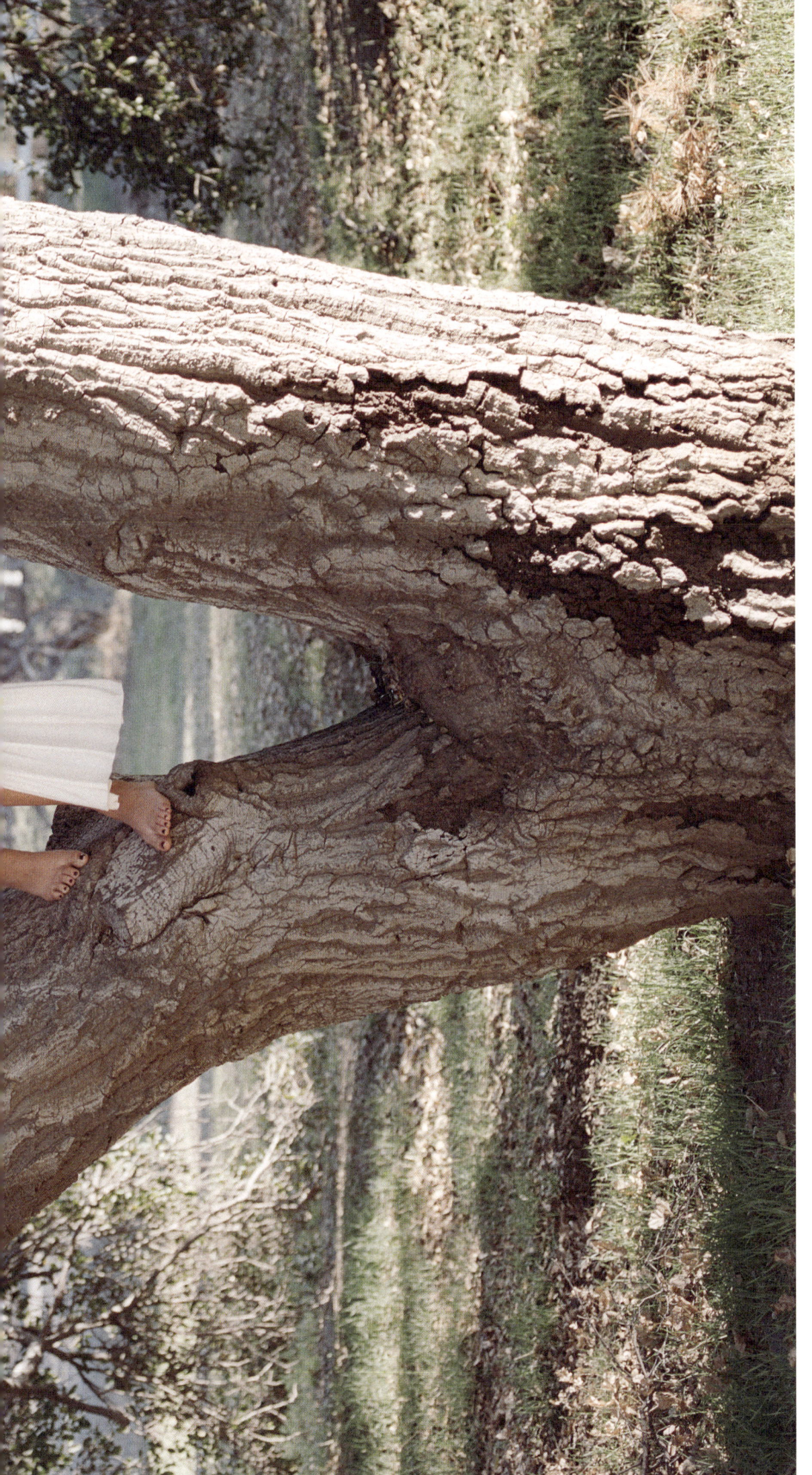

FASHION: TREE HUGGING

Photos Daria Kobayashi Ritch

Styling Gemma Ferri

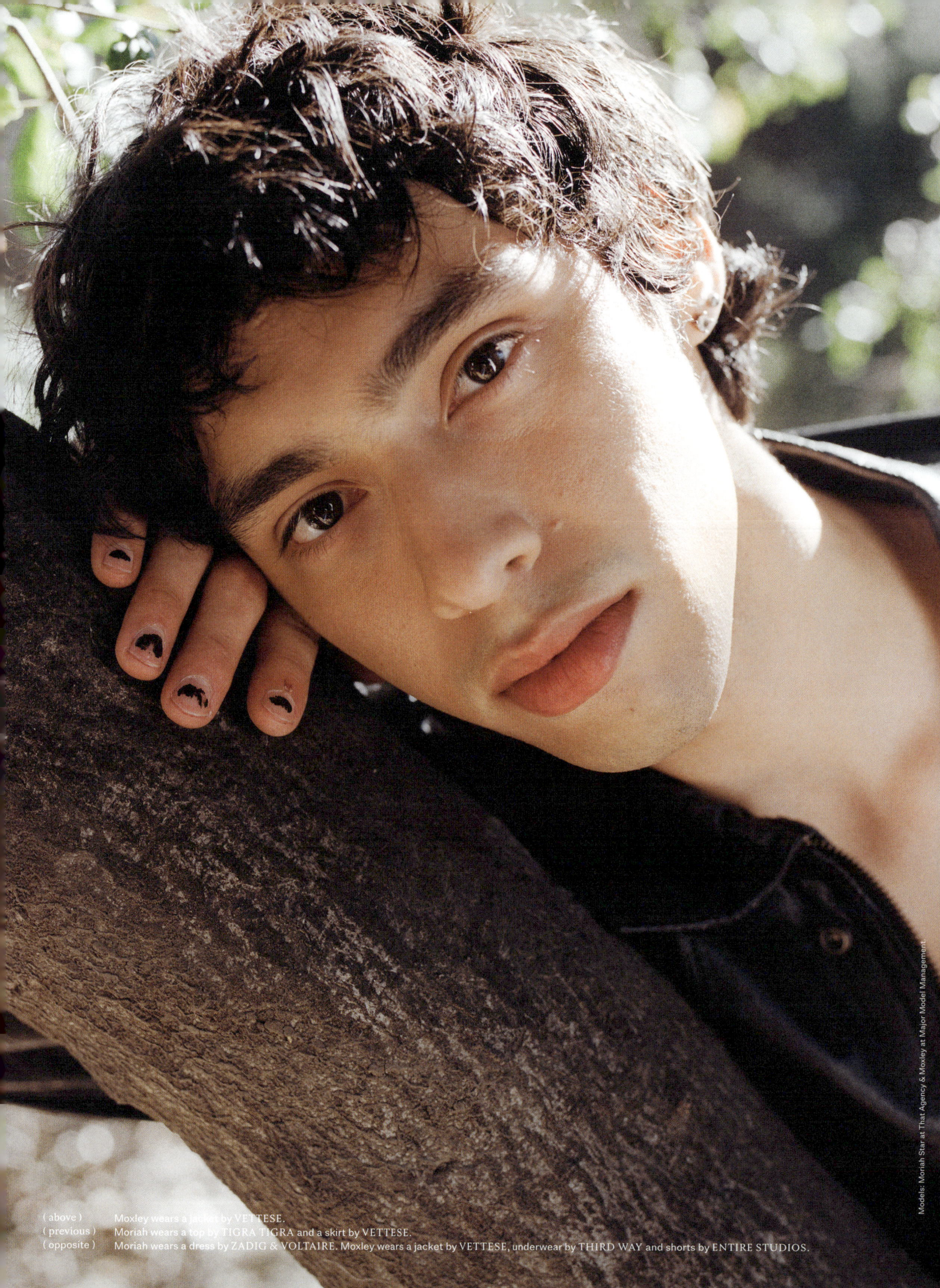

(above) Moxley wears a jacket by VETTESE.
(previous) Moriah wears a top by TIGRA TIGRA and a skirt by VETTESE.
(opposite) Moriah wears a dress by ZADIG & VOLTAIRE. Moxley wears a jacket by VETTESE, underwear by THIRD WAY and shorts by ENTIRE STUDIOS.

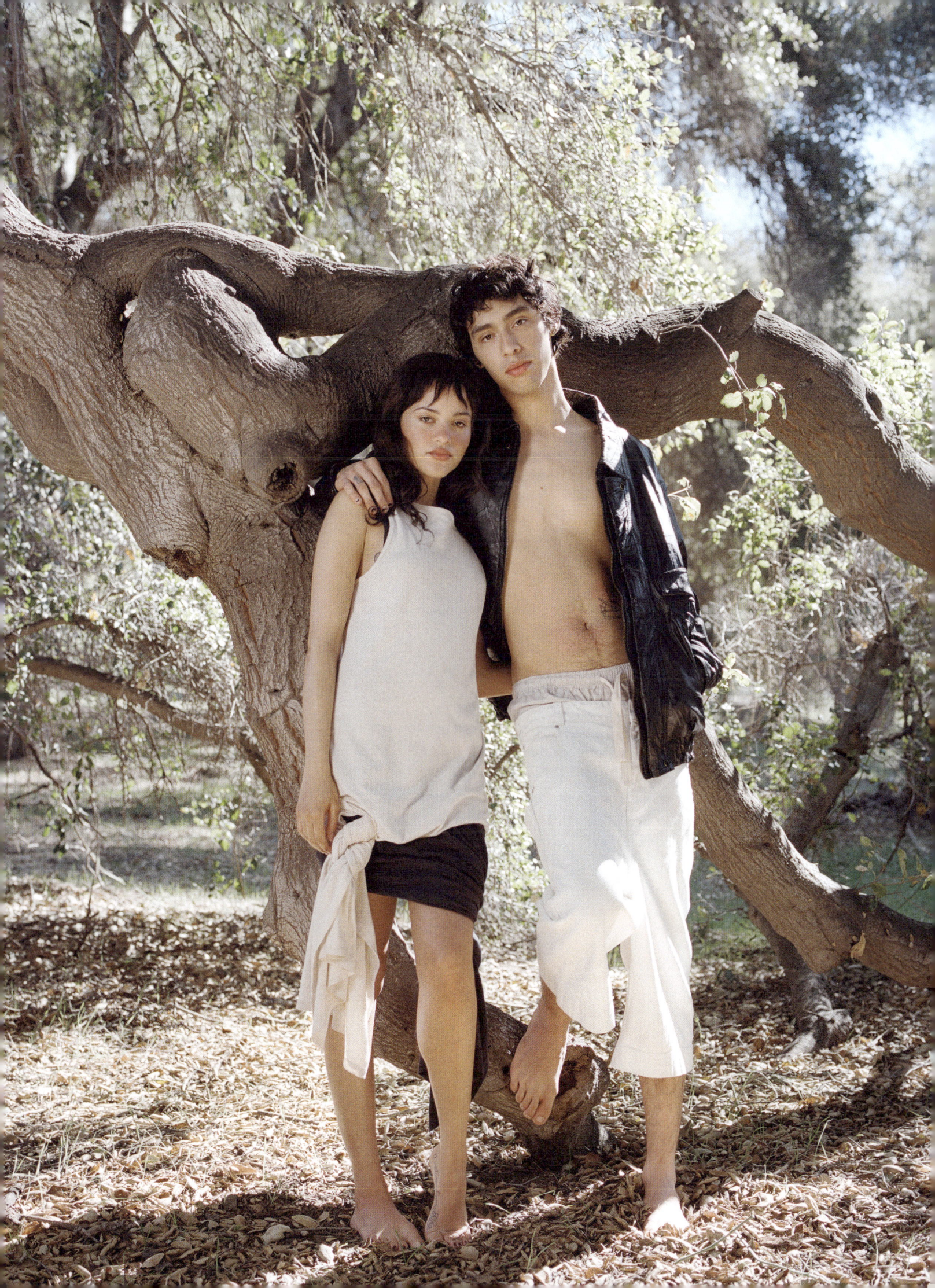

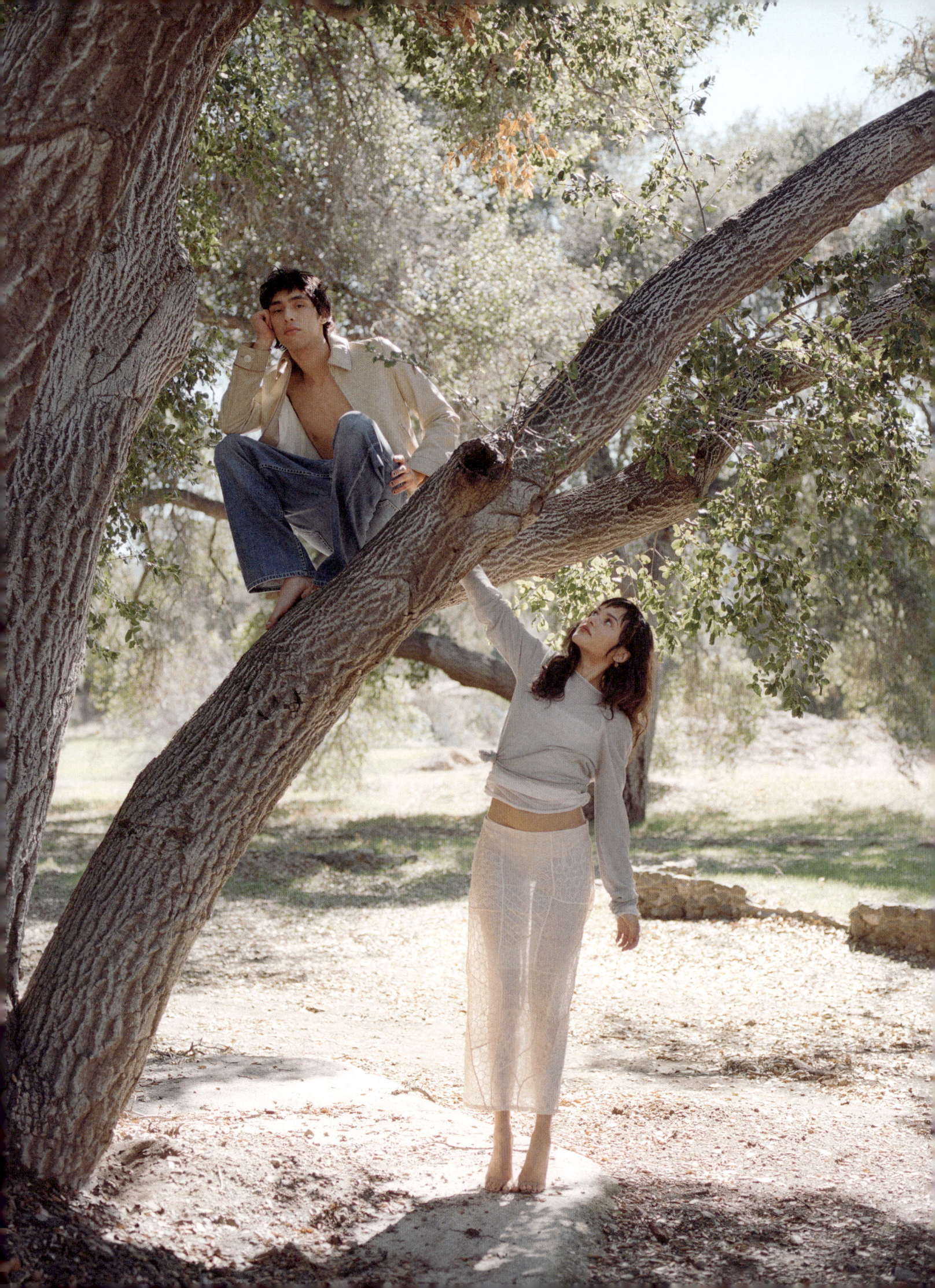

(below) Moriah wears a dress by VETTESE and a bag by TIGRA TIGRA. Moxley wears a vest by THIRD WAY.
(opposite) Moxley wear a jacket by KENZO and trousers by THIRD WAY. Moriah wears a T-shirt by ENTIRE STUDIOS and a skirt by TIGRA TIGRA.

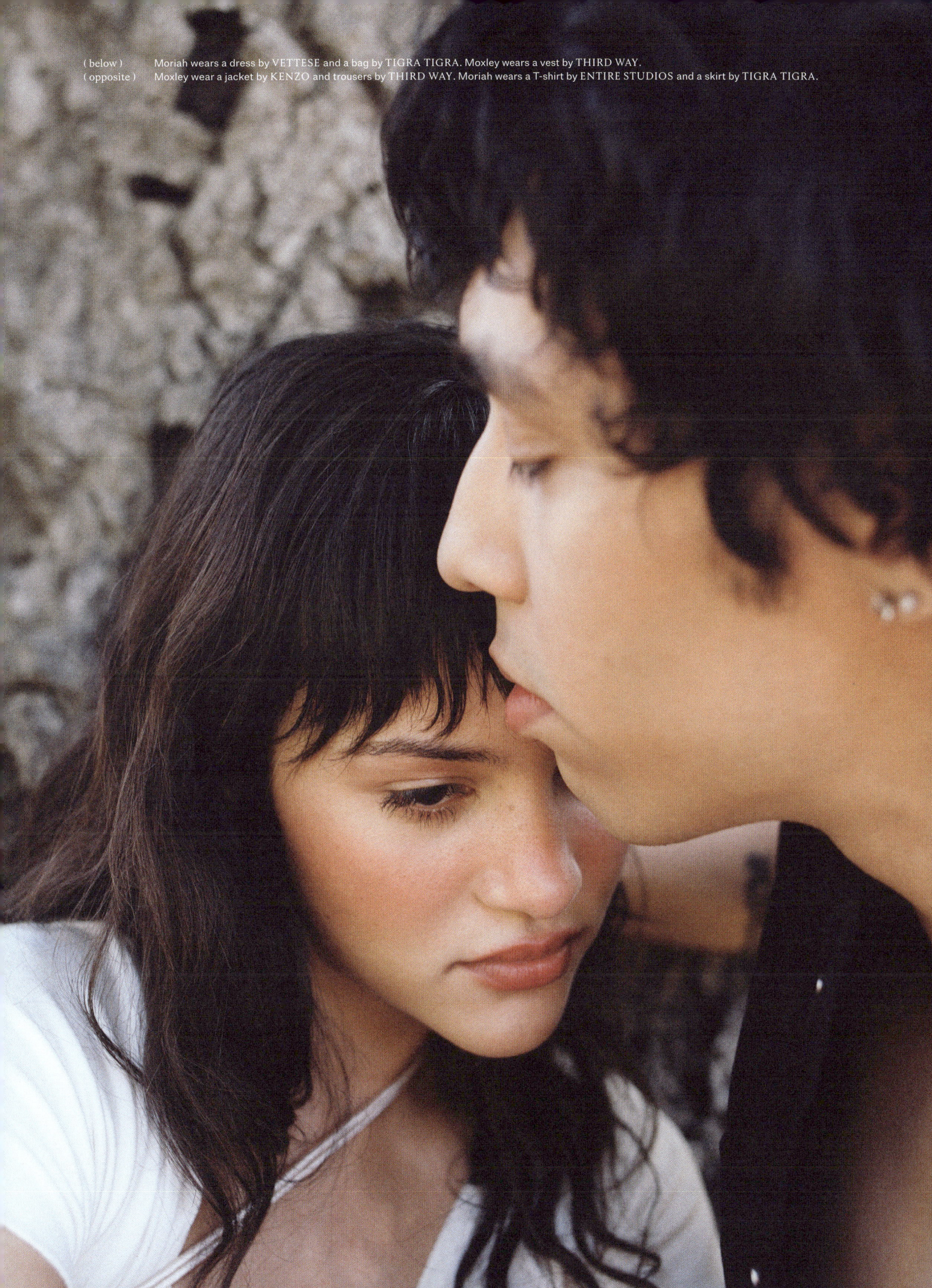

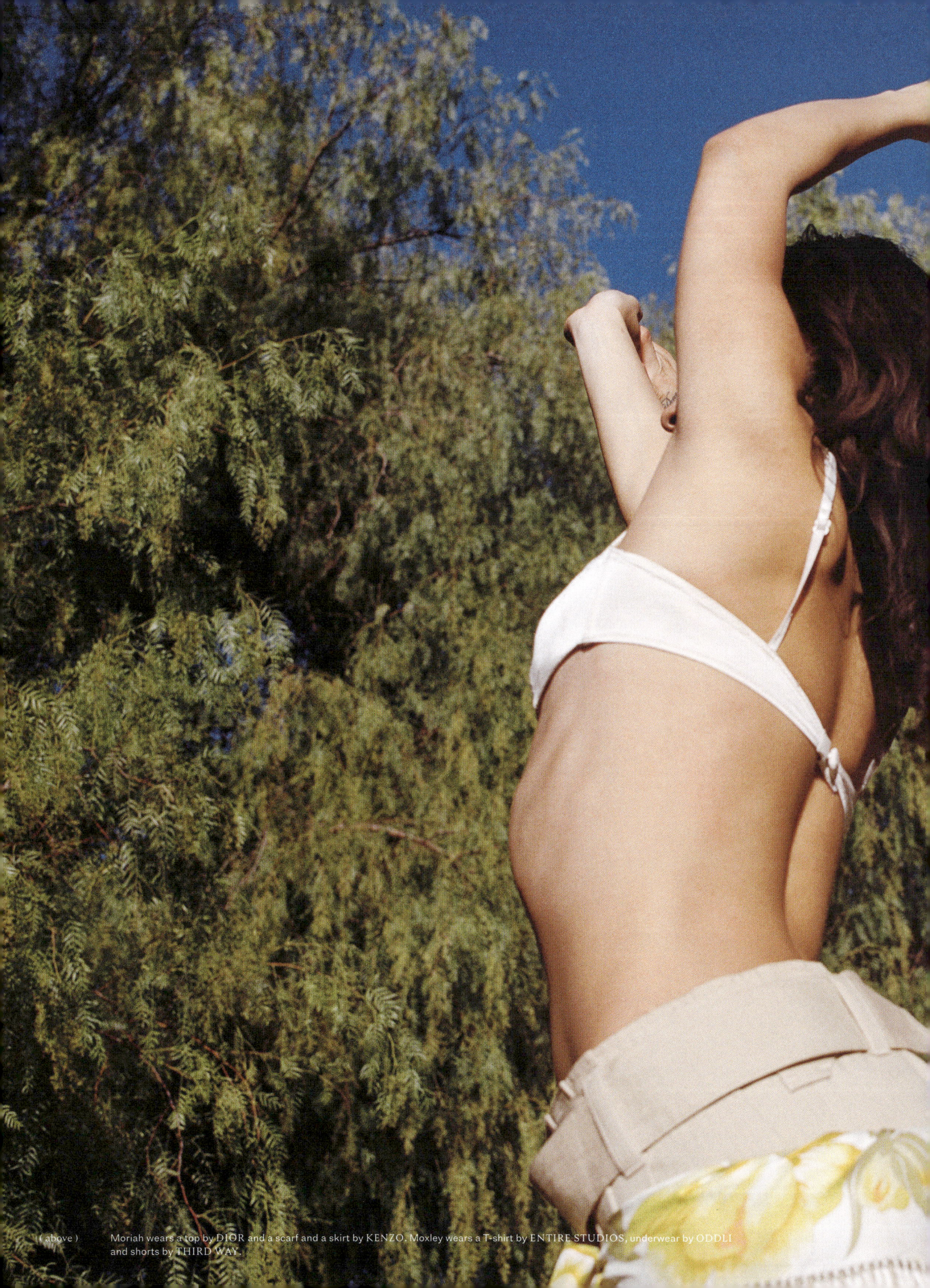

(above) Moriah wears a top by DIOR and a scarf and a skirt by KENZO. Moxley wears a T-shirt by ENTIRE STUDIOS, underwear by ODDLI and shorts by THIRD WAY.

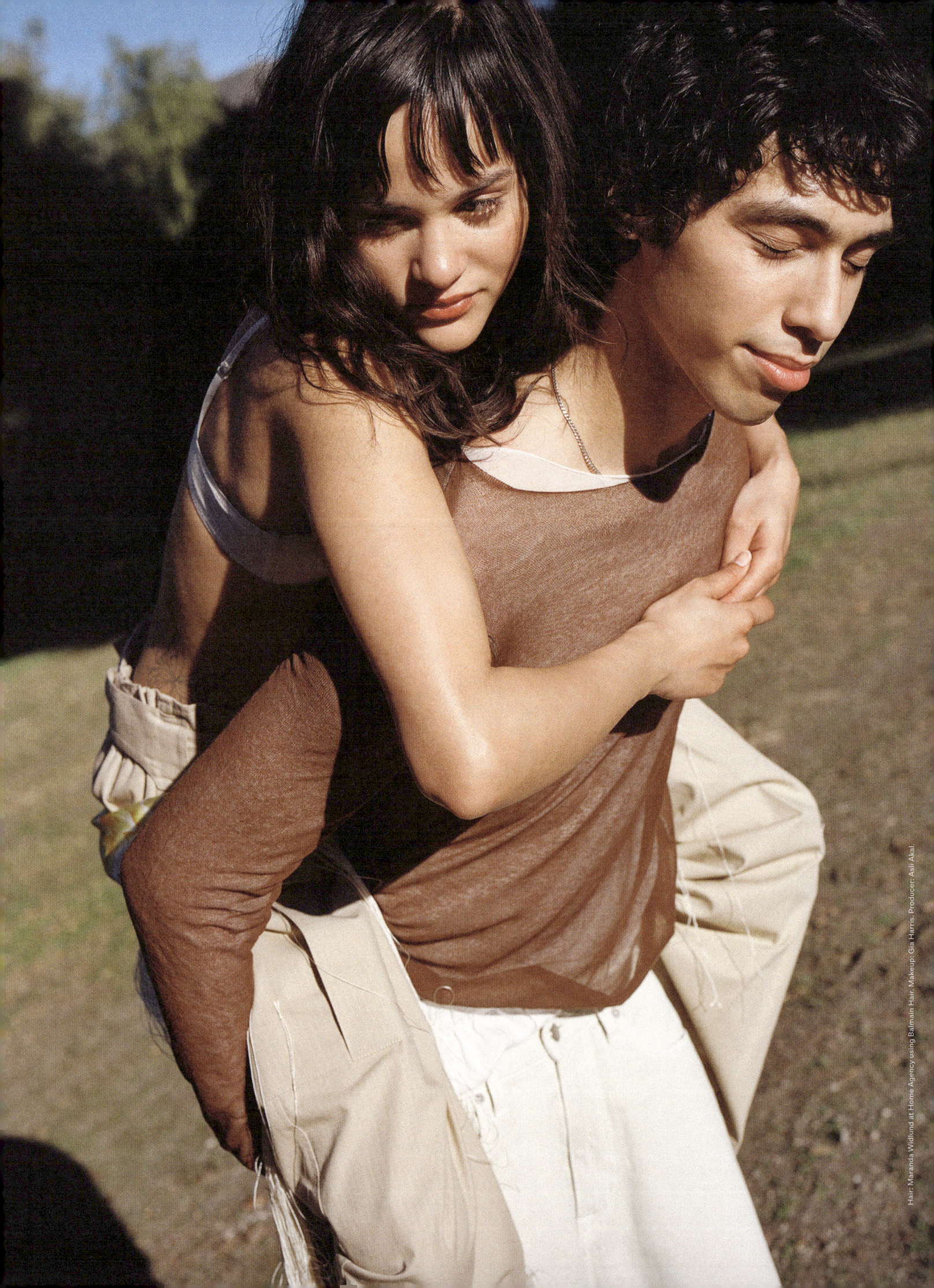

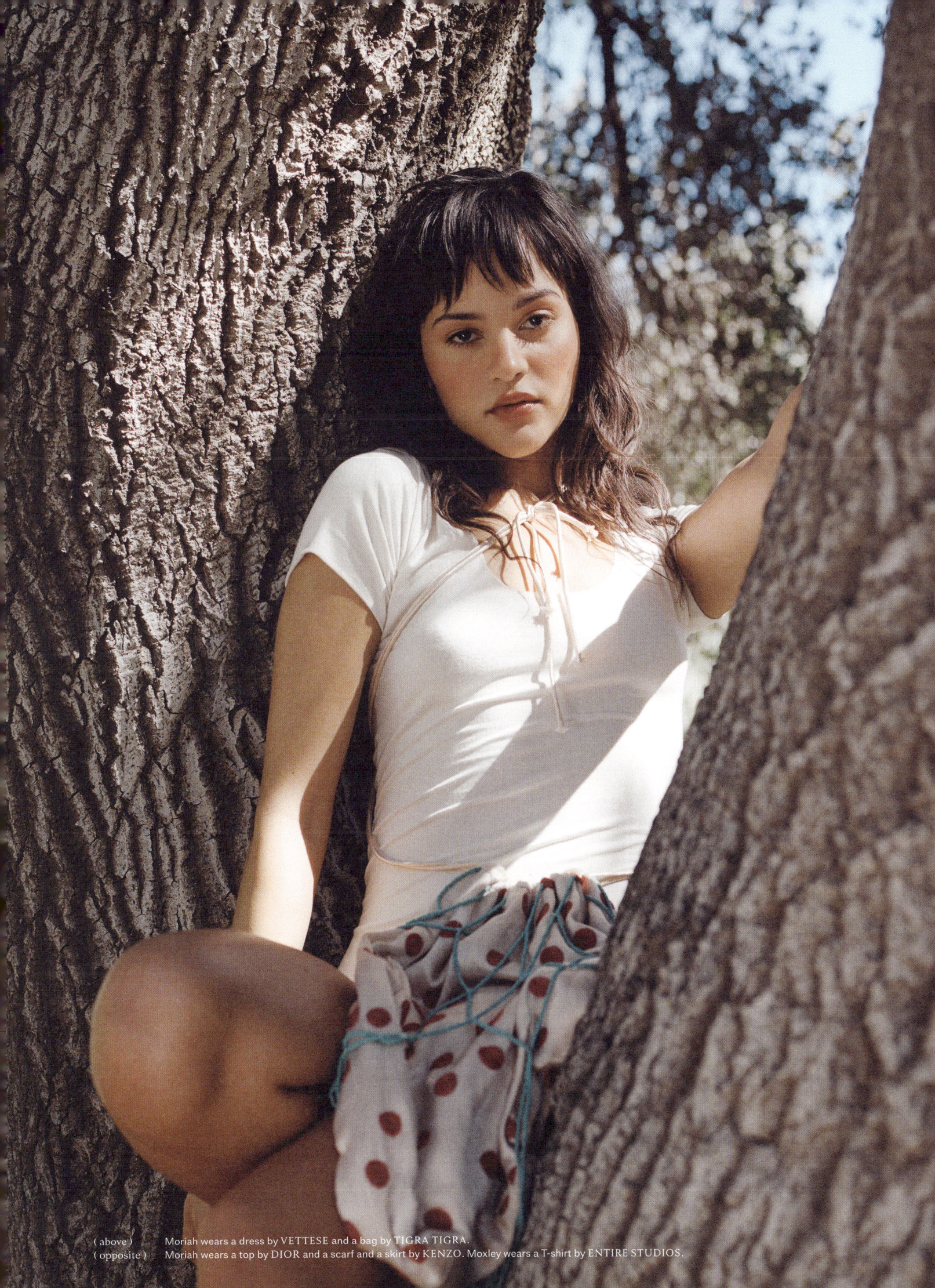

(above) Moriah wears a dress by VETTESE and a bag by TIGRA TIGRA.
(opposite) Moriah wears a top by DIOR and a scarf and a skirt by KENZO. Moxley wears a T-shirt by ENTIRE STUDIOS.

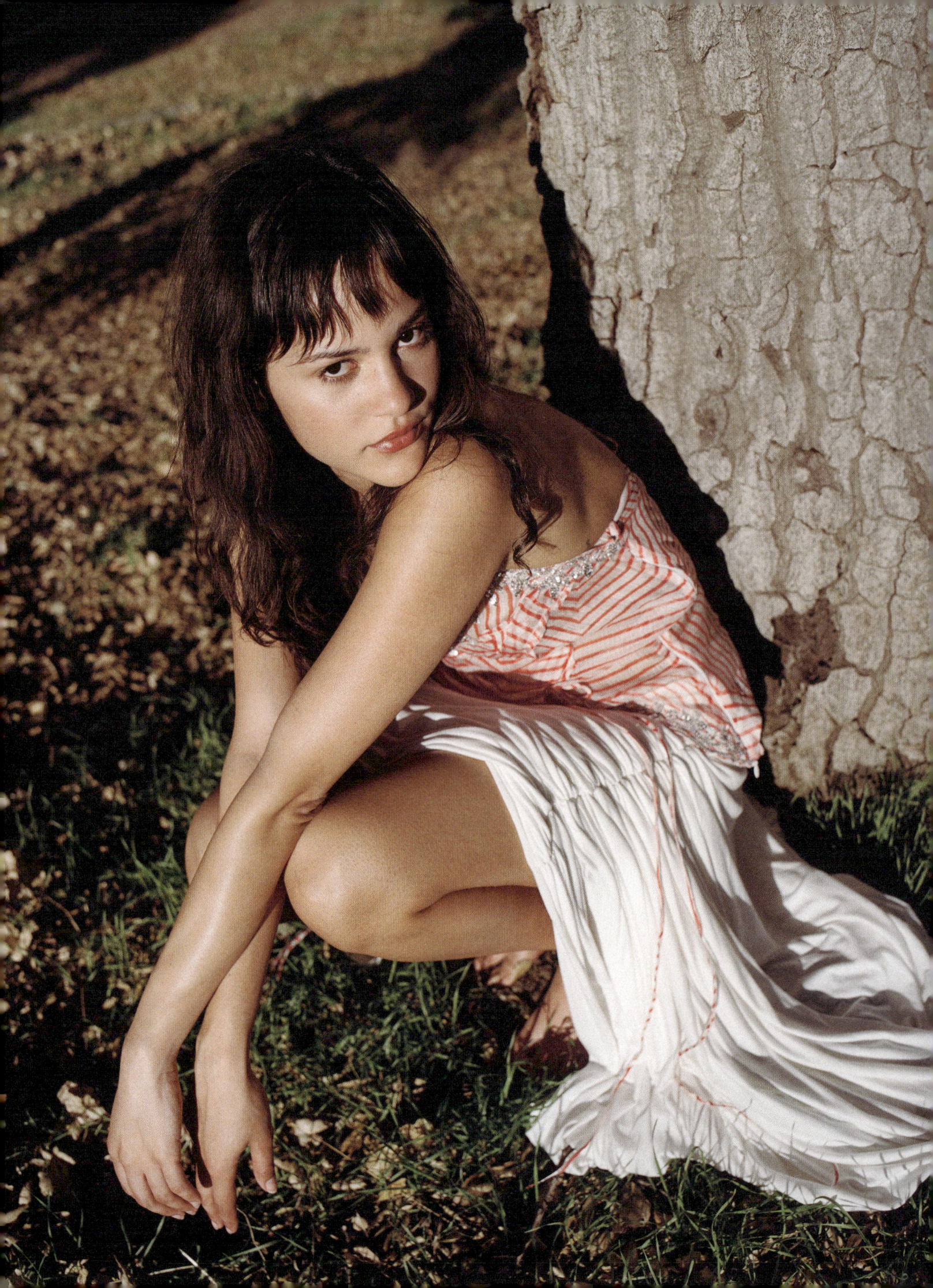

(below) Moxley wears a T-shirt by ENTIRE STUDIOS and shorts by THIRD WAY. Moriah wears a top by TIGRA TIGRA and a skirt by VETTESE.
(opposite) Moriah wears a top by TIGRA TIGRA and a skirt by VETTESE.

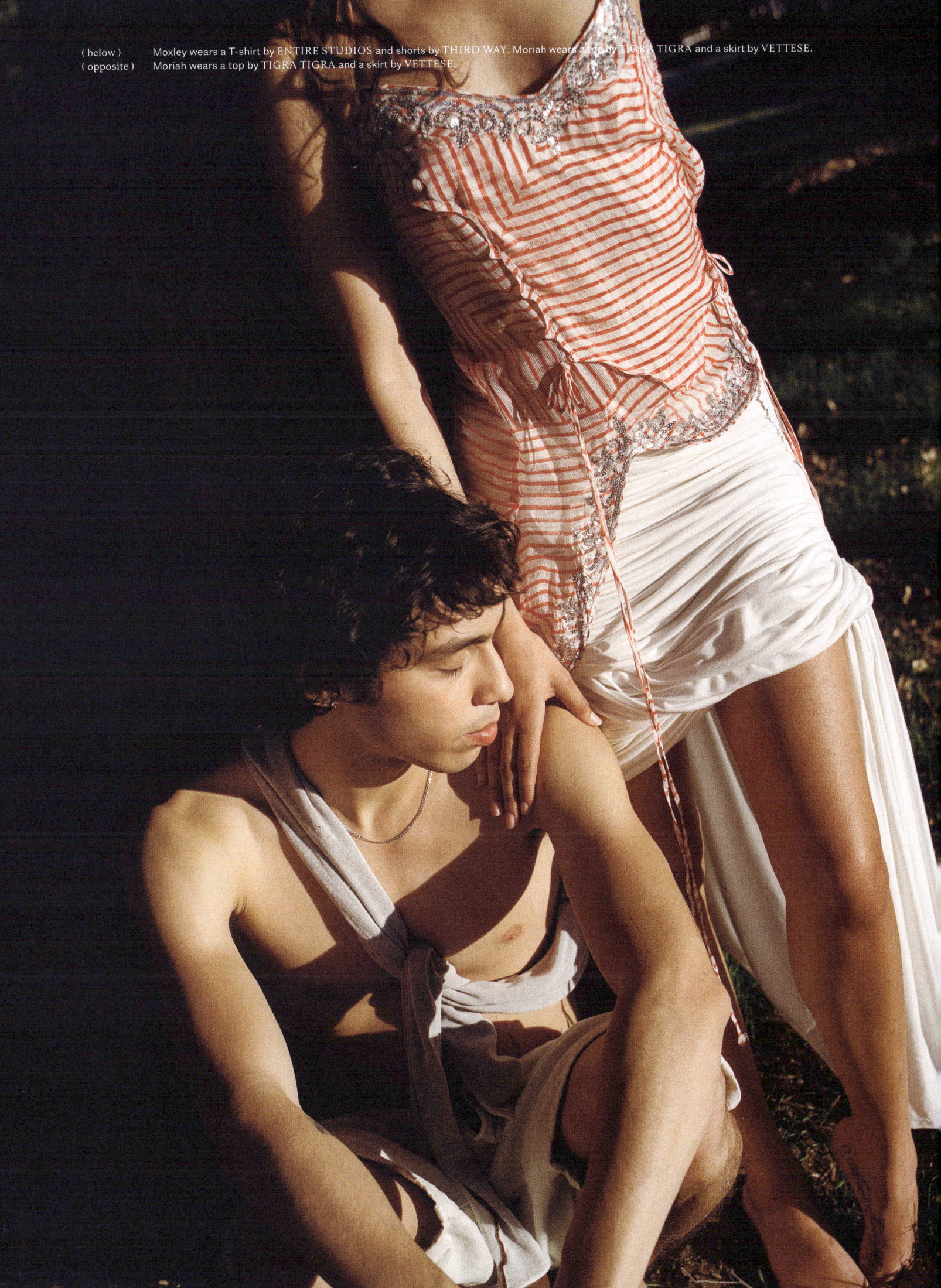

HOME TOUR: Frey House II

Words
Lyra Kilston
Photos
Elizabeth Carababas

The San Jacinto Mountains rise abruptly from the floor of the Southern California desert, a series of steep rocky slopes in shades of mahogany and tan, their ridgeline jagged against the pure blue sky. Half hidden in the mountainside, about 220 feet up, is Frey House II, the home of Swiss-born architect Albert Frey for more than three decades. Completed in 1964, the house is nearly transparent: a simple glass rectangle with a slanted roof, its steel frame anchored to the landscape by a large granite boulder that protrudes into the house. It's a curious meeting of the natural world and rational modernism, perched in a serene, otherworldly setting.

The road to the house winds up from the city of Palm Springs; from the house there are panoramic views of the flat, palm-studded Coachella Valley and, when the glass doors are slid open, a cooling cross-breeze. Frey, who died in 1998 at the age of 95, had designed his house to be both exquisitely in tune with the landscape and, at only 1,220 square feet, sparsely functional. The kitchen occupies a small hallway with everything in reach. In the main, open-plan room, a drafting table doubles as a dining space, and a half level down, the bedroom is separated from the living room by a built-in console and the looming boulder.

"It's a house that is so well thought through and works so well," says Christine Vendredi, chief curator of the Palm Springs Art Museum, who lived in the house for several weeks last year when she first moved to the area. "Everything is prepared for you to optimize your day." Frey gifted the house to the museum in his will, with the condition that it would remain in use, rather than be preserved as an artwork.

The interior is, however, much the same as when Frey left it and his unique touch can be seen everywhere—the Swiss cowbell hung near the entrance, a pencil sharpener bolted beneath the drafting/dining table, the use of peach-colored concrete for the foundation, the carport and pool area to match the mountainside. A practitioner of yoga in his later years, Frey did daily headstands into his 90s and enjoyed being close to the local wildlife here, like the bighorn sheep and a chuckwalla lizard that would come to the turquoise pool in front of the house every morning so he could feed it fruit.

As a fledgling architect, Frey apprenticed with Le Corbusier, absorbing the modern master's teachings and working on his iconic Villa Savoye near Paris, before emigrating to the United States in 1929. He began working in New York but after a couple of years a job brought him out to Palm Springs, a small but growing desert city east of Los Angeles. In a letter to Le Corbusier, he wrote of his fascination with the meeting of civilization and "a wild, savage, natural setting." The mountains, Frey said, reminded him of Switzerland.

That job would change both the course of his life and the city's architectural identity. Frey's European modernism had a profound impact on the architecture of Palm Springs, where he designed many of its iconic buildings, freely experimenting with innovative forms and materials, and he pioneered what would come to be known as Desert Modernism. Combining the austere forms of modernist architecture with the natural landscape, the style came to reflect the lifestyle of a sunny, arid climate, where boundaries between swimming, sunning and being indoors became blurred. In one of his famous designs, the 1946 Loewy House, a swimming pool runs right into the house beneath a sliding glass wall, allowing you to swim both inside and out.

By the time Frey set out to build Frey House II, he had many projects and years of living in Palm Springs under his belt, and had a deep understanding of its climate and geography. He had already built himself a house in the city—Frey House I (now demolished)—but yearned to live in the

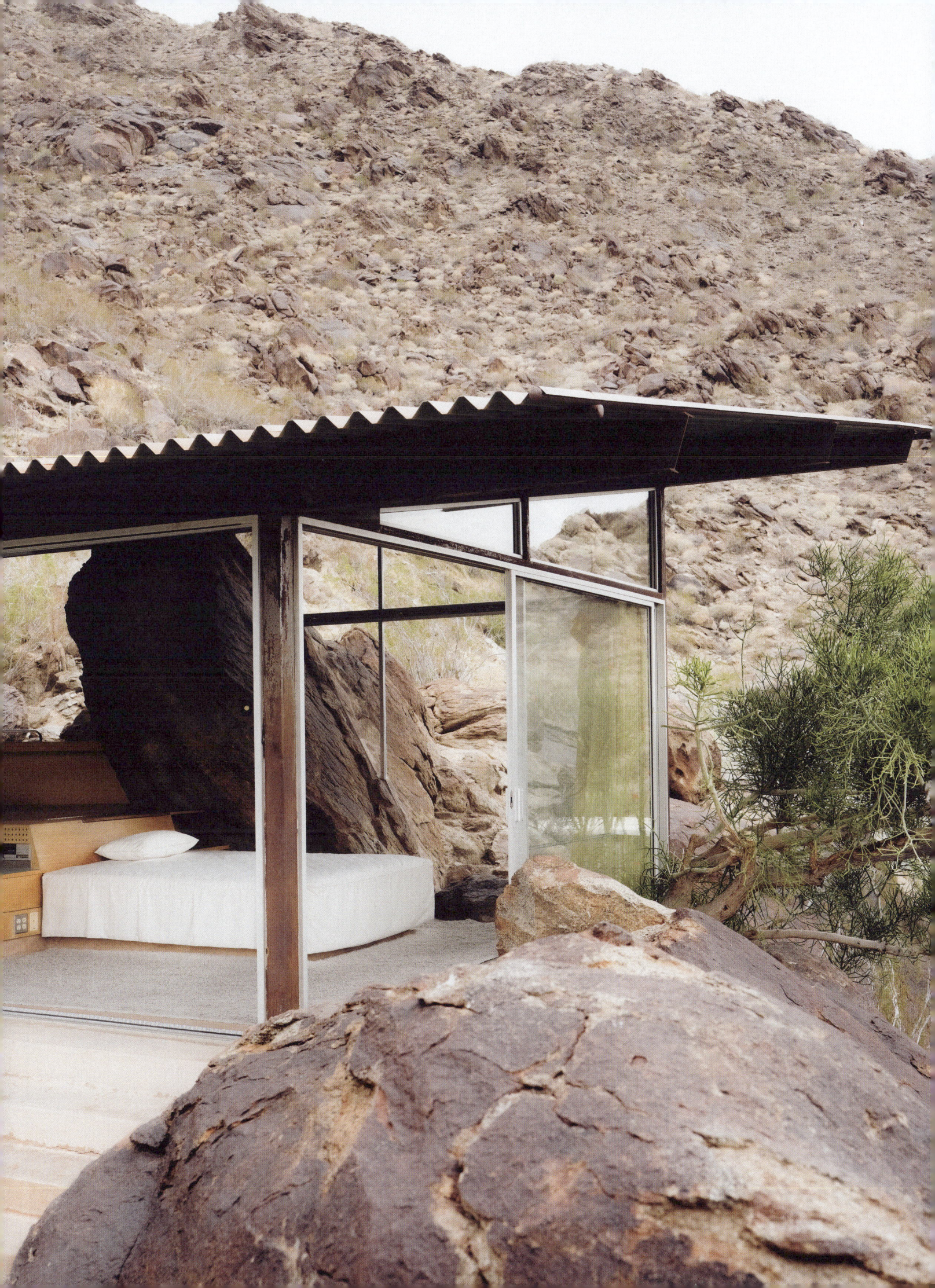

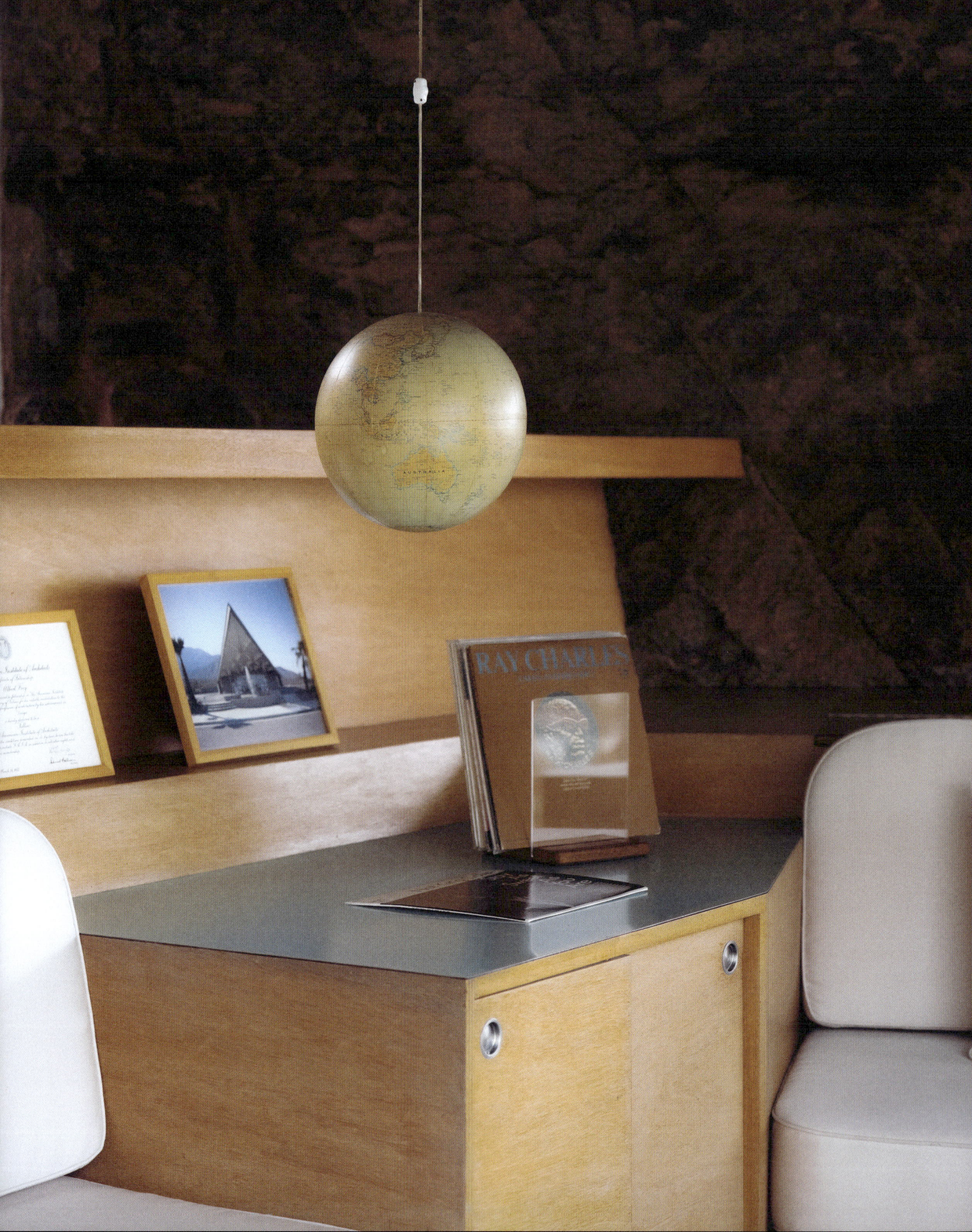

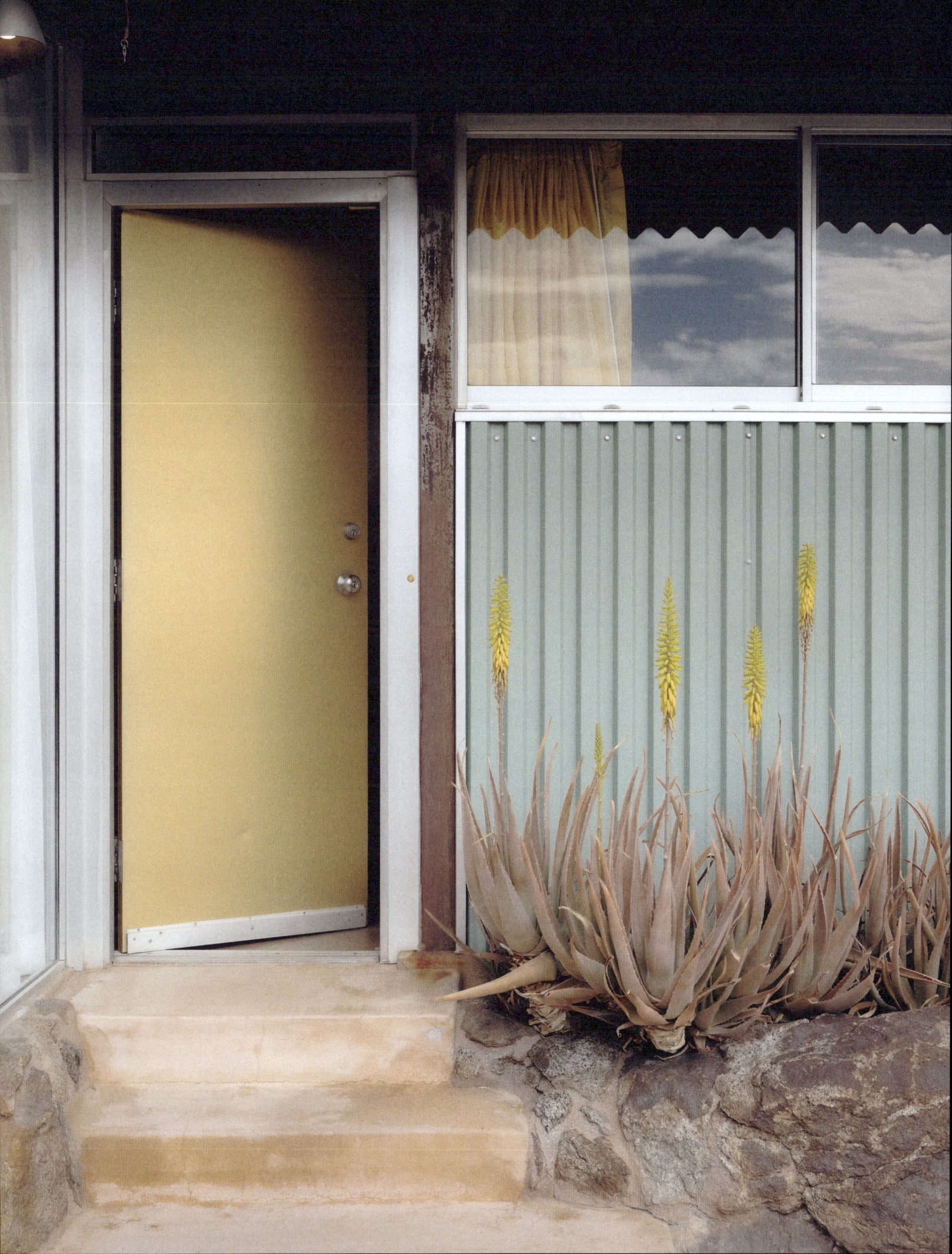

" There's a hum up there that really realigns your thinking."

mountains, rather than just in sight of them. He took his time to get it right: five years just to select the site, and a further year observing the movement of the sun before starting to draw up plans. When he finally visited city hall for permits, they referred to the project as "Frey's crazy house," but knew him well enough that they approved it.

The result of his patience and attention is the perfect calibration of the house to its environment, permitting the morning sun to enter and glide up the bed before it is blocked for the rest of the day by the angled roof overhangs. With a wall of glass doors slid open to the desert winds, the interior can be kept shaded and cool.

But it is the choice to incorporate the boulder that has become the house's defining feature. It may have been gestating in Frey's mind soon after he arrived in Palm Springs, when he observed, in his book *In Search of a Living Architecture*: "Plants and mountains, with their curved and irregular contours, create and welcome contrast to the rectilinear practical house form."

Back then, in the mid-1960s, Palm Springs was a swinging vacation destination with Hollywood celebrity parties, business tycoons meeting on golf courses, and many commissions for luxurious mansions with lavish spaces for outdoor entertaining. It seems particularly notable then, that Frey, who had achieved great success in his career, chose such a modest house for himself. A true acolyte of the modernist belief in affordable and mass-produced housing, he kept his budget low. Some of the materials in the house are pointedly unluxurious, like corrugated plastic and aluminum, concrete cinder blocks and a simple tiled bathroom, pale pink to reflect the sunset skies. Nature was his form of luxury—the ceiling is painted a deep sky blue and yellow curtains are the same bright shade as the desert brittlebush flowers that bloom on the mountain.

Michael Hinkle, the museum's associate director of development, oversees the house's upkeep, though it has required remarkably little intervention. "It's really built to last," he says. "Of course, over time things need to be replaced and cared for." While Frey prioritized off-the-shelf materials available in 1964, replacing them today means getting them custom-made. The conservation team also regularly measures the position of the rock to check stability, but they have never found the slightest movement. "The rock is supporting the entire structure," Hinkle explains. "A few years ago, there was a lot of rain and flooding and the whole road to the house had washed away. We had to hike up there to check on the house, but it was perfectly fine." Hinkle has also spent the night in the house. "There's a hum up there that really realigns your thinking," he says.

The museum recently acquired Frey's first American building, the Aluminaire House, a case study built for an exhibition in New York in 1931. It's now displayed on the museum's grounds, not far below Frey House II. A three-story aluminum and glass cube, the house is radically different from the architect's later California projects, offering a fascinating look at the early stage of his career. As Vendredi notes, the Aluminaire House was designed to show off new industrial materials and was meant to be mass-produced and used anywhere. In contrast, Frey's house, while using similar materials, was harmoniously adapted to a specific landscape and topography. "The Frey House II is really anchored to one mountain in Southern California," she says. "It can only exist where it exists."

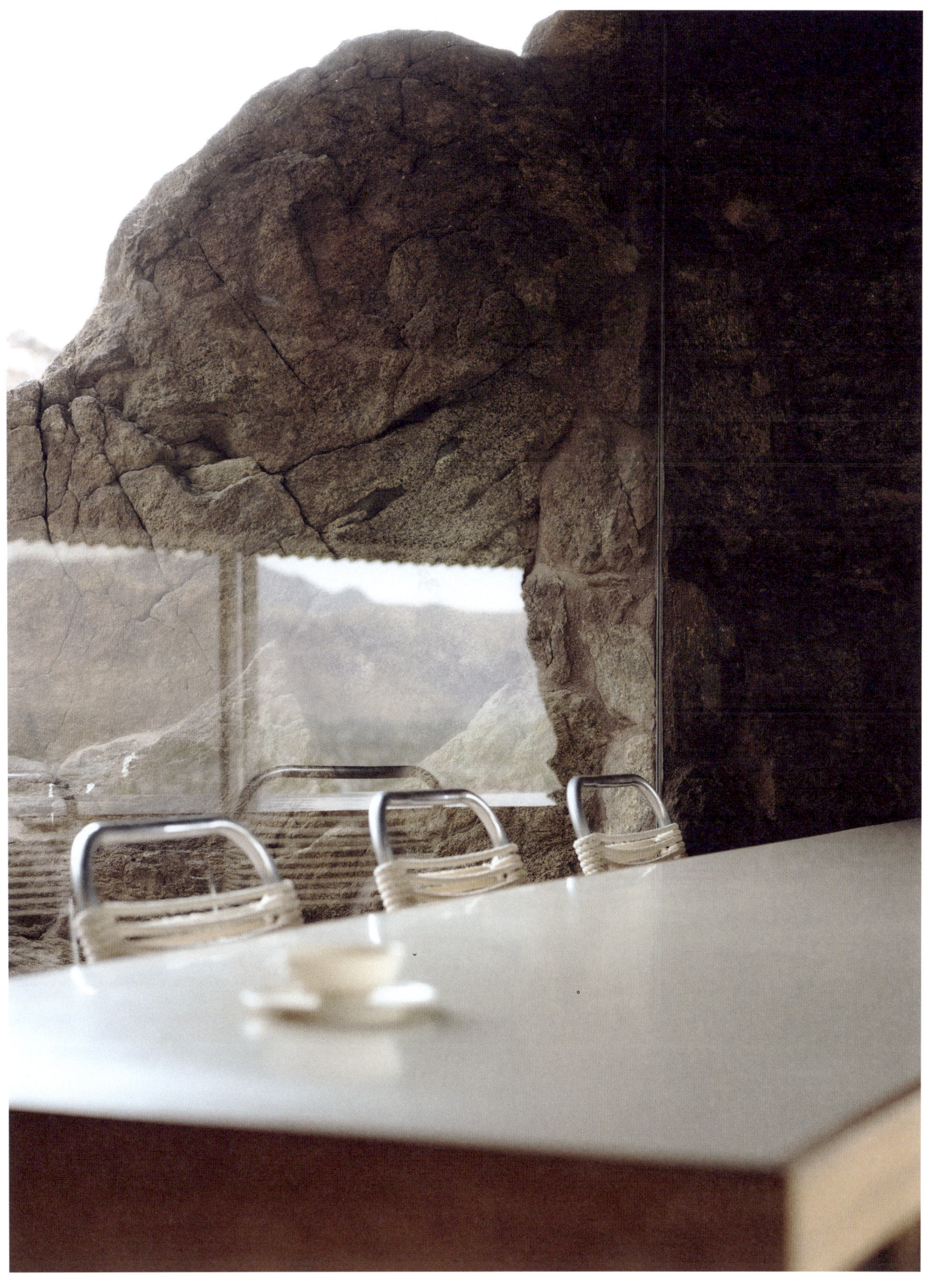

(above) The dining table also served as Frey's drafting table, offering views across the pool to Palm Springs.

(opposite) The home's bathroom echoes the pale pink tones Frey used for the concrete outside, harmonizing the property with the desert landscape.

CALIFORNIA

98	Raed Khawaja
108	West Coast Cooking
122	Betty Reid Soskin
130	Emile Haynie
140	The Artisans of AI
148	Blunk House

Raed Khawaja

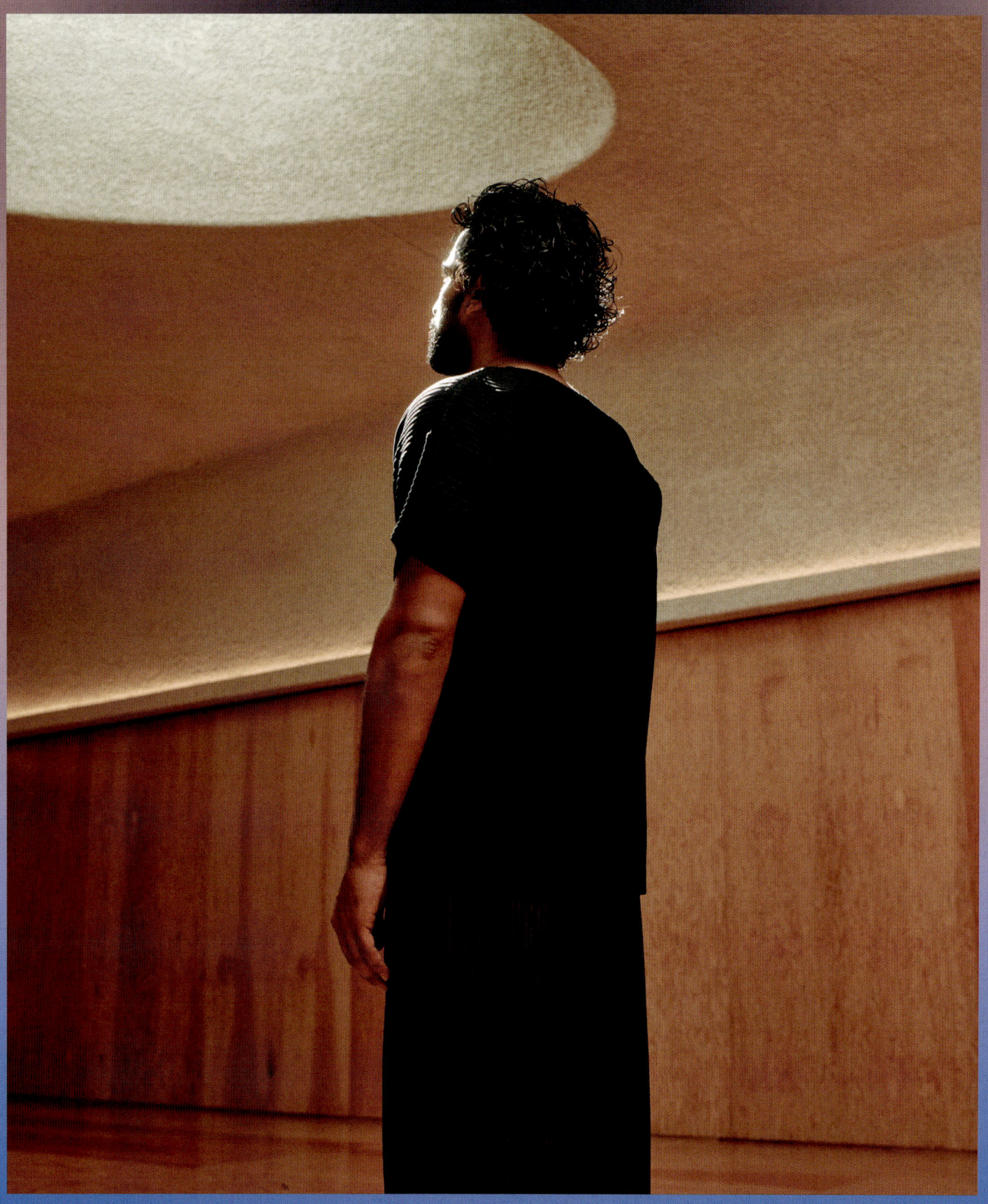

Words
Robert Ito

Photos
Daria Kobayashi Ritch

Taking a moment with the CEO of wellness start-up Open.

Raed Khawaja has a cold. Or if not a cold, some other ailment that makes his head ache and his ears ring, so much so that he didn't get great sleep last night. In short, he's not well, which is funny because Khawaja is in the business of wellness, or more specifically, mindfulness.

"I realize it's odd," he says, in the headquarters of his company, Open, a short walk from Venice Beach in Los Angeles. Through the expansive windows of the building's second floor there are palm trees gently waving in the ocean breeze. "Any time you're interacting with nature in this way, it makes you mindful," he says. "There's so much natural beauty here that it forces you to wonder: How did we all get here? What's my purpose?"

There are two parts to Khawaja's business. There's Open, a "mindfulness studio for everyone" not far from here, where one can take classes in breath work, movement and meditation in a vast space illuminated by an oval skylight. And then there's Open, the app, which allows you to take many of the same classes in the comfort of your own home. It's likely your home is not nearly as distraction-free as Khawaja's studio, but you can do the classes in your underwear, or pause a class if, say, you get a delivery.

Khawaja grew up in the suburbs of Chicago. "I had an awesome, middle-class, very suburban upbringing," he says, though his parents made sure that he spent his childhood summers in Pakistan, where they had emigrated from, "to get out of the myopic American experience." A devout Muslim, he prayed five times a day, even more so during Ramadan, but his relationship with Islam faded in his late teens. Now, though, he feels lucky that he built a foundation of meditation and mindfulness when he was younger, as well as the discipline and focus that comes with praying several times a day, every day. "I wouldn't have called that a meditation practice at the time," he says, "but looking back, it was profound."

In 2018, after about a decade of "secular meditation" and a series of longer and longer meditation retreats ("10-day Vipassanas and things like that"), Khawaja founded Open, organizing his own group meditation classes in San Francisco, where he was working at a tech start-up. "I tried to get a lot of my friends to meditate, but no one really took to it," he says. "Actually, exactly two friends took to it." The few times that were successful, he remembers, were when the sessions had taken place in fun spaces "with a more social vibe." One particularly popular class on breath work led him to organize a series of pop-ups around the city, including at the city's planetarium, which featured a booming sound system and curated music. "I was just playing, to be honest," he says.

Khawaja moved to Venice in 2020 and, together with Manoj Dias and Peter Tseng, launched the Open app in 2021; the IRL studio followed in 2023. He explains that California has always been open to progressive movements and new ideas, and so something that might seem too weird for other places—like, maybe some of his company's own classes—makes perfect sense here. As for his mobile app, he doesn't see any contradiction in using technology to become more mindful, even if it's been tech that has contributed so fundamentally to our general inability to focus. When he was living in San Francisco, among the tech crowd, he realized the futility of rejecting tech wholesale. "I'm ideologically opposed to having an angsty relationship with tech," he says. "It's a tool. Be the user, not the used."

But is it possible to stay mindful, while running and growing a company, with its accompanying worries and stresses about cash flow and funding rounds and hiring the right people? "I think people make an enemy out of stress," he says. "A lot of these practices have been popularized as tools to relax, to de-stress, to get better sleep. But the tools can also be used to wake up, energize, focus and increase your awareness. So there's no avoiding the stress. I'm not

(below) Khawaja wears a shirt and trousers by INTODUSK and shoes by NAHMIAS.

"It's pretty hectic living in San Francisco.
Asking people to suddenly observe their breath coming in and out of their
nostrils is kind of a lot to ask."

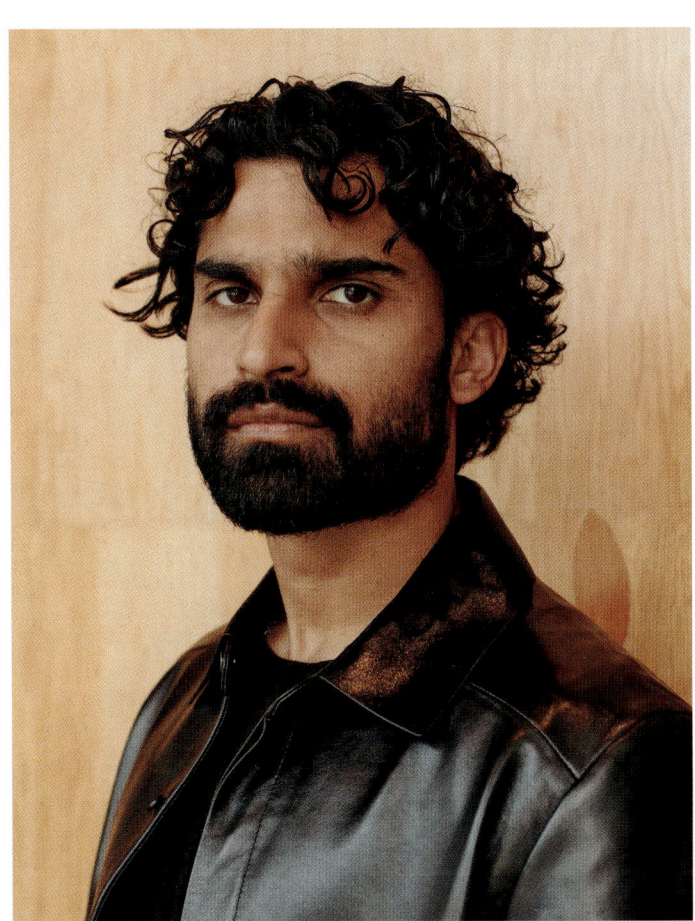

(above)
He wears a jacket by
ENTIRE STUDIOS and a T-shirt
by ACNE STUDIOS.

trying to be the most Zen CEO or founder. It's about taking the experience, with its ups and downs, and having a smile on your face while you're doing it."

Khawaja acknowledges that Open didn't invent Pilates, yoga or Vipassana meditation, or any of the other disciplines they teach, nor does he do anything radically different with them. "I'm interested in finding out how we can glean the knowledge and wisdom of all these different traditions, and present them to people in a way where it's digestible, approachable, accessible and inspiring," he says. For the most part, he explains, he strips them of any religious overtones that some might find off-putting. "You go into a yoga class and someone makes an allusion to some random guru, or they're dropping Sanskrit, and you're like, wait, why is this information being presented to me in this way? It's actually disempowering. Just tell me what's happening here. Describe that to me."

One thing Khawaja doesn't mind saying to people is *I don't know*. "That's a missing sentence in a lot of these spaces," he says. He recalls a time when he overheard a person at another facility ask the leader of a sound bath why he had seen a vision of his grandmother during the session. "I won't even try to replicate what they said in response," he says. "But they were like, this means this, and that means that. For me, I would say 'I don't know.' I don't know! What I can tell you is that your body's in a really relaxed state, and that's it."

Open's Breath and Sound class has been around, in some form or another, since those early days in San Francisco, and remains one of their most popular. The idea was to introduce people to active breath work in an engaging way, where they could feel the benefits of a lifelong meditation practice at the very first session, rather than after months or years. It was a tough sell. "It's pretty hectic living in San Francisco," Khawaja says, "and then asking people to suddenly observe their breath coming in and out of their nostrils is kind of a lot to ask." His solution was to introduce music to the practice—played over a good sound system—and encourage people to breathe to the beat. The idea took off. Now Open counts Grammy-winning musician James Blake as their chief sound officer.

In an odd move for a CEO, Khawaja says you really don't need what he's selling. "You don't need our studio," he says. "You don't need the app. That's the beauty of something like meditation practice, breath work practice. If you learn the techniques and you have the discipline to do it yourself, you can. I'd be happy if somebody got into all these things because of Open, and years later, they developed a practice to the point where they don't need any of this. That would be amazing. That's graduation."

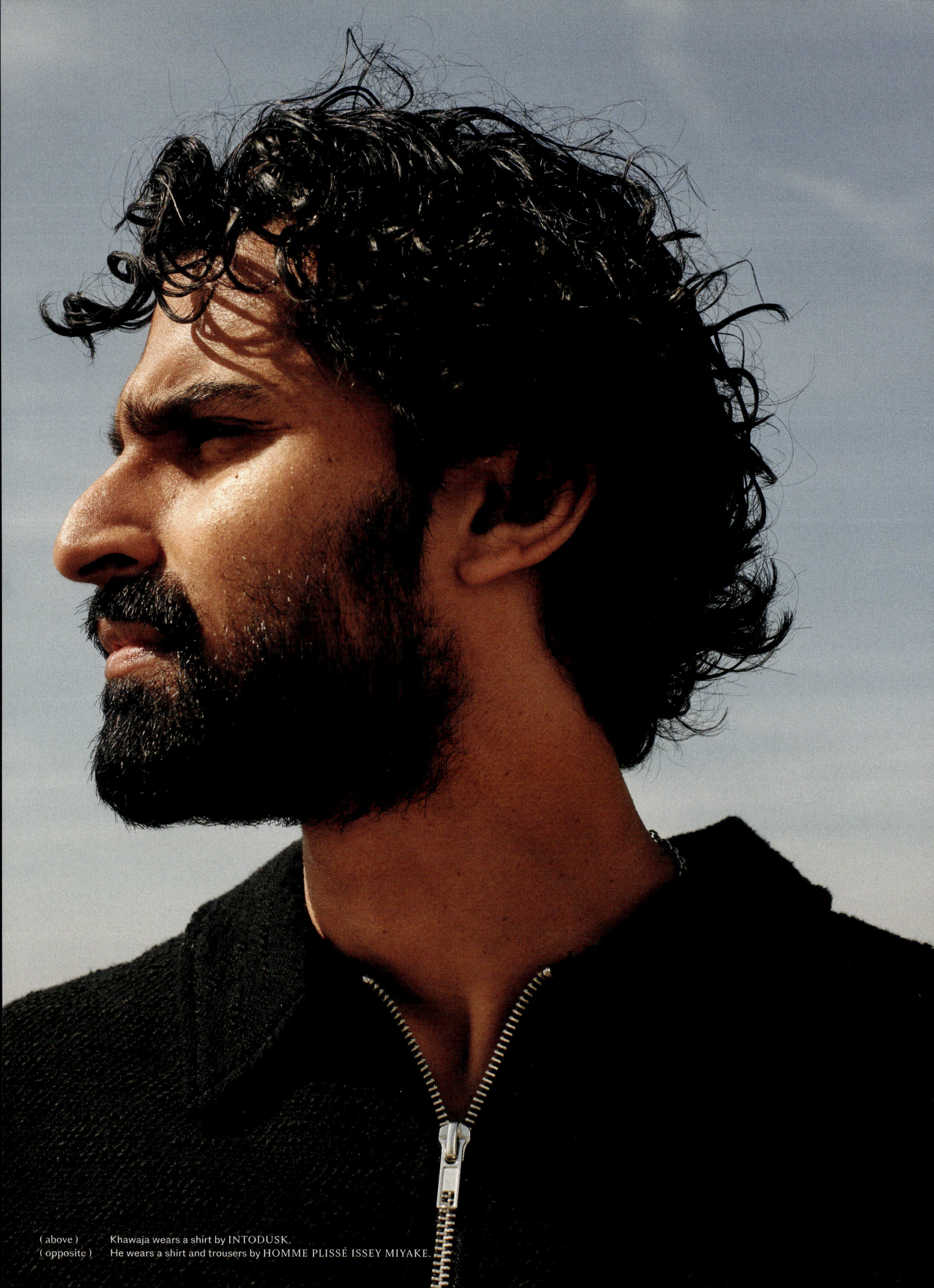

(above) Khawaja wears a shirt by INTODUSK.
(opposite) He wears a shirt and trousers by HOMME PLISSÉ ISSEY MIYAKE.

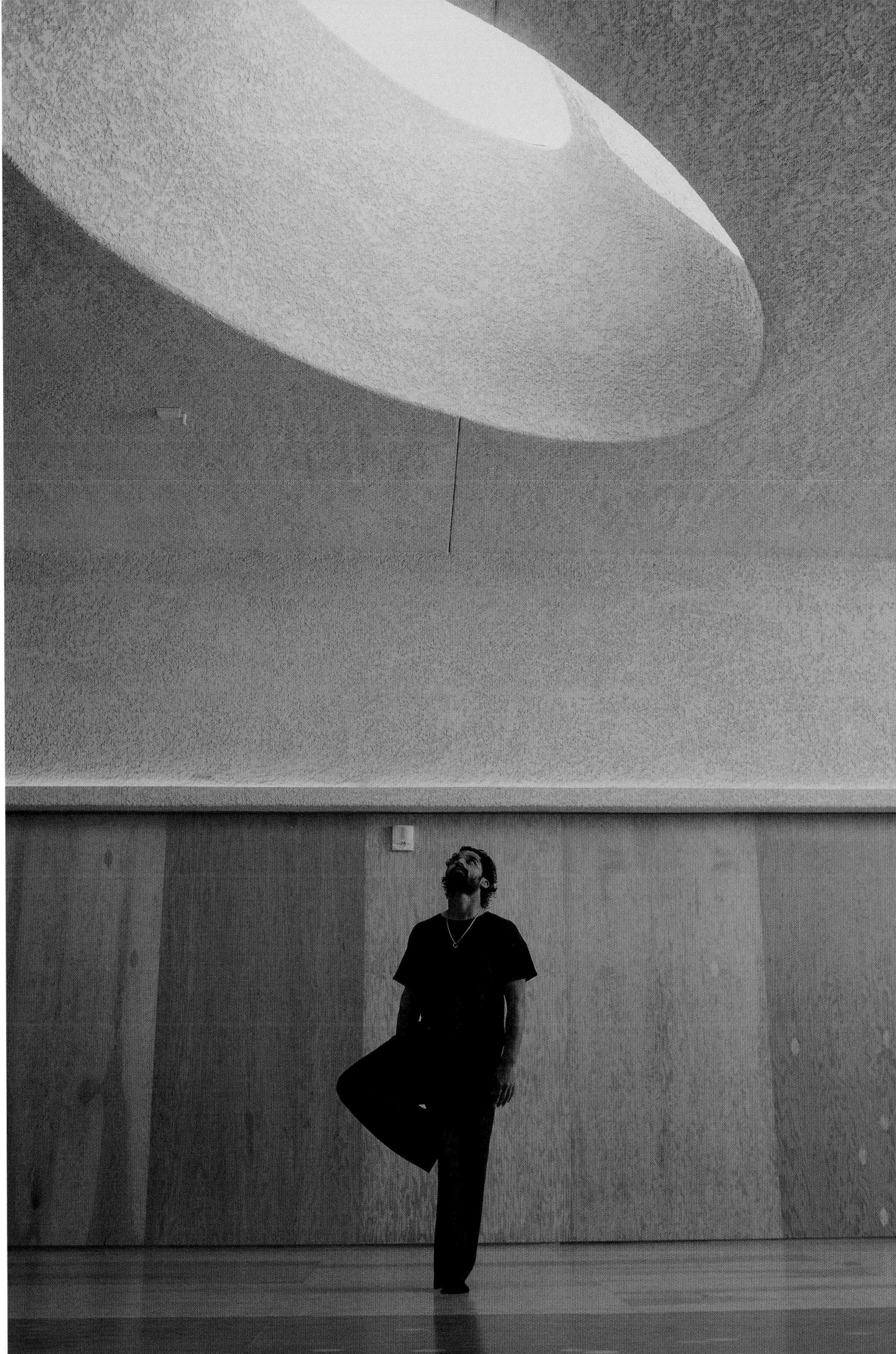

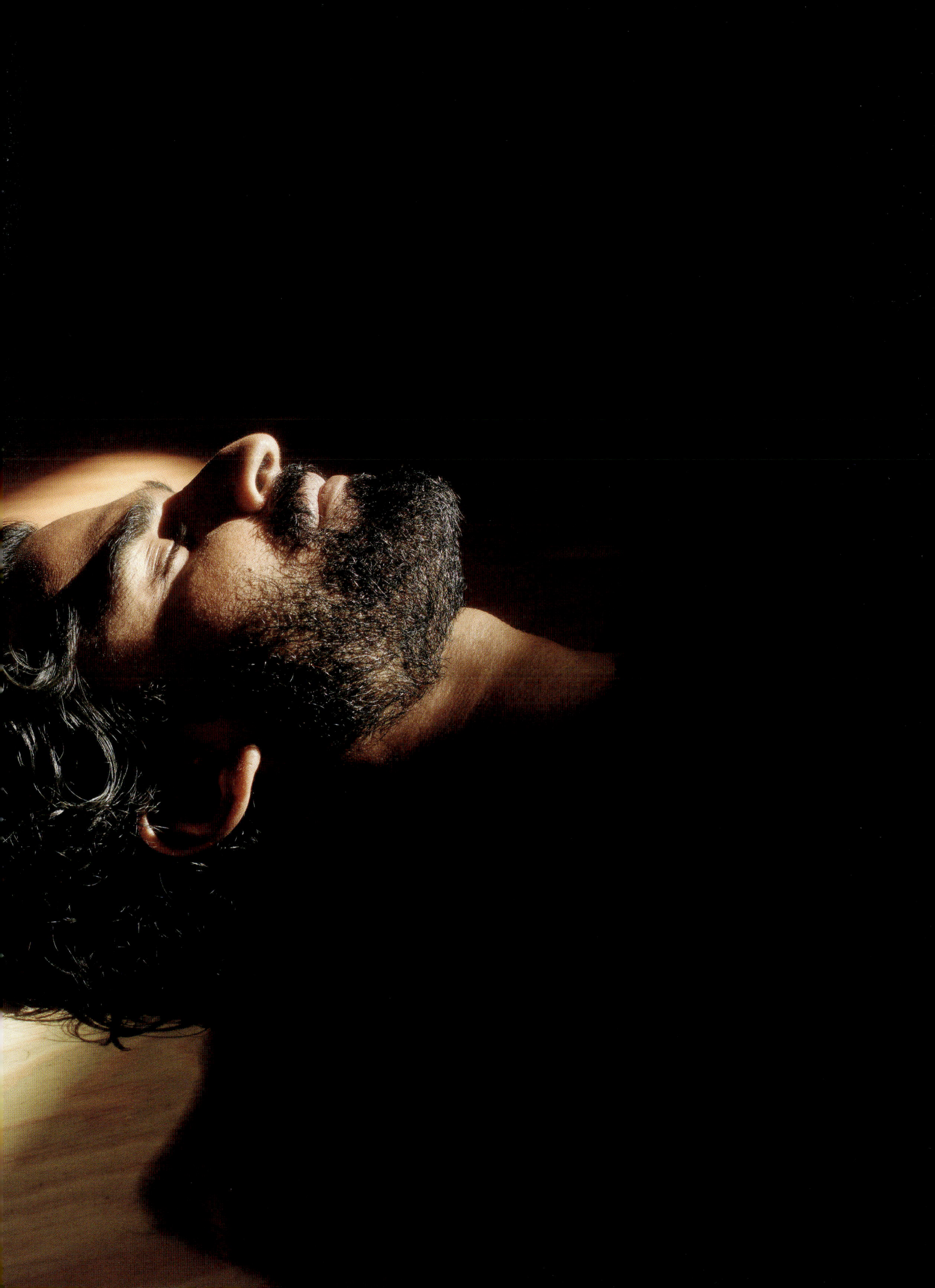

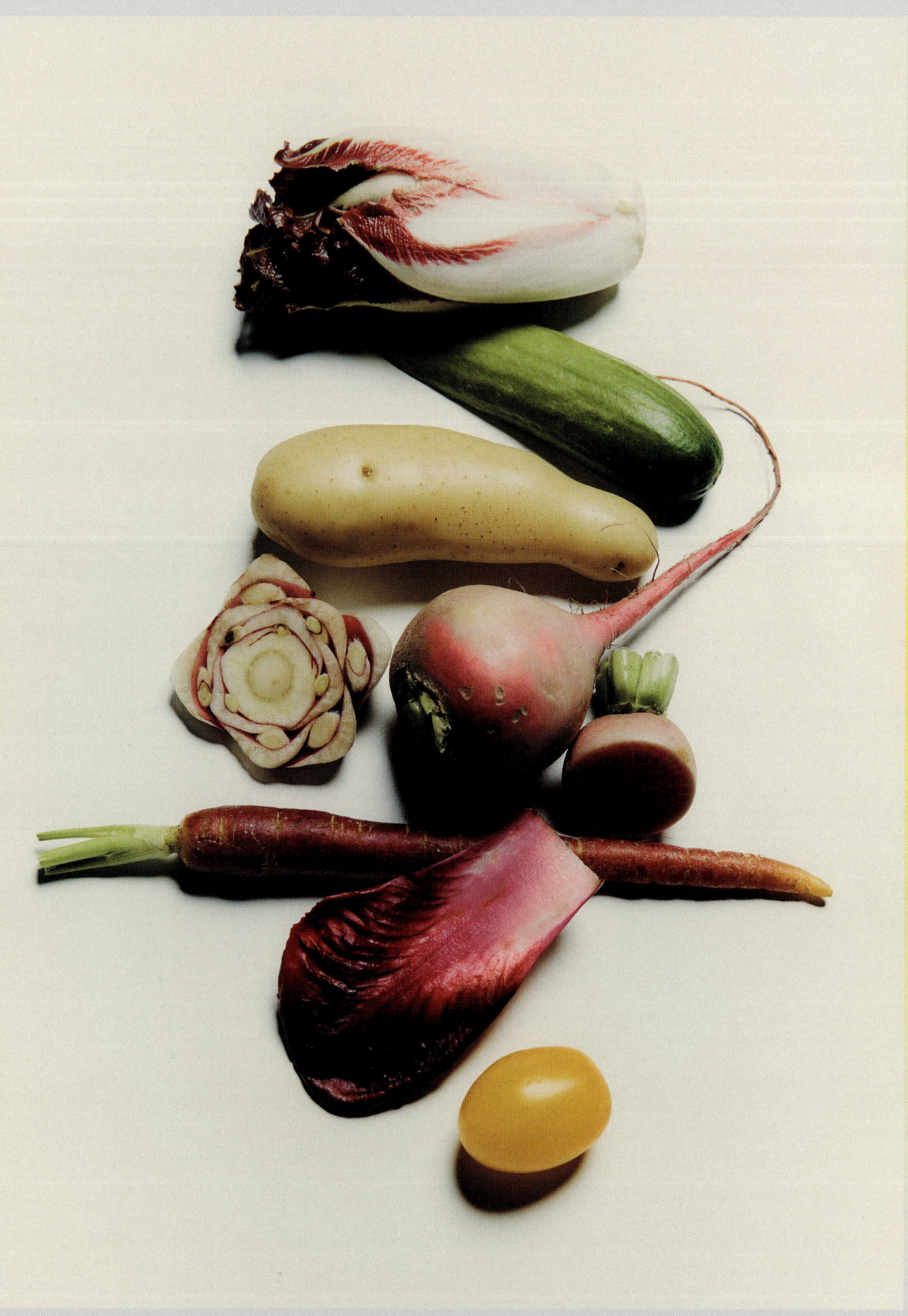

A taste of California.

Recipes
Rebekah Peppler

Photos
Annika Kafcaloudis

West Coast Cooking

I

Walnut Romesco Dip with Crudités

Often served in Catalonia with seafood or calçots (torpedo onions), romesco easily makes the transition from condiment to dip. This take on the classic Spanish spread swaps out the traditional almonds for toasted walnuts—California produces over 99% of the walnuts grown in the US—and drops the classic's breadcrumbs, though it's great served alongside a crusty baguette. Make it in advance, surround with whatever crunchy vegetables you find at your market—snap peas, radishes, slices of cucumber, summer squash, fennel, carrots and/or celery—and serve whenever your guests are ready.

SERVES 6

4 red bell peppers
⅓ cup plus 2 tablespoons (110ml) extra-virgin olive oil
1 cup (110g) walnut halves
2 garlic cloves
2 tablespoons sherry vinegar, plus more to taste
1 tablespoon fresh lemon juice, plus more to taste
1 teaspoon freshly grated lemon zest
1 teaspoon smoked paprika
Pinch ground cayenne pepper
Fine sea salt
Freshly ground black pepper
Crunchy vegetables for dipping such as radishes, snap peas, sliced cucumbers, sliced carrots, sliced celery and/or sliced fennel

Preheat the oven to 400°F (200°C). Place the bell peppers on a baking sheet and drizzle with a tablespoon of olive oil. Rub the oil into the peppers, then roast for 25 minutes. Remove from the oven and use tongs to turn the peppers before continuing to roast for 15 to 20 minutes, until the peppers are charred all over. Remove from the oven, transfer to a bowl and cover with a plate, and set aside to cool.

Lower the oven to 350°F (180°C). Evenly scatter the walnuts on a baking sheet and place in the oven. Bake for around 8 to 10 minutes, until the walnuts are toasted, then remove from the oven and set aside to cool.

Once the peppers are cool enough to handle, remove and discard the skins, seeds and stems. In a food processor, pulse the toasted, cooled walnuts and garlic until coarsely chopped. Add the roasted peppers, sherry vinegar, lemon juice and zest, paprika and cayenne pepper, season with salt and black pepper, and pulse to incorporate. While the food processor is running, drizzle in ⅓ cup (80 ml) of olive oil, and blend until a thick, textured puree forms. Taste and season with additional salt, sherry vinegar and/or lemon juice, as desired. Transfer to a shallow serving bowl, drizzle with the remaining olive oil and serve with the crunchy vegetables.

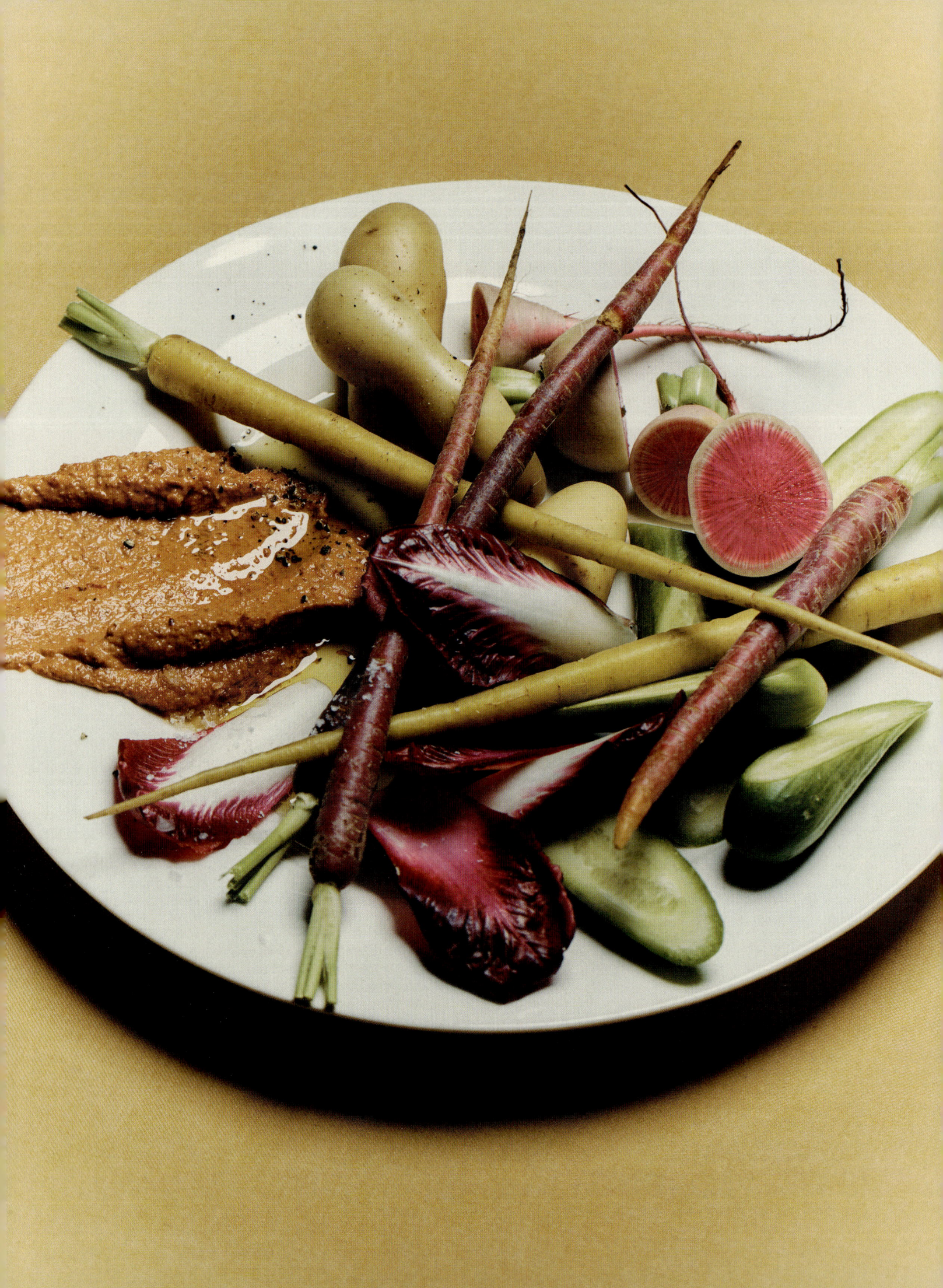

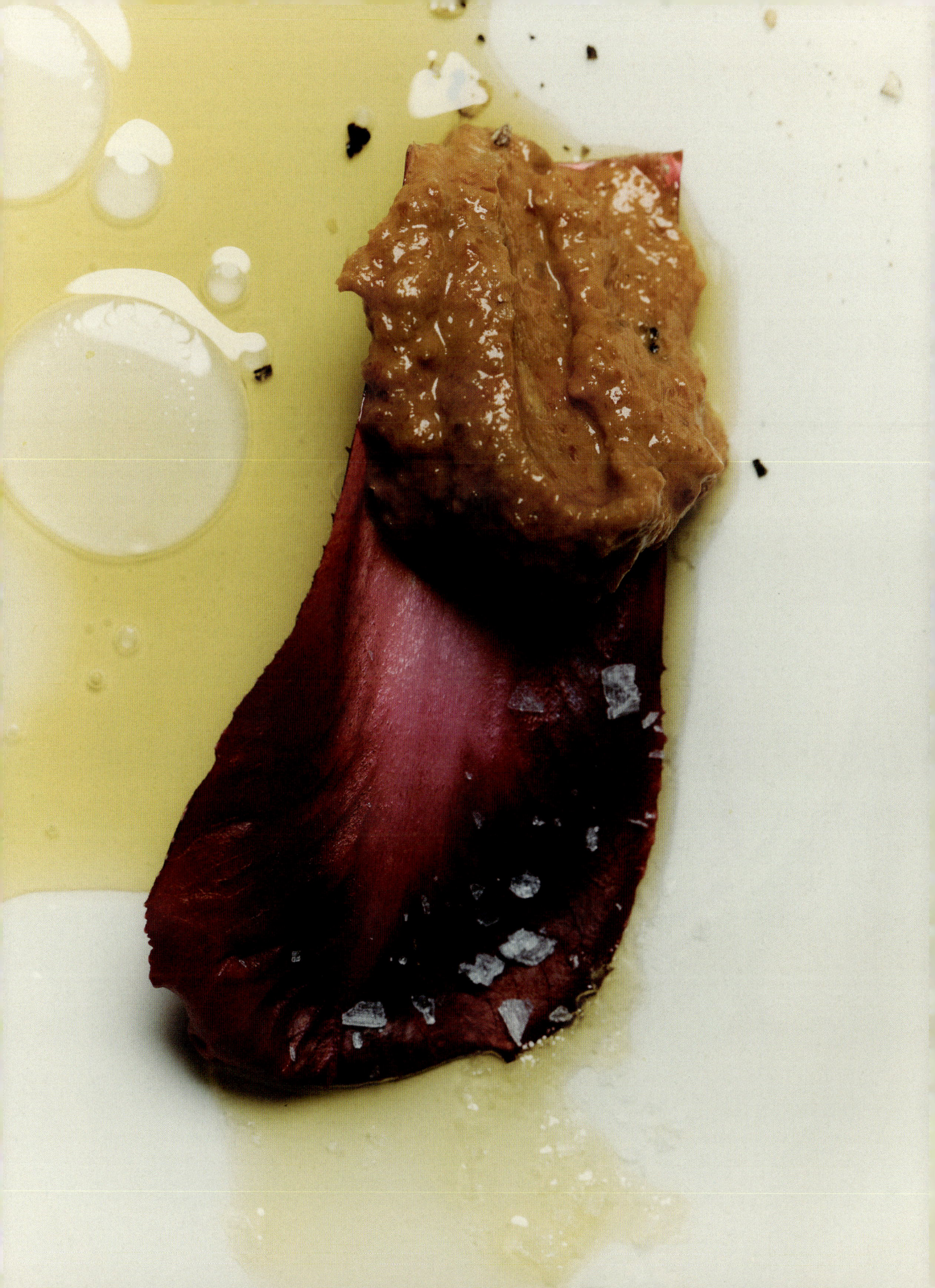

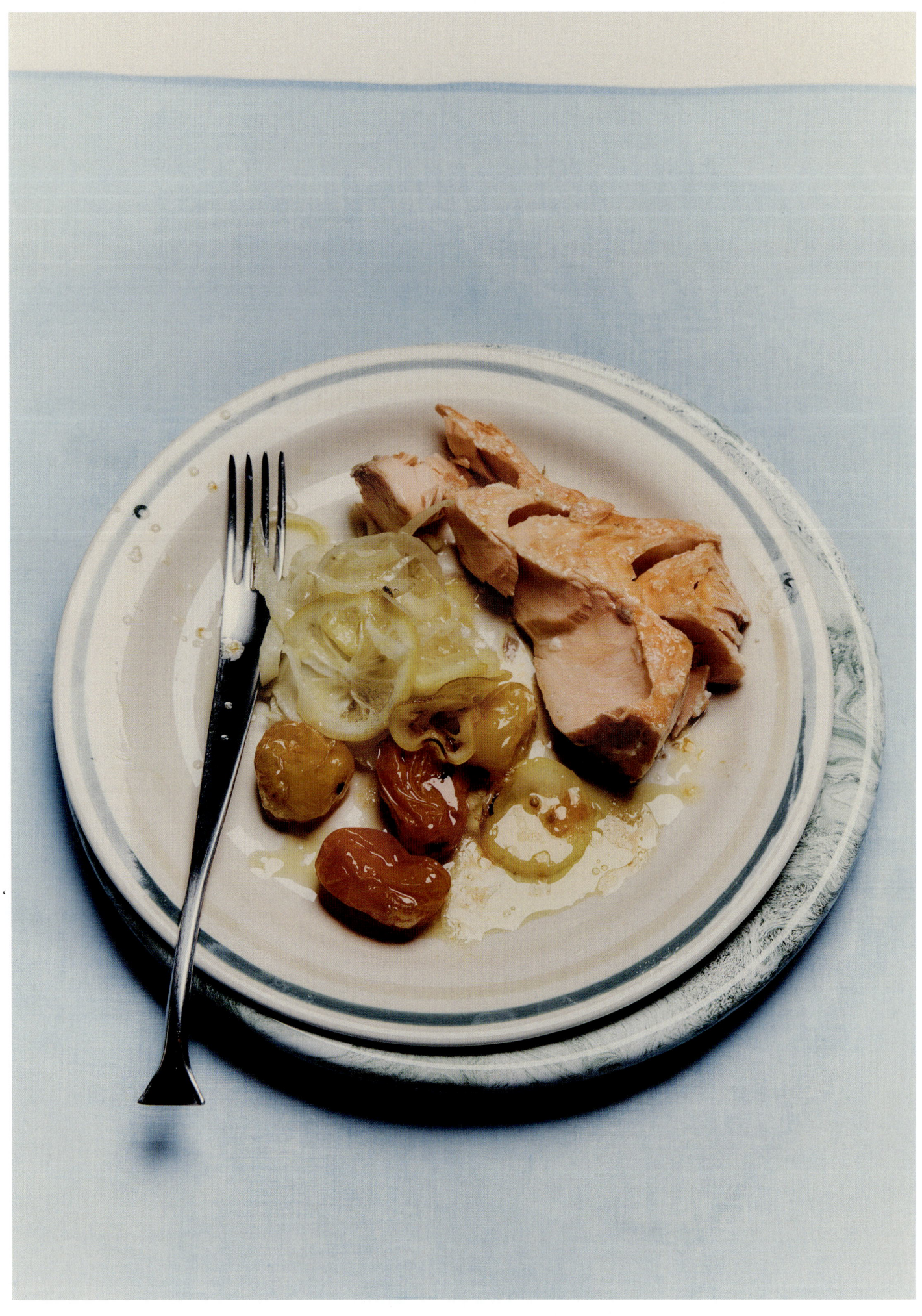

II

Slow-Roasted Salmon with Tomatoes, Fennel and Citrus

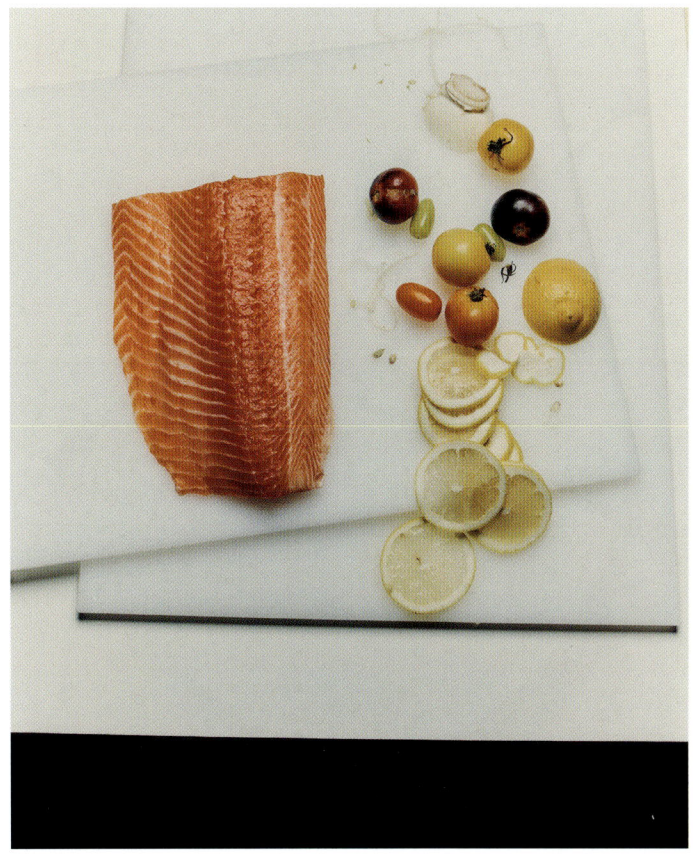

There are several species of both salmon and trout native to California, including Chinook (also known as California King Salmon) and rainbow trout. Slow-roasting any large fillet—salmon, trout, halibut or cod (choose whatever is freshest in your area)—in plenty of olive oil will ensure the fish is tender and perfectly cooked. Here, a medley of fennel, lemon and tomatoes serves to flavor the fish and also provides an easy side. Use a mandoline for very thin fennel and lemon slices, choose the smallest cherry tomatoes you can find (in whatever colors and varieties you like best), and make sure to use a high-quality olive oil.

(A few basic tips to follow when shopping for olive oil: Look for extra-virgin olive oil that is sold in a dark glass or opaque bottle and stored away from windows. If available, check for a recent harvest—also called pressing—date to ensure freshness. The best producers will proudly list the harvest date on their bottles.)

SERVES 4-6

2 fennel bulbs, very thinly sliced on a mandoline
1 lemon (standard or Meyer), very thinly sliced on a mandoline
1 pound (455g) small cherry tomatoes
1¾ cups (420ml) extra-virgin olive oil
Fine sea salt
Freshly ground black pepper
1½ pound (680g) skinless salmon or trout fillet
Lemon wedges, for serving

Preheat the oven to 300°F (150°C). In a large baking dish, add the slices of fennel and lemon, the tomatoes and about half of the olive oil, season with salt and pepper and toss to coat. Season the fillet on both sides with salt and pepper and place on top of the fennel and lemon slices, nudging the tomatoes to the sides of the dish. Drizzle with the remaining olive oil and place in the oven for around 30 to 35 minutes, until the salmon is opaque and easily flakes with a fork. Serve with lemon wedges.

III

Arugula-Parsley Salad

This is a bright and refreshing salad: a combination of peppery baby arugula, fresh parsley leaves and diced avocados tossed in a shallot-heavy vinaigrette. If you're in California, look out for summertime varieties including Hass, Lamb Hass or Reed avocados. No matter the variety, though, the most important thing is that your avocados be ripe—they should feel soft and yield to gentle pressure but not be mushy to the touch. If your avocados need to ripen more quickly, place them in a paper bag along with an apple or banana.

To prepare the salad in advance, add the dressing to your salad bowl first and top with the arugula and parsley before covering with a damp towel and storing in the fridge. Then, just before it's time to serve, cut and season the avocados and toss the salad.

SERVES 6

For the vinaigrette:
2 medium shallots, thinly sliced
2 tablespoons white wine or champagne vinegar
2 tablespoons freshly squeezed lemon juice
Fine sea salt
Freshly ground black pepper
1 tablespoon Dijon mustard
1 teaspoon honey
Hot sauce, if desired
¾ cup (180ml) extra-virgin olive oil

For the salad:
2 ripe avocados, pitted, peeled and diced
½ lemon, juiced
Flaky sea salt
8 cups (160g) baby arugula
1 large bunch Italian flat-leaf parsley, washed, leaves picked and stems discarded

For the vinaigrette, combine the shallots, vinegar and lemon juice in a resealable jar. Season with fine sea salt and pepper, stir to combine, and set aside for at least 20 minutes. Add the mustard, honey, and a few dashes of hot sauce (if using), stir, and pour in the oil. Close tightly with a lid, shake to emulsify and season with fine sea salt and pepper as desired.

For the salad, add the diced avocado and lemon juice to a medium-sized bowl, season lightly with flaky sea salt and toss gently to coat. Transfer about half of the vinaigrette to a large serving bowl, add the arugula and parsley, and toss to coat. Add the avocado, season the salad with flaky sea salt and serve immediately with extra vinaigrette on the side.

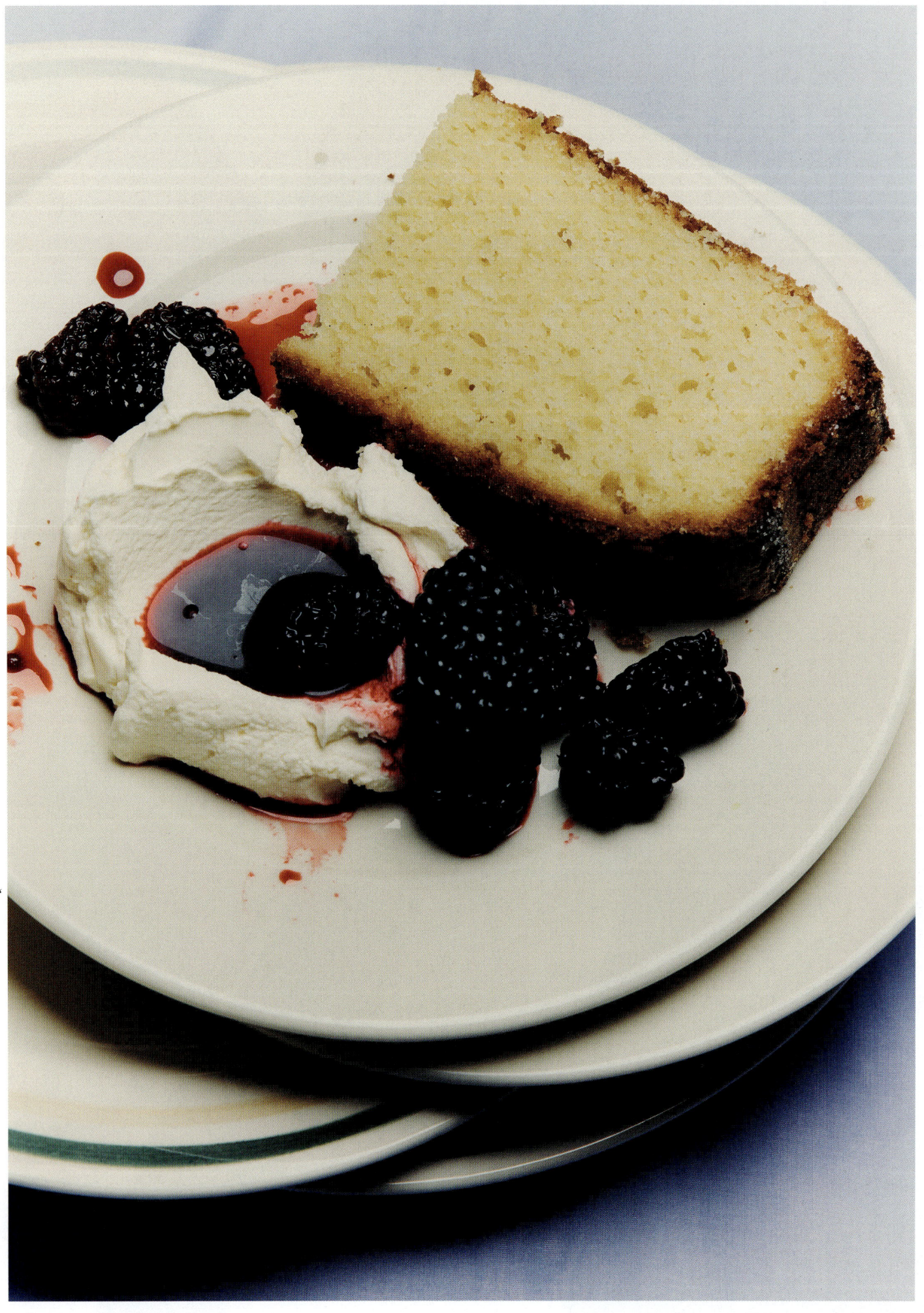

IV

Olive Oil Cake with Crème Fraîche and Blackberries

The characteristics of California olive oil can be hugely varied—mild and fruity, green and fresh, assertive and peppery. For this rich, lightly sweet cake, opt for a high-quality oil of the more mild and buttery variety. Served with crème fraîche and a quick, sweet-tart sauce of cooked and fresh blackberries, it's the ideal end to a summer meal (and should you have leftovers, it also pairs well with morning coffee).

Blackberry season in California runs spring through fall and peaks in summer. If you can't find them, swap in another berry or slices of ripe, seasonal fruit such as peaches, nectarines or plums.

MAKES ONE 9-INCH (23 CM) CAKE

For the cake:
1 cup plus 1 tablespoon (255ml) extra-virgin olive oil
1 cup plus 4 tablespoons (250g) sugar
2¼ cups (315g) all-purpose flour
1 teaspoon baking powder
½ teaspoon baking soda
¾ teaspoon fine sea salt
2 tablespoons freshly grated lemon zest
3 large eggs, at room temperature
1 cup (240ml) whole milk, at room temperature
¼ cup (60ml) fresh lemon juice
1½ teaspoons pure vanilla extract

For the blackberries:
4 cups (480g) fresh blackberries
¼ cup (85g) light honey, such as acacia
¼ teaspoon fine sea salt
1 tablespoon red wine vinegar
1½ cups (360g) crème fraîche
Flaky sea salt

Preheat the oven to 350°F (180°C). Grease a 9-inch (23 cm) round springform pan with 1 tablespoon (15 ml) of the olive oil and line the bottom with parchment paper, flipping it so it is evenly coated in oil. Sprinkle the bottom and sides of the pan evenly with 2 tablespoons (30g) of sugar and set aside.

In a medium bowl, whisk together the flour, baking powder, baking soda and fine sea salt, and set aside. In a separate large bowl, add 1 cup (200g) of sugar and the lemon zest, using your fingers to rub the zest into the sugar until fully combined and fragrant. Add the eggs and whisk vigorously for 1 minute. While still whisking, slowly pour in the remaining 1 cup (240ml) olive oil, the milk, lemon juice and vanilla. Next add the flour mixture and whisk until just combined.

Transfer the batter to the prepared pan and sprinkle the top evenly with the remaining 2 tablespoons (30g) sugar. Place in the oven and bake for 45 to 50 minutes, until the cake starts to pull away from the sides of the pan, the top is golden brown, and a toothpick inserted in the center comes out clean. Remove from the oven and leave to cool on a rack for 20 to 30 minutes. Run a knife around the edge of the pan then remove the sides and leave to cool completely.

For the blackberries, combine 3 cups (360g) of blackberries with the honey and fine sea salt in a medium saucepan. Bring to a simmer over a medium heat for about 8 minutes, swirling the pan occasionally until the berries release their juices (but are not falling apart). Strain through a fine mesh sieve, transfer the solids to a medium bowl and return the juices to the saucepan. Stir in the vinegar and bring the liquid back to a simmer over medium heat, stirring often until the juice thickens slightly and is reduced by about half (about 10 minutes). Add the reduced juice to the reserved solids and leave to cool completely before stirring in the remaining 1 cup (120g) of blackberries.

To serve, use a long, serrated knife to cut slices of cake and then top with the blackberry sauce, crème fraîche and a sprinkling of flaky salt.

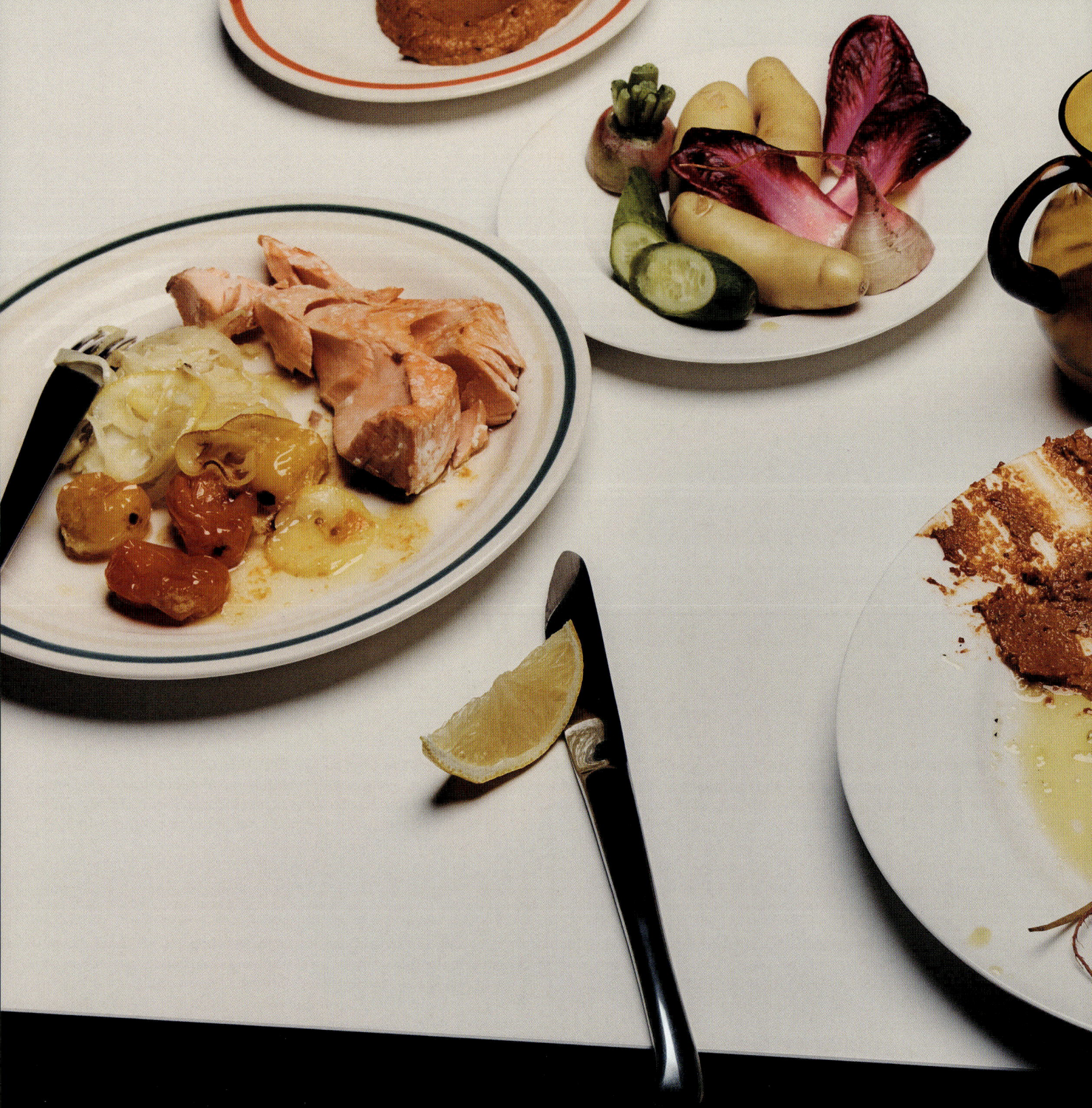

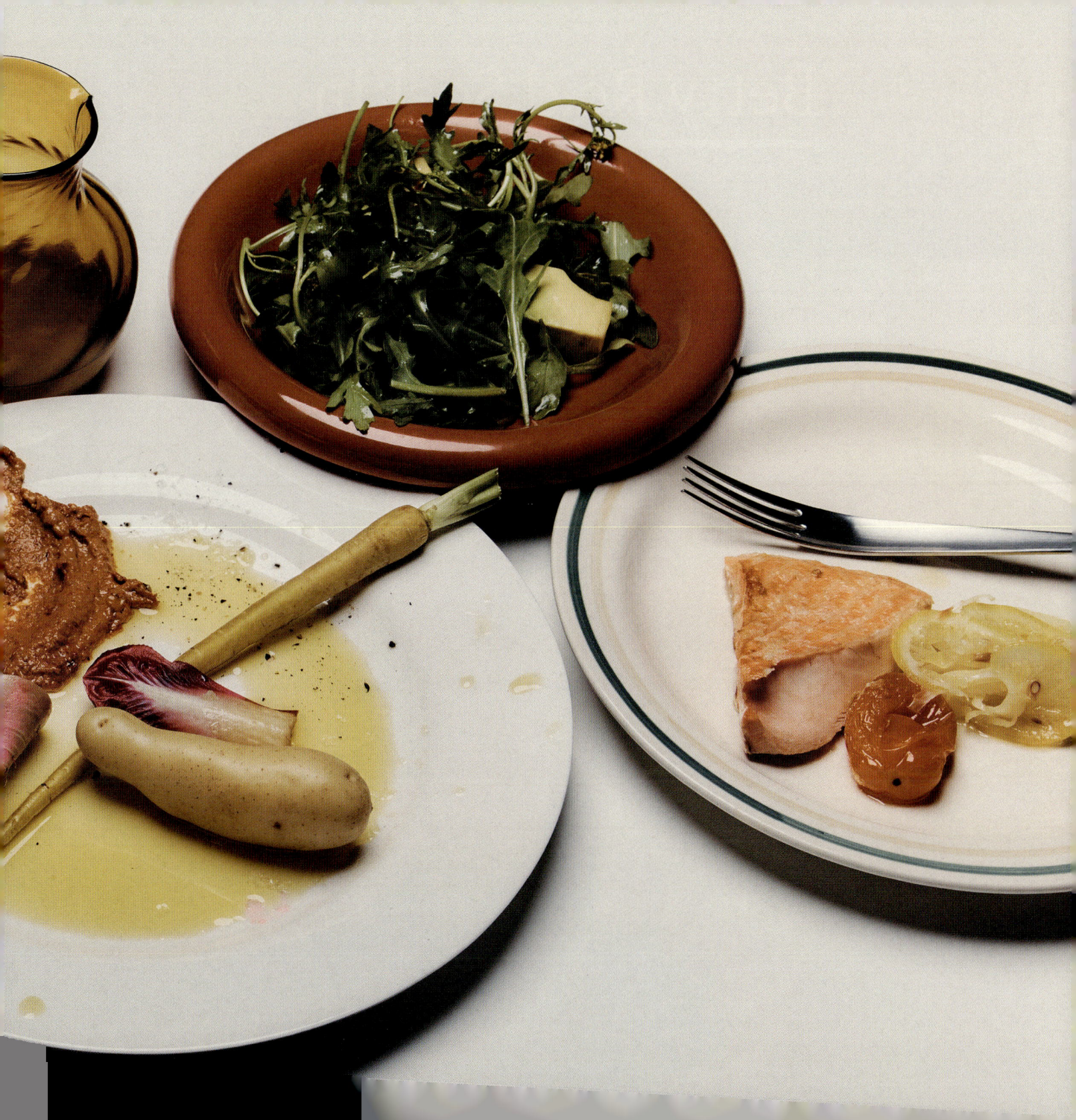

Betty Reid Soskin

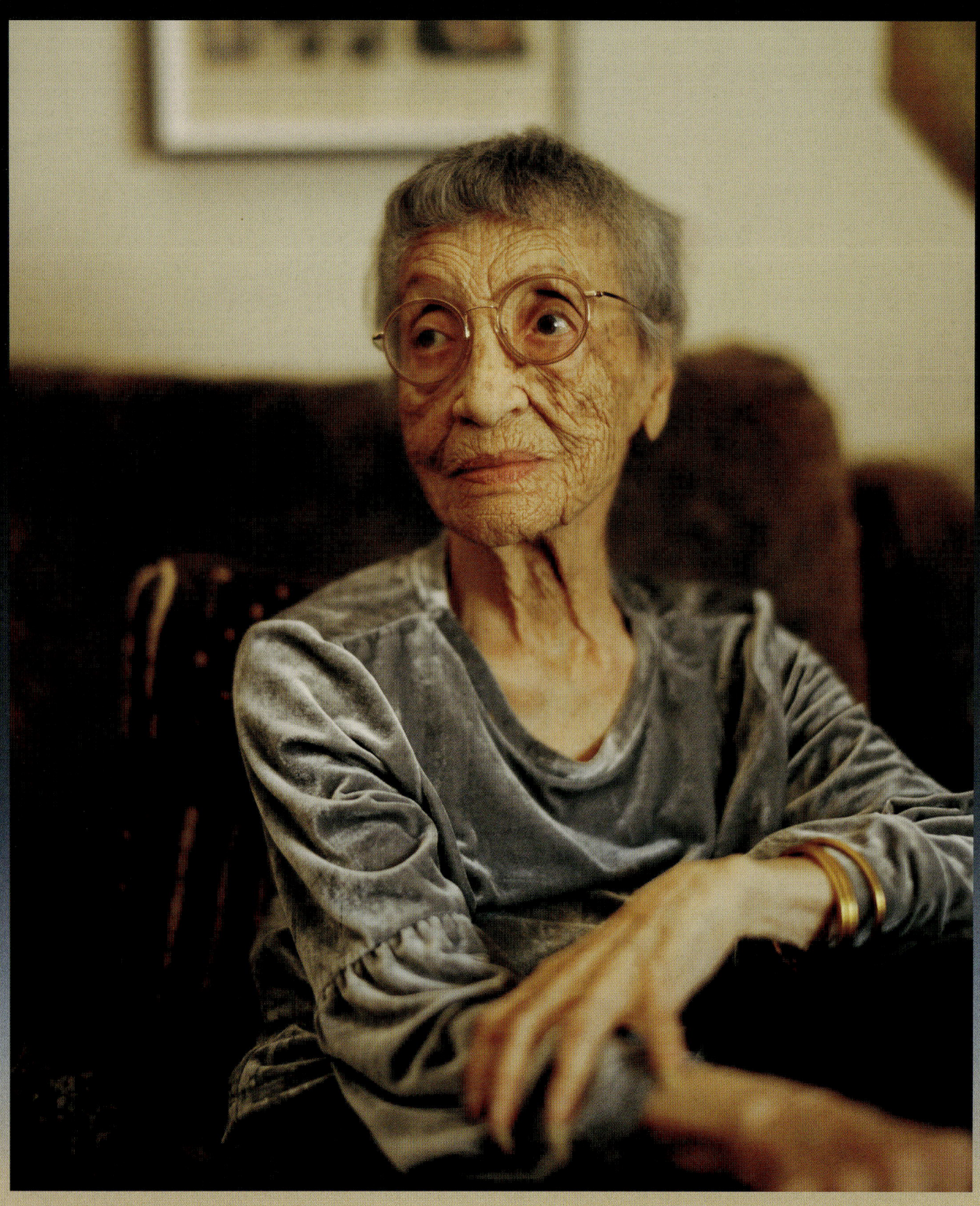

Words
Emma Silvers

Photos
Justin Chung

Activist, community leader and the oldest park ranger in US history.

She's been named California's Woman of the Year, honored at the White House, recognized by Congress, and covered in *The New York Times*, *TIME* magazine and *Vogue*. President Barack Obama called her work "profoundly inspiring." But for 103-year-old civil rights activist Betty Reid Soskin, past honors are just that—in the past. "I don't plan anything. I don't look into the past to make decisions about the future. Everything that happens to me is in the present moment—it's always about right now," says Reid Soskin over a video call from her home in the port city of Richmond, California.

Her casual demeanor belies an astonishing biography. She spent World War II as a clerk in the Boilermakers trade union; co-founded one of the first Black-owned music shops in California (Berkeley's Reid's Records) with her first husband, Mel Reid; fundraised for the Black Panthers; became a prominent community activist and songwriter after composing songs inspired by freedom fighters; raised four children; helped design Rosie the Riveter World War II Home Front National Historical Park at the site of the former Kaiser Shipyards in Richmond; and became a docent there at 85, sharing lesser-known stories of how racial segregation shaped the war effort. That made her the oldest park ranger in the US, a title she held until retiring in 2022 at the age of 100.

EMMA SILVERS: You were born in Detroit and lived in New Orleans as a child before your family moved to Oakland. You've been a Californian ever since. Did you ever consider living elsewhere as an adult?

BETTY REID SOSKIN: I don't think I ever anticipated being anywhere else. I didn't even travel out of the state until I was around 50. But ever since then, I've been traveling. And now, I don't know how I would have made it had I not discovered the world. I got to see how other people handled life. There's so much I didn't understand until I got to see Selma, for example, and walked on the bridge to Montgomery, or when I walked into Martin Luther King's church and stood beside his grave. And I got to return to New Orleans and stand beside the grave of the man who started my family, and realize that we had all come from this one person.

ES: You've said you didn't actually "find Betty" until later in your life, after your father and ex-husbands died?

BRS: Yes, that turned out to be a real surprise. All of those men who had shaped me—because they did shape me—all of them died within three months. And at the end of those three months of grief, I suddenly woke up and found that I was no longer Betty Charbonnet, or even Betty Reid, or Betty Soskin. There was just Betty left, and she didn't need them anymore. Everything that happened after that... I had my first real job at 50.

ES: You seem especially interested in the role names play in preserving history—you've spoken about how many women's stories are lost to time because they change their names when they marry.

BRS: That was something I discovered when I was in my 80s, when I was working on my genealogy, and I found that it was impossible to follow the women. That was when I started trying to write my story, because I wanted it to not be lost.

ES: In your memoir, *Sign My Name to Freedom*, you reflect on being the only person of color at the planning table when the government was establishing Rosie the Riveter Park, dedicated to women's contributions to the war effort during World War II—and that when it comes to national monuments, "What gets remembered is a function of who's doing the remembering." Tell me about becoming a park ranger at 85.

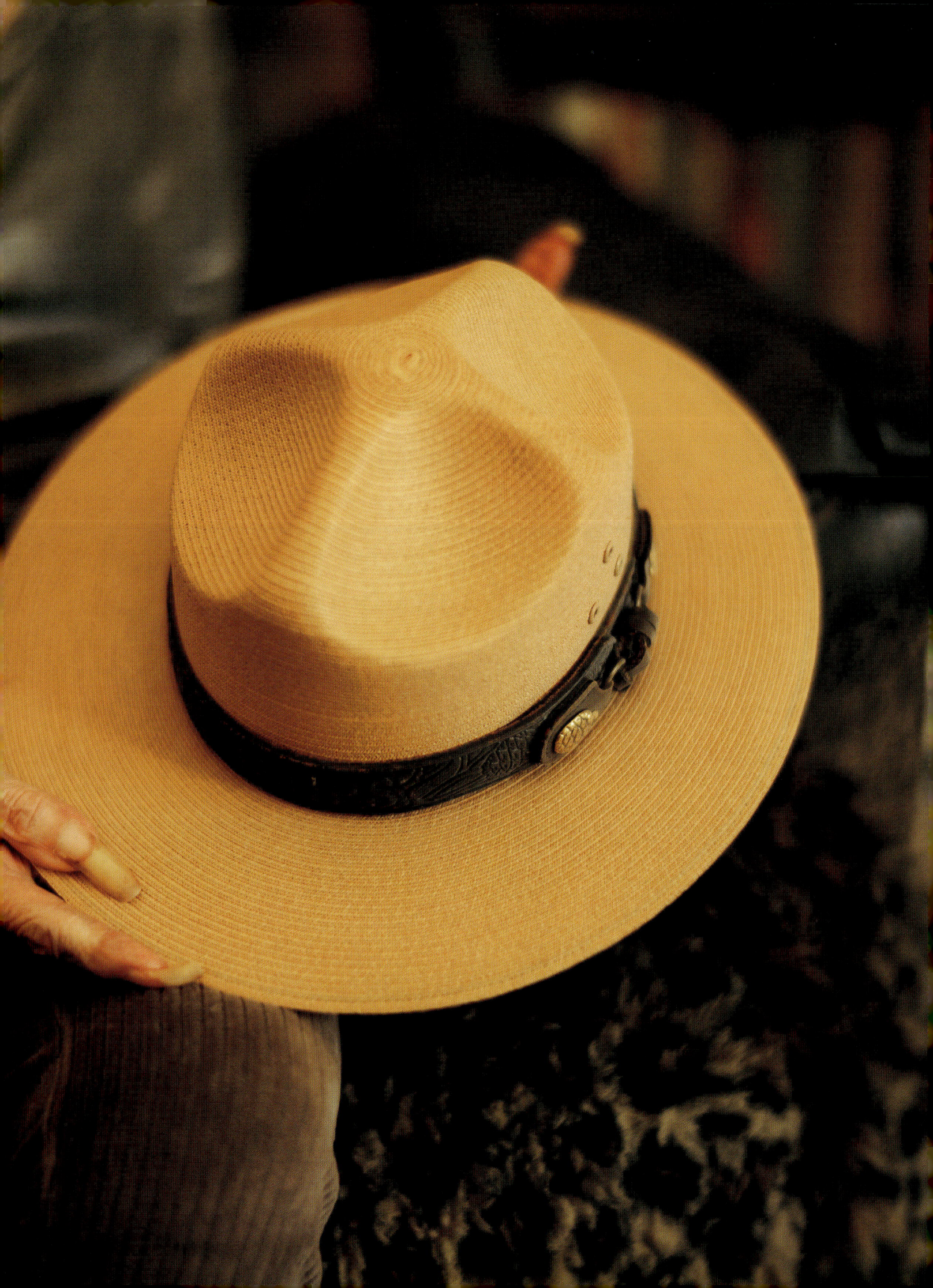

BRS: It was an accident. I never really sought out a job; I've always had jobs handed to me. I was in full retirement and wasn't planning on anything, least of all being a park ranger. But I accepted a temporary position [with then-California State Assembly Member Dion Aroner], and her office was working on Rosie the Riveter Park. They were in the process of finding a real reason for establishing the park… of course, I didn't really consider myself a Rosie at all, because [Black] women were not allowed at that time to even work in the shipyards. I never saw a ship. I worked in the office of the Boilermakers [a segregated, all-Black "auxiliary" union whose members had fewer job opportunities and less voting power than the white equivalent], and that was only because a friend of mine had come out to head up that portion of the work. But now I was meeting with the planners who had come out from Washington, and they needed to know what to do with this park. I had no idea that I knew all that I knew, but I began to work with them, and now I have a park with my fingerprints all over it.

ES: Are you following what's happening with the Trump administration firing park rangers across the country, and defunding so many parks?

BRS: Yes. And [because of the National Park Service's hiring practices that prioritize veterans] I think it's a lot of veterans. The parks have been one of the few places where veterans could find a new life, new career. So there are many, many veterans who have now lost their jobs, and I don't know what they're going to do. I really feel sorry for them.

ES: Looking back, is there anything that makes you feel especially proud? You've done a lot in 103 years!

BRS: That's true. I think I've done my job, plus the jobs of some others (laughs). Meeting Obama is something I didn't think I would ever do, and that still surprises and amazes me. But really, just that my world is filled with people I love.

ES: Do you have a belief about the afterlife?

BRS: No, I don't. There are times when I wish there was such a thing, but I don't know. I think that we have one chance at it, and I've had mine. I've followed mine as far as it could take me.

ES: Do you think about what your legacy will be?

BRS: I have a middle school named after me [Betty Reid Soskin Middle School, in nearby El Sobrante, California], so there are children who are going to remember who I am even when I'm gone. Kids learning about me feels like a legacy.

ES: What advice do you have for younger people as we try to navigate these complicated times?

BRS: Always follow the questions. It's questions that lead to growth, so the questions are what's important—the answers are always temporary.

> "I don't think I ever anticipated being anywhere else. I didn't even travel out of the state until I was around 50."

(previous) Reid Soskin's classic National Park Service broad-brimmed "flat hat." The hat's archetypal shape, complete with a dome pinched into four quadrants — also known as the Montana Peak or the Montana Pinch—was inspired by dimpled hats worn by vaqueros in Mexico and the Buffalo Soldiers who protected Yosemite National Park.

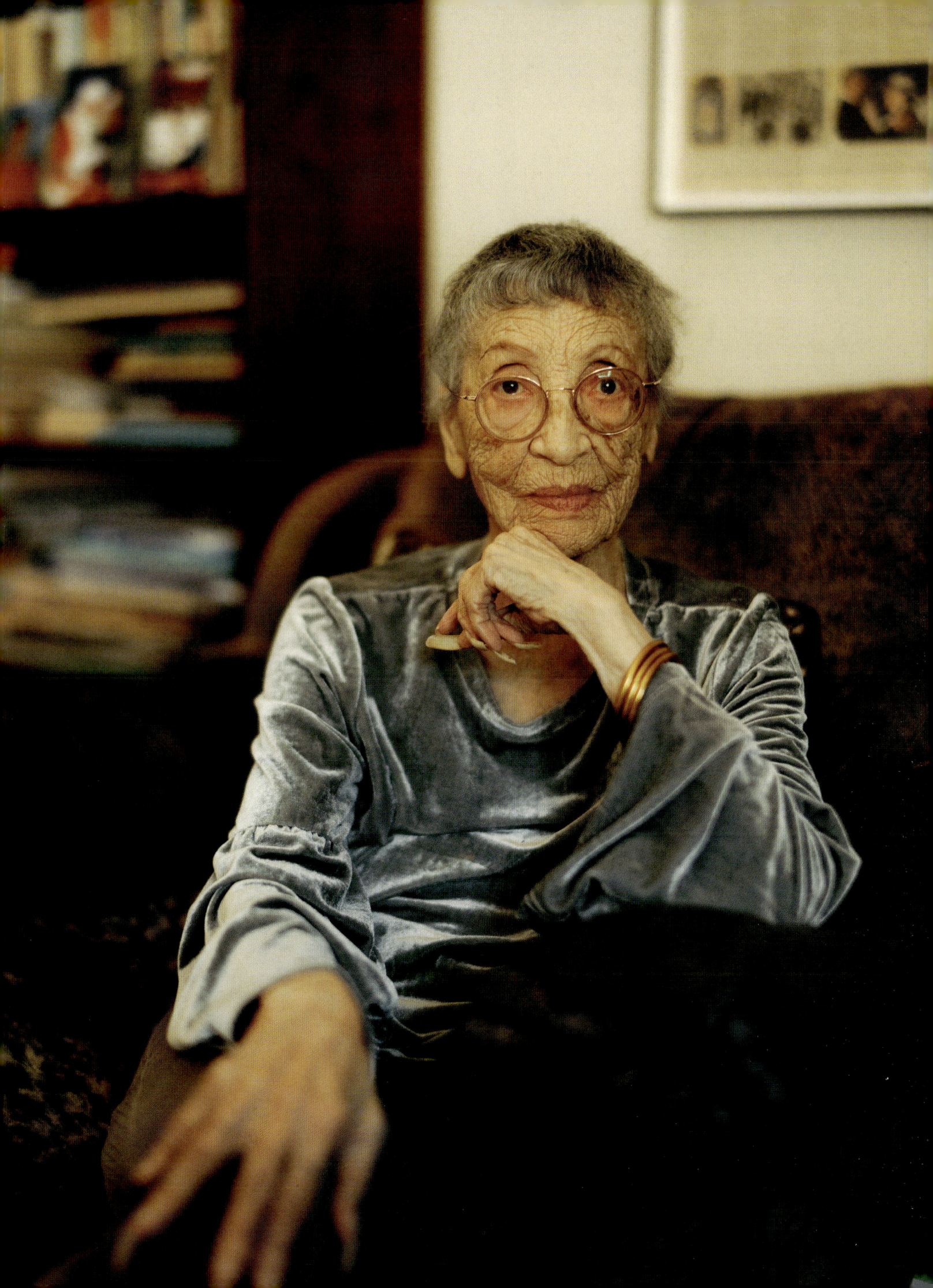

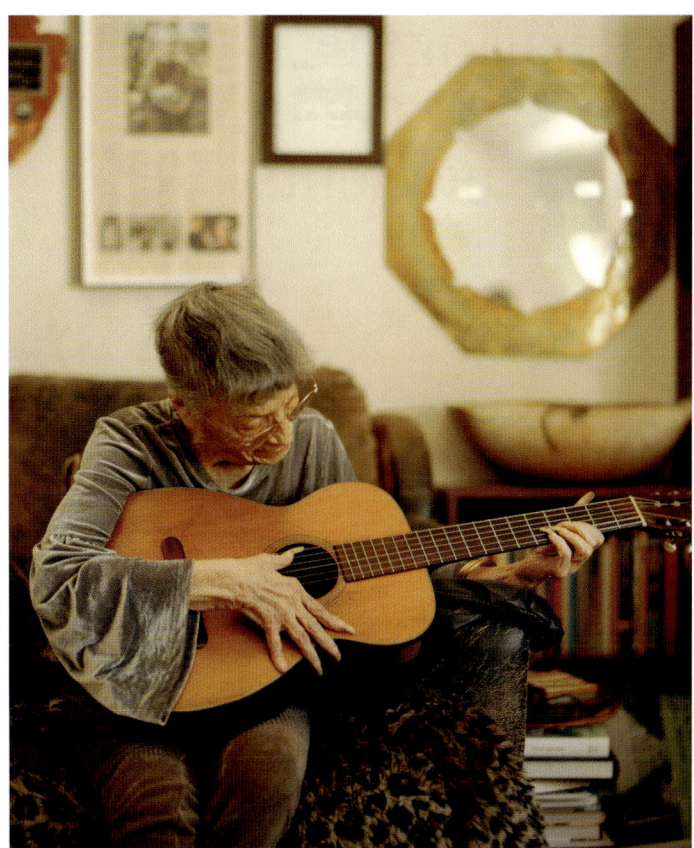

(above) Reid Soskin is a singer-songwriter whose music was lost to old reel-to-reel spools of tape, stashed in a plastic container in the back of a closet. Filmmaker Bryan Gibel discovered the tapes while making a documentary about Reid Soskin and eventually encouraged her to take the stage in Oakland, backed by a symphony orchestra and a 200-member choir.

Meet the hitmaker bringing artists together—not just to make music, but to share meals and moments.

Emile Haynie

Words
Benjamin Dane

Photos
Julien Sage

Emile Haynie has built a career on capturing lightning in a bottle. The songwriter and producer is the architect behind some of the most atmospheric and emotionally charged pop records of the last two decades from artists such as Lana Del Rey, Adele, Bruno Mars, SZA and FKA Twigs. His signature touch brings a sample-based hip-hop approach to pop music, crafting soundscapes that feel both cinematic and personal, and pulling raw emotion from the artists he collaborates with.

In an industry often defined by closed doors and exclusivity, 45-year-old Haynie is turning the tables. His studio in the Silver Lake neighborhood of Los Angeles has evolved into something more than just a workspace—it's a place to gather; a spot where songwriters, musicians and friends drift in and out, breaking bread as often as they break into song.

These aren't just social events; they're extensions of Haynie's creative ethos and a way of fostering connection in a city that can often feel isolating. As the music business grows ever more digital, with artists collaborating via WeTransfer rather than coming together in a studio, Haynie is cultivating something refreshingly analog: real-world community.

BENJAMIN DANE: Your studio has become known for its impromptu dinner parties. What inspired you to open up your space in this way?

EMILE HAYNIE: I used to have my studio at my house and I would always end up either cooking for artists on the spot or having chefs come over. There was this merging of music, hosting and cooking. About a year ago, when I found my current space, it was easy to create what I wanted: multiple recording studios, a proper kitchen and an outdoor dining space. I've always appreciated working in a social atmosphere, where you can step out of the studio and be around people enjoying themselves, and then slip back in. There's something magical about that dynamic and sometimes it can spark new ideas.

BD: Where does your desire for community stem from?

EH: I think part of it comes from moving to LA from New York. In New York, people are stacked on top of each other in tiny apartments, so the culture is all about going out. LA doesn't really have that. I wanted to create a space people could come to and enjoy themselves, while I could duck away and work without having FOMO because something fun is happening elsewhere. It's a bit selfish, I admit, but when you grow up in New York, you're constantly surrounded by people, whether you want to be or not. In LA, at least when you're not from here, you have to make a conscious effort to create that kind of environment, and that's what I'm trying to do with my studio.

BD: Do these gatherings lead to collaborations, or is it more about decompressing?

EH: Both. One of the things I miss about old-school studio culture in New York is how people would bump into each other in big studio complexes like The Hit Factory. The magic was in those unplanned moments—people crossing paths in the hallway, pulling each other in to listen to something, and next thing you know, they've made a song together. That culture kind of died in New York when the big studios shut down. It still exists a little in LA, and you really see it in Atlanta, where the music scene thrives on that kind of spontaneous collaboration.

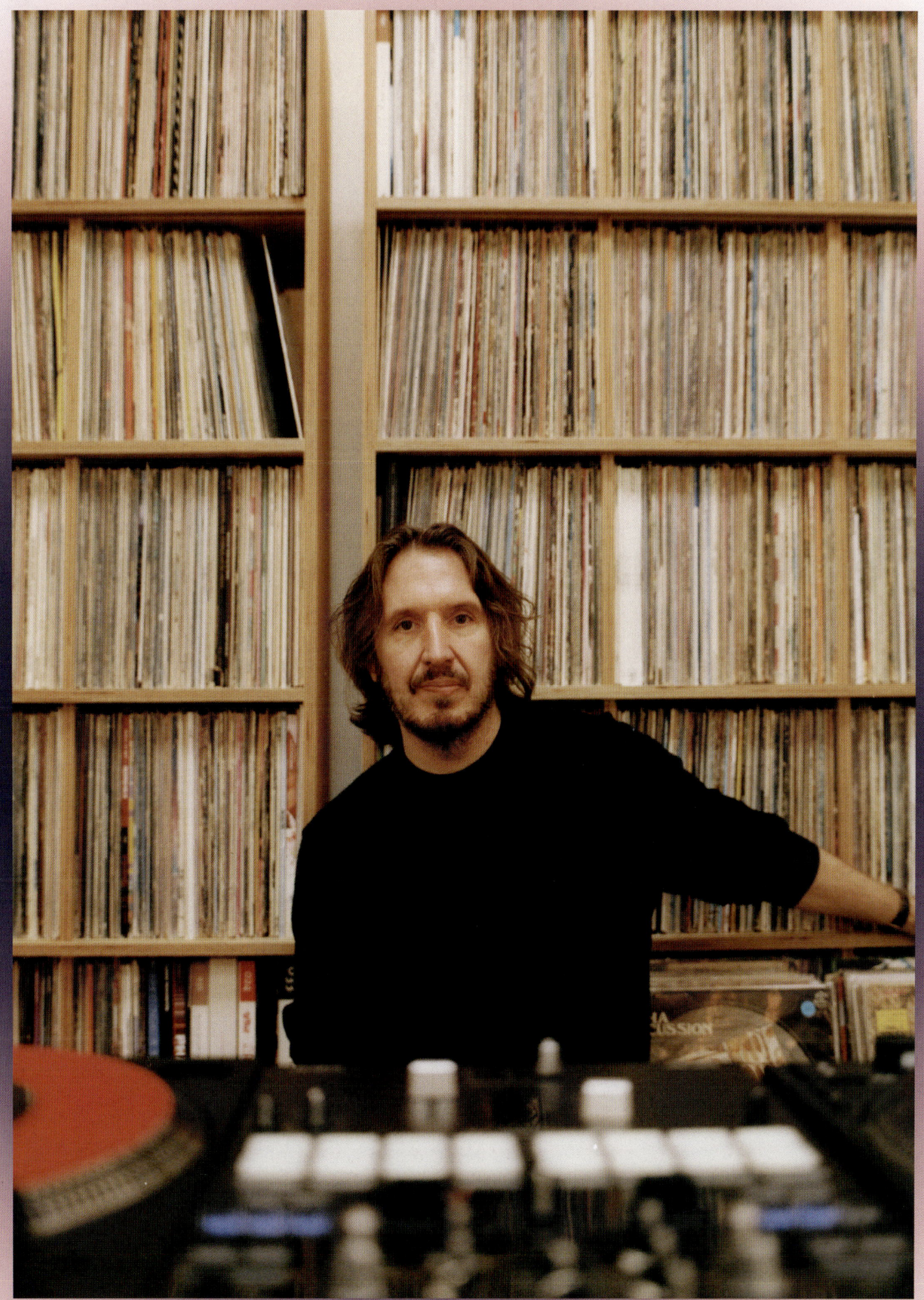

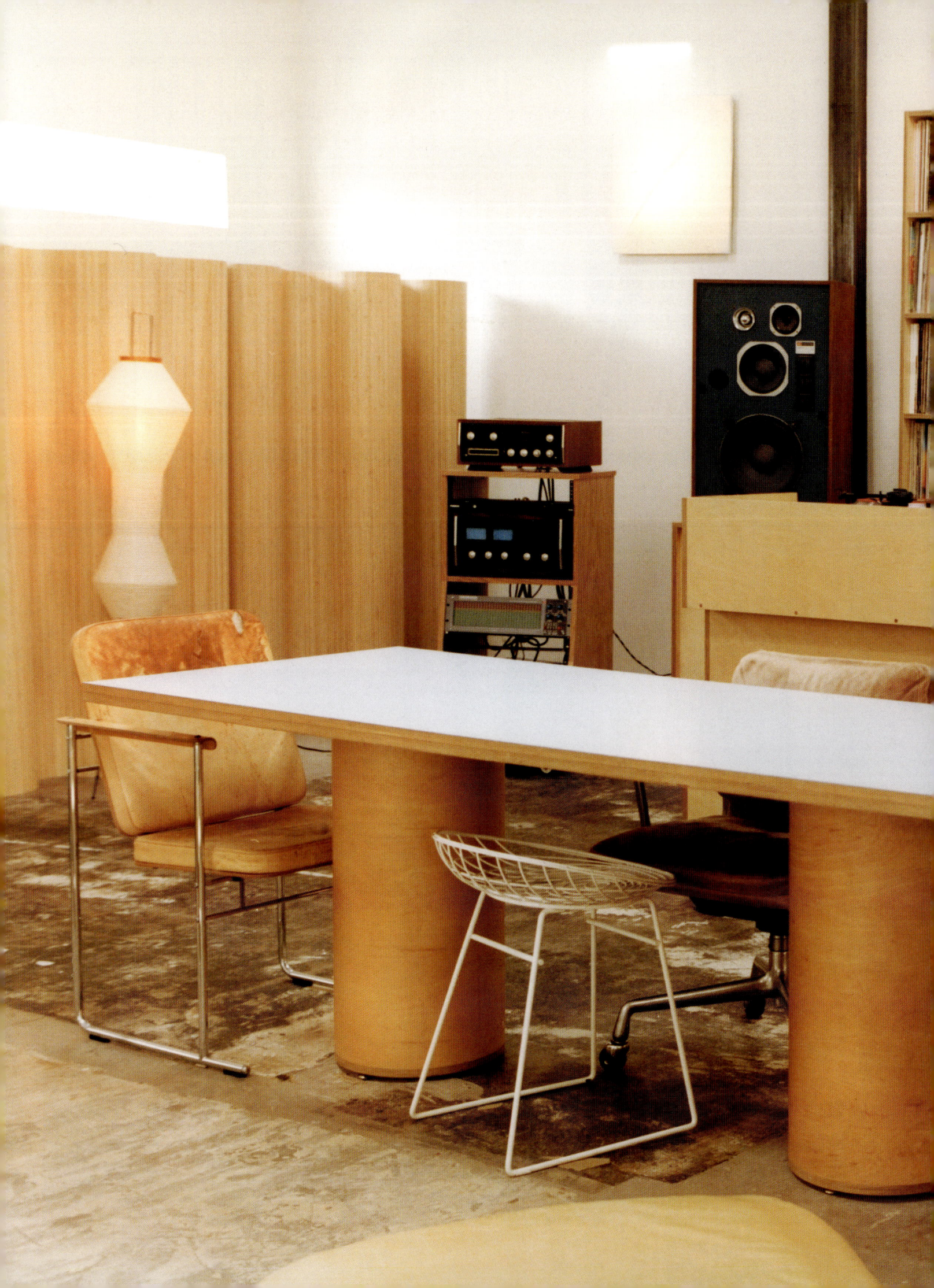

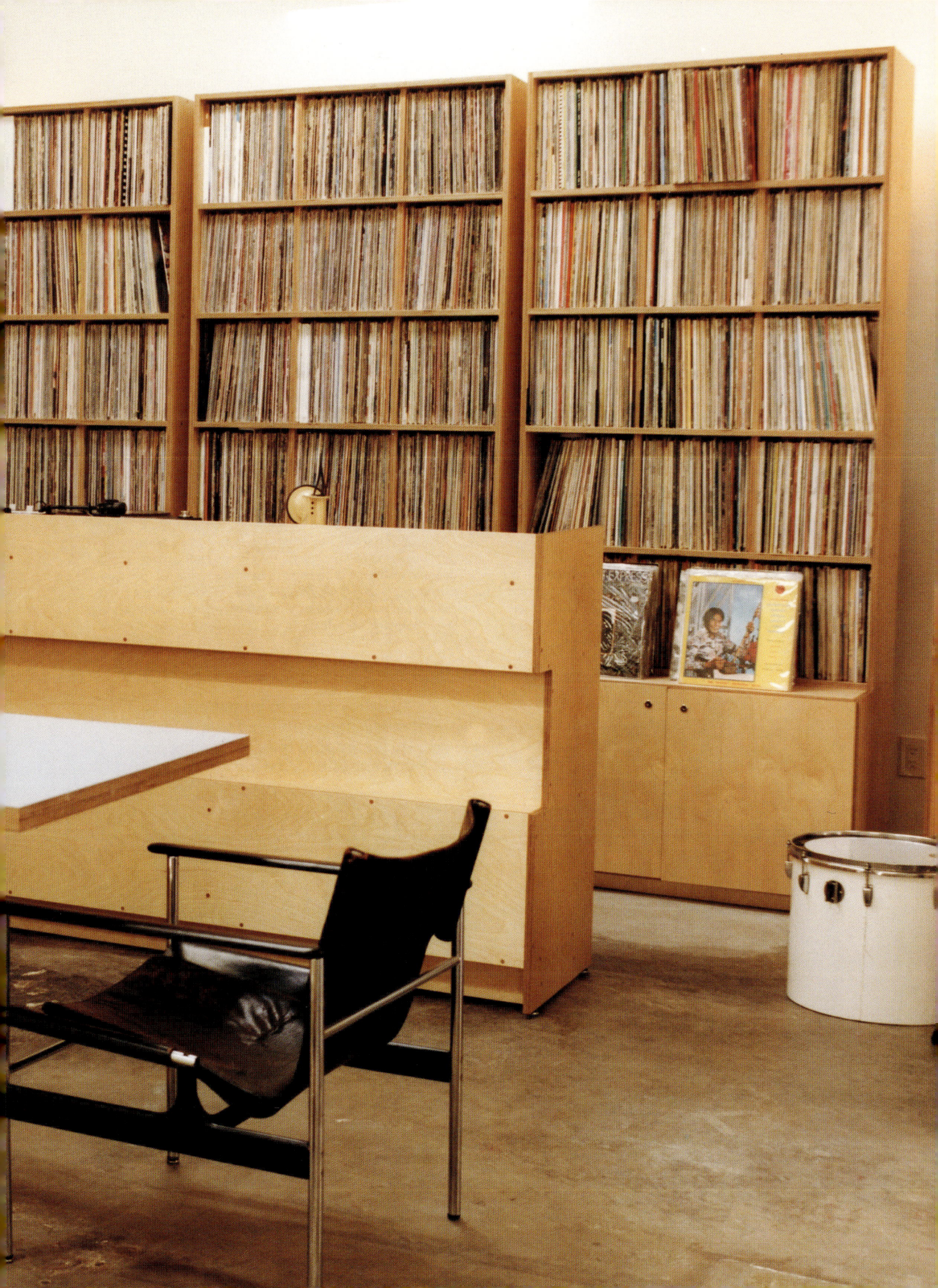

BD: What does it mean to you and your guests to have these moments in such a rarified industry?

EH: Artists tend to love it. There's something about knowing that good musicians or people with great taste are on the other side of the door—it kind of pushes you to step up your game. I've seen artists in the studio work a little harder because they know there are interesting people nearby who might hear what they're doing. It creates a different energy, a good kind of pressure. It's also just a fun way to break up the intensity of the creative process. Music can be so consuming and sometimes you need that release—just stepping outside, having a conversation, sharing a meal.

BD: What do you think makes LA unique as a music hub?

EH: I can't go to the grocery store without bumping into somebody whose work I genuinely like and talk about getting together. The studio culture is thriving, and there's always new songwriters, producers and artists coming in from all over the world—even the biggest K-pop records are made here. Perhaps it's always been the case to some extent, but LA has really become the capital of recording music, at least in the US, if not in the world. What New York is to restaurants, LA is to music.

BD: Does food play a role in your creative process in the same way that music does?

EH: It's more like a welcome break. The thing about cooking a big meal for everyone in the studio is that it gives you a sense of accomplishment. Making songs is ambiguous—it's never really done until it's released. But cooking? You make it, people eat, you clean up, it's done. If we did absolutely no good music that night, at least we had a good meal and a good time.

BD: What does a perfect day in the studio look like?

EH: I'm a clean freak and I love to organize, so I usually get in early to do that. I'm organizing files and records, making sure the equipment is properly connected, etc. It's like mise en place. If my kitchen is trashed when I'm cooking, the food is going to be kind of shitty, but if it's immaculate before and after, the food will be way better. It applies to my music as well, because things can get really messy once an artist gets in and we're doing 27 different takes with different ideas and sounds flying all over the place. We write, record and work through the day, and at some point, I'll step outside, talk to people, maybe grill something, then head back in. Then the ideal situation is to be finishing a song I really like, but if that doesn't happen, just reorganizing the drum folders on my computer can give me a sense of achievement.

BD: Is there a common thread between the artists you connect with most?

EH: The artists I work best with tend to be strong writers and a lot of them have a hip-hop approach to writing, even if they aren't rappers. Lana Del Rey works like that: She's got the beat in her headphones, and she's just putting pen to paper, the way a rapper would.

BD: Do you think there's such a thing as a "formula" for a hit song, or is it all just about instinct and timing?

EH: Recently, I was in the studio with this huge pop producer named Ryan Tedder, and he has this thing he calls "pop math." It's not a strict formula, but a framework that tends to work: Certain chord progressions, the length of a verse to a pre-chorus to a chorus, things that have been studied and refined for decades, not just by modern pop artists but also, like, The Beatles. But then, sometimes, something completely weird comes out of left field and becomes gigantic. I can learn so much from a guy like Ryan and his approach to songwriting, but I'm a little bit different. The artists I've worked best with weren't pop, but somehow the music they made ended up becoming pop and changing the zeitgeist. In cooking, it's like precision fine dining—you know, tweezer food—versus French country chalkboard make-whatever-you-feel-like-making and it fucking slaps. Both are awesome, and who's to say what's better?

"Music can be so consuming and sometimes you need that release—just stepping outside, having a conversation, sharing a meal."

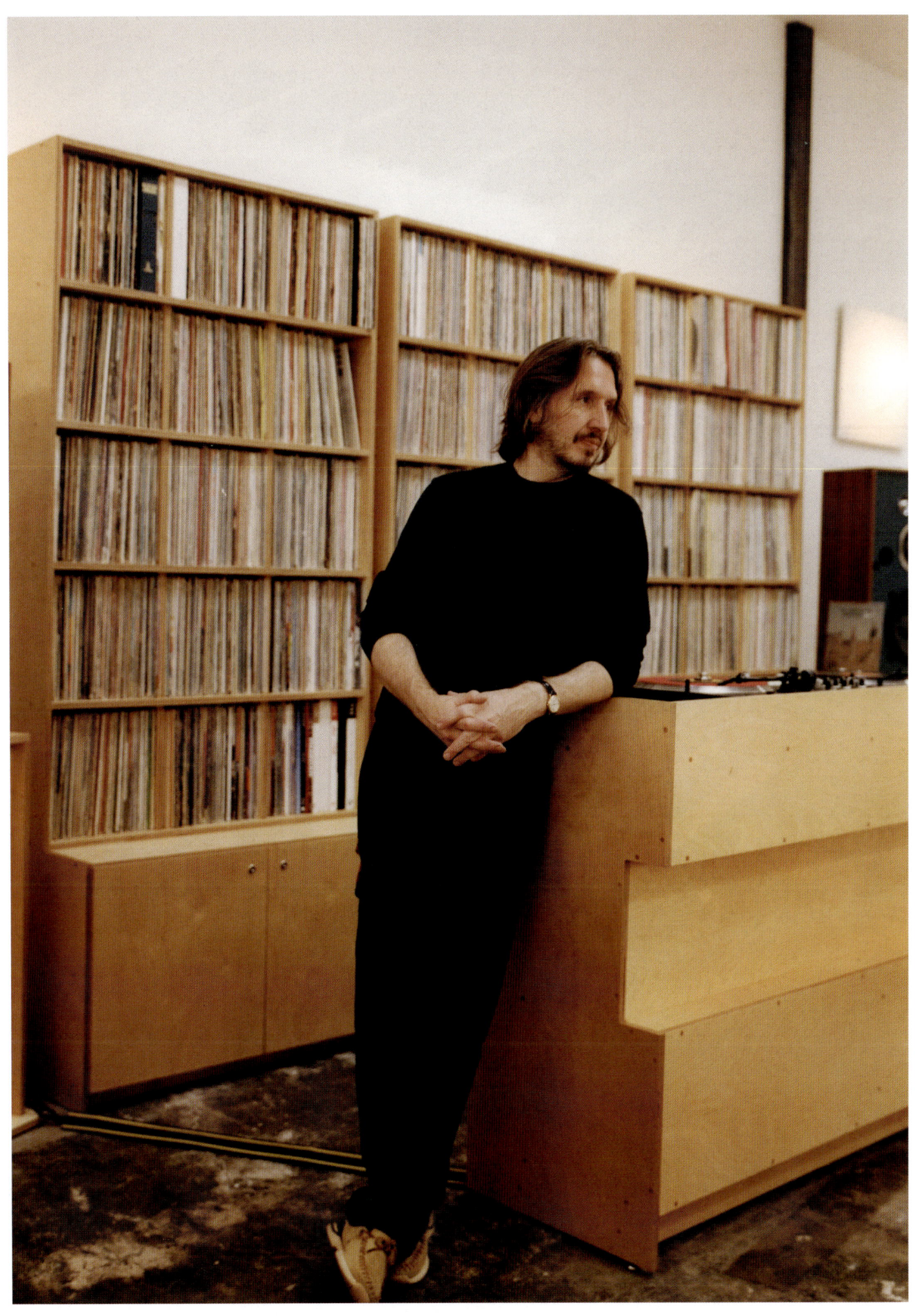

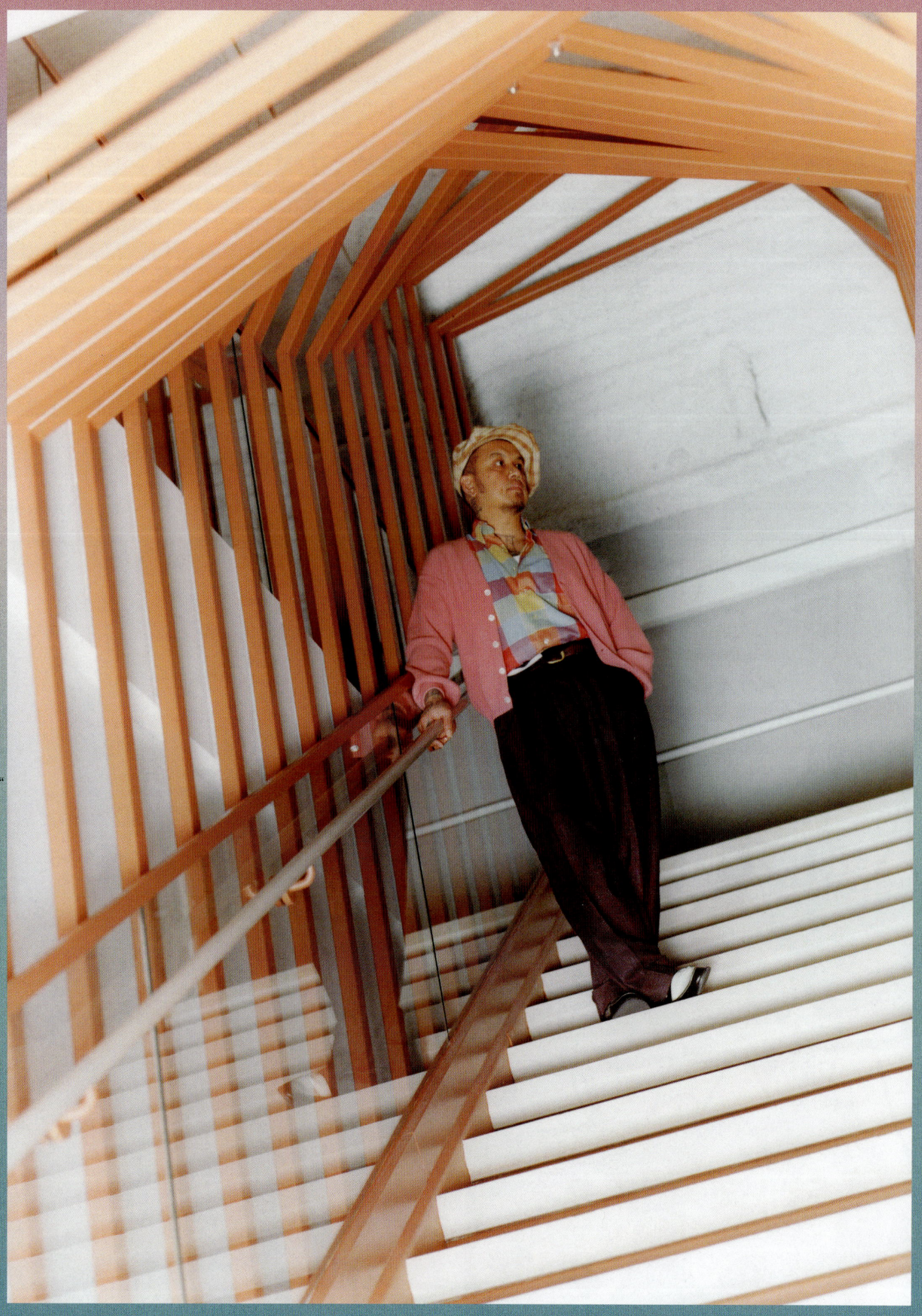

Meet the designers
merging code with creativity to build
a more human AI.

The Artisans of AI

Words
Celine Nguyen

Photos
Julien Sage

"I've always been into vintage things," the creative director Everett Katigbak explains. "Anything that's a form of old technology, in the broad sense. Letterpress and screenprinting: Those, at one point, were very modern production methods that now have a more human, tactile quality. I'm very interested in how these things emerge."

An exhibition Katigbak designed while working at the J. Paul Getty Museum in Los Angeles early on in his career featured the enormous bellows camera used by photographer Carleton Watkins during the mid-19th century. He's passionate about analog forms of creativity and shoots at least one roll of 35mm every week—an intriguing mindset, considering Katigbak's day job: the first designer and creative director of Anthropic, the high-profile San Francisco artificial intelligence start-up co-founded by siblings Daniela and Dario Amodei.

Anthropic is best known for Claude, an AI assistant first released in spring 2023 as a thoughtful companion that can help users navigate the burgeoning intersection of human creativity and technology. The overall goal for the company is that Claude is less of a tool and more a collaborative canvas: It currently features three language models—Haiku, Sonnet and Opus—that are designed to help with research, writing and creative tasks, and Anthropic's researchers have taken a conscientious approach to training the large language model behind Claude so that it's as "helpful, honest, and harmless" as possible.

While Claude wasn't the first chatbot on the market, it has steadily gained an insider following among technologists, especially those torn between techno-optimism and fear of AI's potential for harm. Anthropic hopes Claude will inhabit a more nuanced terrain between these two binaries, offering a responsive environment that acknowledges the intricacies of human thought and invites creativity. Instead of treating AI as an impenetrable "black box," for example, Anthropic has tried to develop a more rounded character for Claude—in the same way a mentor might guide their protégé—so that the chatbot comes across as collaborative but not sycophantic; respectful but not impersonal or overshadowing the unique voice of the user. "We want Claude to be empathetic and genuinely helpful, without being overly prescriptive," Katigbak explains. A chatbot, he thinks, should "be a better listener than talker."

Listening may be exactly what's needed right now, given the anxieties people have about artificial intelligence. An unusually capable chatbot can trigger fears of automation, and the social and economic disruption that might follow. But encountering an incompetent AI—one that's far from capable of taking your job—isn't much better. Many creatives have expressed concerns that generative AI will devalue their work and contribute to cultural blandness or even stagnation.

It's a problem that Kim Bost, a design leader at Anthropic, thinks about a lot. "We're in a really tender moment right now [with AI]," she says. Like Katigbak, Bost's career began in a traditional way: an internship at the renowned design firm Pentagram, then a stint at *The New York Times* as an art director. But she found herself drawn to software design, and it's clear that—despite her scrupulous awareness of people's anxieties—she believes that technology can be a positive force. "People are trying to understand these tools," she says, explaining that creatives are increasingly curious about "where they're valuable in their practice." They're also, she adds, "trying to find tools they can trust."

While many artists and creatives have so far steered clear of AI—out of unfamiliarity, cautiousness or hostility—others have

"How can software, especially software meant to facilitate creative expression, feel personable and handmade?"

KINFOLK X ANTHROPIC

embraced it as another artistic tool. The Canadian writer Sheila Heti (interviewed on page 164) trained a chatbot to be the narrator of her short story "According to Alice," published in *The New Yorker*. The experimental musical artists and composers Holly Herndon and Mat Dryhurst trained a machine learning model on Herndon's voice that anyone can use online. (The model, Holly+, is a "vocal deepfake" that reflects Herndon's interest in more iterative, collaborative music—and an ingenious way to subvert the fear of artistic theft and copying.) And the multidisciplinary designer Ezra Miller, who's worked with fashion brands such as Balenciaga and musicians such as Caroline Polachek, uses AI to deform photographs of architecture, landscapes and interiors. In all these works, the artist's hand is still present—it's just augmented by AI.

"We talk a lot about the idea of the mark of the maker," says Kyle Turman, who joined the design staff at Anthropic a few months after Katigbak. The two collaborated on Claude's early interface and brand identity (soft beige tones, hand-drawn illustrations, serif typeface) with an ambitious goal in mind: How can software, especially software meant to facilitate creative expression, feel personable and handmade? Claude's visual identity, Katigbak says, "leans into the imperfections of human, handmade things… There's a warmth and tactility that we try to bring into the interface." One of the most distinctive features of the interface is the "spark," a hand-illustrated asterisk that stays still when Claude is listening, and flutters gently while it responds, like a 21st-century Clippy—albeit more abstract than anthropomorphic. The goal is to make people feel as if "the software acknowledges you as a person and reacts to you," says Turman. That feeling, they hope, will "give a bit of trust back to the user."

A sense of trust and safety can open the door to what Bost describes as "expansive moments." She hopes that artists, writers, designers and other makers can use Claude throughout their creative processes, and in ways that complement their natural interests. Turman, whose personal creative pursuits include music-making, drawing and occasionally painting, describes how they use Claude to help them research and assemble reference points. "What can be really fun and interesting, especially as an art history nerd," says Turman, "is to ask: There's a vibe I'm trying to convey and experience. Here's what I'm thinking about. Which other artists have thought about this before?"

It often seems as if Claude's designers are trying to recreate the best parts of their design education and figure out how to deepen those experiences with AI. "I grew up in this design era where we lived and breathed and died critiques," says Katigbak. As a young art school student in Pasadena, that meant pinning up work on the studio walls for his peers to respond to. Chatbots like Claude, he suggests, can act as thoughtful interlocutors and critique partners in a similar, meaningful way. "When I'm refining an idea," he says, "I never outsource the idea to AI." But Claude does help him "vocalize an intention or thought…and bounce things back at me without judgment." In the early years of his career, he says, "There wasn't a way for designers to [prototype] at a rapid cadence and sharpen their skills in such a compressed amount of time." He envies the resources available to younger designers today: "They have access to stuff that we never had in our formative stages. In many ways, they're way further ahead."

Bost's face lights up when she starts thinking about AI's potential in art and design education. She's enthusiastic about the work of educators like Kelin Carolyn Zhang, who teaches an AI design studio at the Rhode Island School of Design. Zhang's own practice combines a deep affection for the arts with an interest in technology: Her cheerfully retro Poetry Camera project, designed in collaboration with Ryan Mather, is an instant camera that writes AI-generated poems about what it sees, instead of producing photos. Zhang's classes help students tackle sophisticated coding projects—with Claude's help. For the students, being able to make something real—and not be hindered by their nascent technical skills—is transformative. Turman concurs: "It's helped people take an idea and make it into a reality… I'm seeing more ideas come to fruition a lot faster."

(opposite)
From left to right: Kyle Turman, Kim Bost and Everett Katigbak, part of the design team at Anthropic.

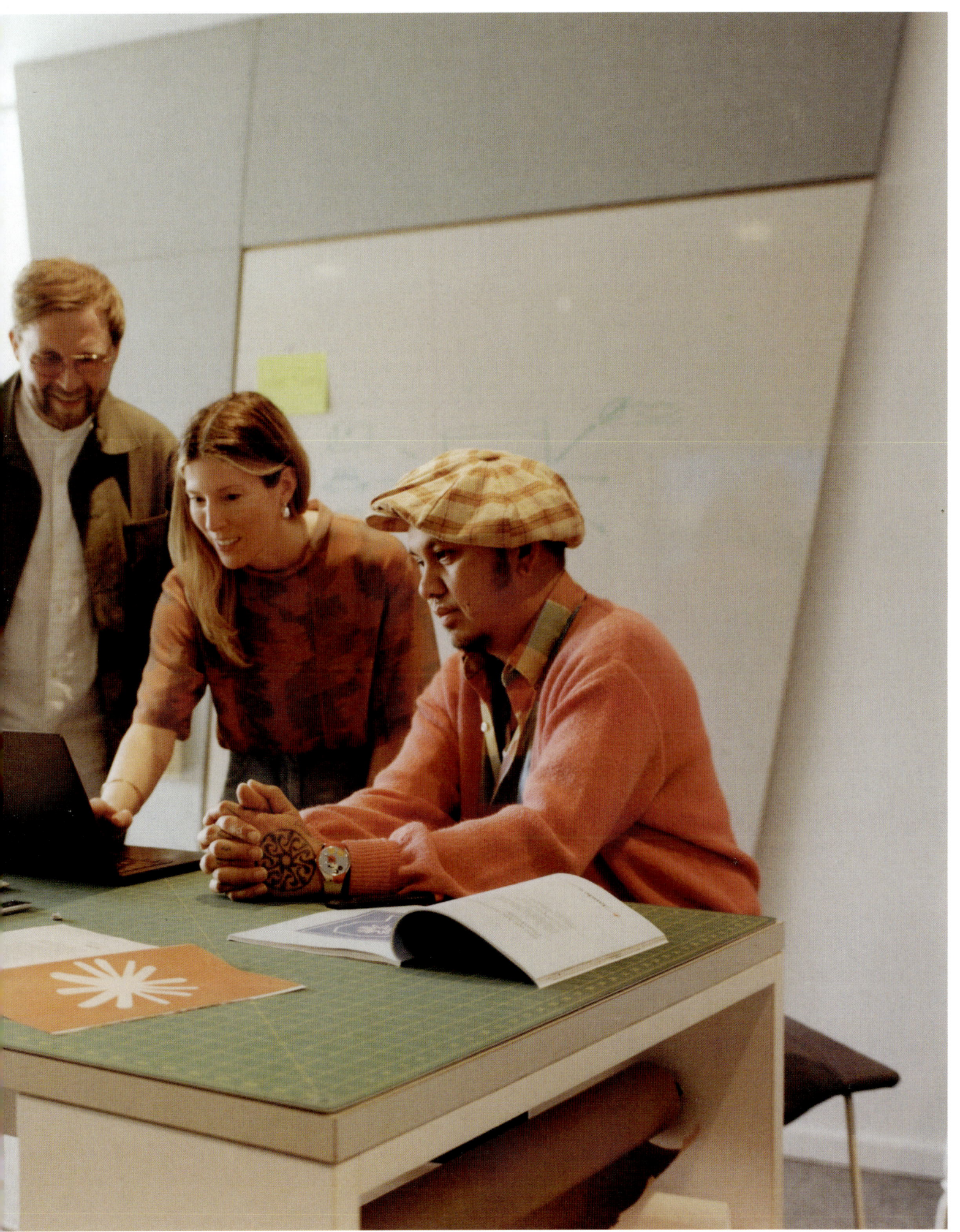

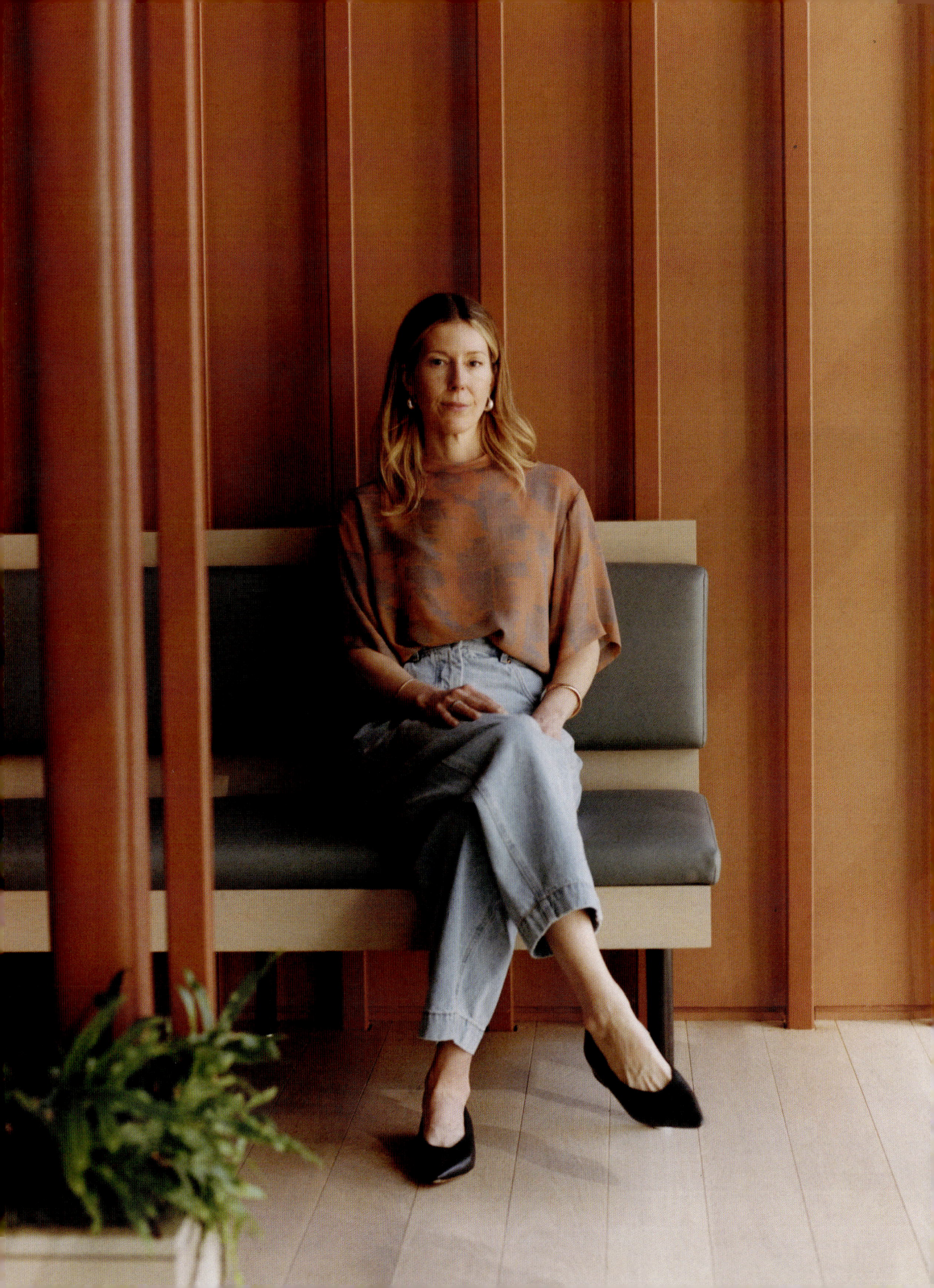

> "It's going to be *more* important that your own perspective is added."

Speed, however, isn't the only thing that Anthropic's designers are interested in. "Every paradigm shift in technology," Katigbak muses, "has promised more efficiency and more productivity." But the more interesting project, he says, is whether technology can help people with "that last little bit" of the human experience: self-actualization.

"On one hand," he says, "I'm this anachronist: I drive '60s cars, I type with typewriters. But I'm also a futurist, and I think about how technology continues to evolve while human creativity stays the same." For Katigbak and his colleagues, there's no fundamental conflict between revering the past and pushing technology forward. If anything, AI might heighten our appreciation for certain intangible qualities: discernment, intuition, subjectivity, intention. When it comes to physical crafts, he suggests, the ease of digital fabrication may "add more value and meaning" to, say, a handmade ceramic.

Anthropic's hope, of course, is that creatives will find value and meaning in working with AI, too. "I believe that people, particularly designers and artists, choose products because they see them as a reflection or an extension of themselves," Bost says. Artists and writers develop attachments to specific pens, pencils and brushes. Creatives working today might develop similar attachments to AI assistants like Claude.

"If we think about the potential harms," Turman adds, it's possible that "someone could automate a bunch of content and art," therefore devaluing creative and artistic labor. But the more likely future, they think, is that: "It's going to be *more* important that your own perspective is added." Making creative technologies such as Claude more accessible to creative people, according to Turman, will ultimately emphasize "how your own taste and personality come through in the things you make." The goal isn't to automate away someone's point of view; it's to help them express it in new ways.

This article was produced in partnership with Anthropic.

(opposite)
Kim Bost, design leader at Anthropic, at the company's headquarters in San Francisco.

KINFOLK X ANTHROPIC

Blunk House

CALIFORNIA

A visit to an artist's home hewn from the wild landscape of Northern California.

Words
Shonquis Moreno

Photos
Julien Sage

Blunk House is tucked into a thickly wooded ridge above the coastal hamlet of Inverness, 50 miles north of San Francisco. Its wooden shingle roof sits at a jaunty tilt and its redwood clapboard, washed with sun and fog, has turned pewter. The timber-framed house, art studio and all the contents therein—every door, dish and daybed—was handmade between 1959 and 1962 by American artist JB Blunk and his first wife, Nancy Waite Harlow.

California was built on the violent clear-cutting of old-growth forest, but Blunk and his wife used materials reclaimed from demolished chicken coops and barns, disused piers and a defunct train station. Grafting together rural Japanese and back-to-the-land Northern California architecture, they salvaged windows from scrapyards, stone from a nearby ridge and driftwood from nearby beaches. The wood for the kitchen table and two columns—still recognizable as knotted bishop pine trunks—fell on the property.

Blunk and Waite Harlow separated in 1965 and the house, which had been "completed," became a work in progress again, made by Blunk's hand inside and out, over and over, from wood, clay and stone. He considered everything—the house and studio, the orchard, the kitchen garden and the chickens—to be "one big sculpture," by which he meant something less precious and more profound than what the phrase usually suggests. The house is Blunk's masterpiece, and a total work of art, though more because of the way it was built and used than because of the structures and objects themselves.

> "My father didn't fetishize his work. In a way, he didn't see it as special."

"My father didn't fetishize his work," says Mariah Nielson, Blunk's daughter with his second wife, Christine Nielson. She grew up in the house and worked as an architect before becoming director of the JB Blunk Estate following her father's death in 2002. "In a way, he didn't see it as special. He had so much in him that he needed to get out through his artwork. It was just what he had to do," she says.

Today, visitors to the house pass piles of offcuts, a brick kiln built by Blunk but used only twice, and the now lichen-embellished redwood portal, *Entry Arch* (1976). The front door—heavy, rustic and distinctly Japanese-inspired—slides open to reveal an open-plan living room and kitchen flanked by silvering wooden decks on each side. A large alcove holds one of Blunk's hand-carved *Penis* stools and a long paper lantern by Isamu Noguchi. In the bathroom, a massive sink has been carved from a single piece of cypress and a skylit, windowed shower feels more outdoors than in.

A ladder leads playfully up to the bedrooms and office where Nielson and her husband, designer Max Frommeld, have created some furniture pieces themselves. Originally a storage space, it was built out in 1985 to add a mattress on the plywood floor and a desk for Blunk. Nielson explains that a door here opens onto an arched bridge that the artist built as a shortcut to his studio, "so that when he was firing the electric kiln, he could check it at two or three in the morning without having to go down the ladder."

(opposite)
Nielson recently returned to live at the house and runs Blunk Space, a gallery in nearby Point Reyes Station that exhibits art and design influenced by Blunk's practice.

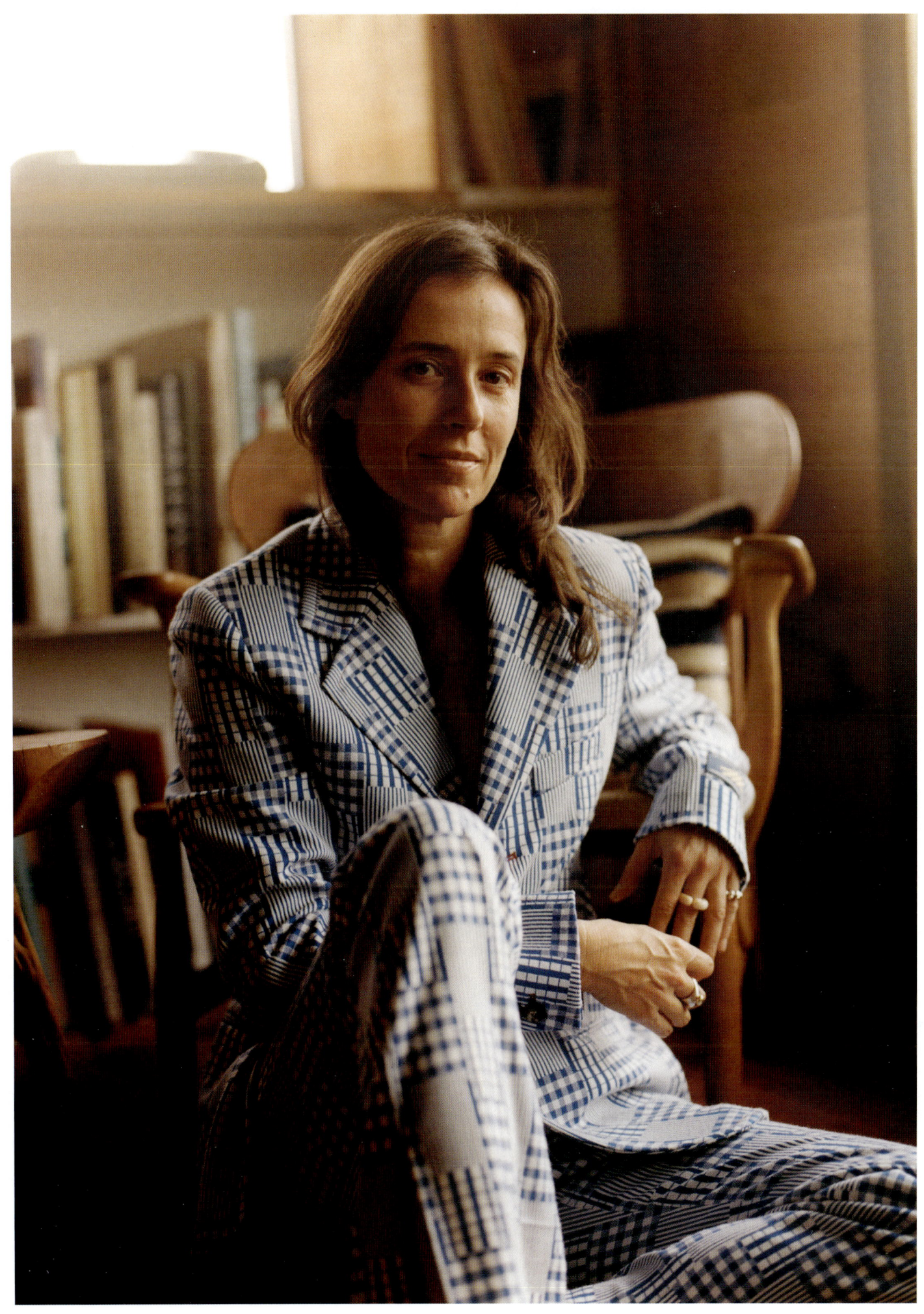

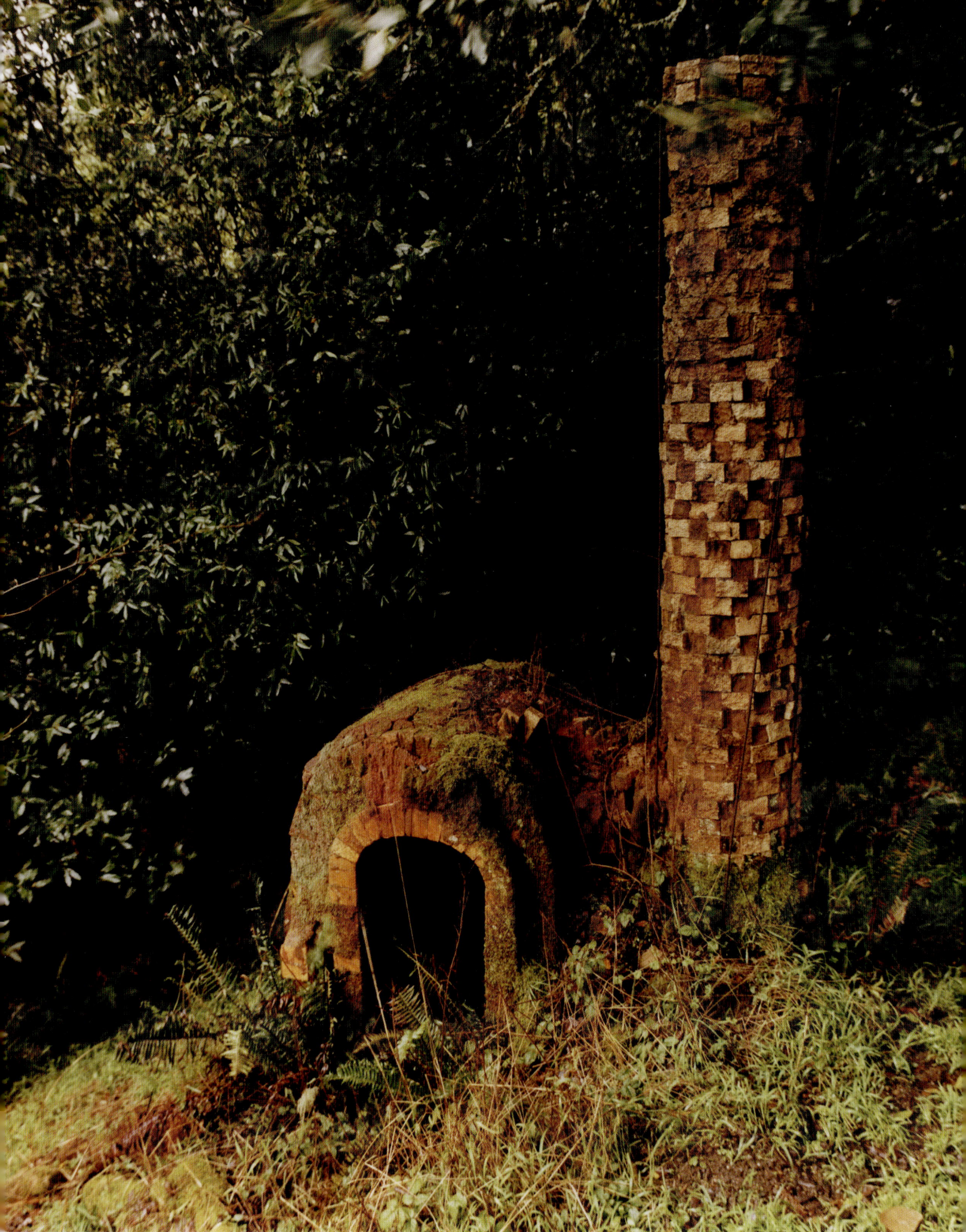

The house embodies self-sufficiency, ingenuity, imagination—*Walden* without the pond or the pontificating. The dimensions of the salvaged timbers determined the dimensions of the buildings; the views suggested their form. Looking toward the ridgeline or across Tomales Bay to the Point Reyes National Seashore through those junkyard windows still makes the hills look like Japanese ink paintings. In the house's handworked surfaces, in its artisanal textures and biomorphic furniture, both the human hand and nature can be felt. The materials create a warm, sheltering domesticity, a Northern California hygge. Its spaces feel layered *and* coherent, a single fabric woven from different media, as lived-in as a favorite pair of jeans. And it stands as a testament to Blunk's ability to move between intimate and massive scales: from a ceramic sake cup to monumental public sculptures.

Blunk anticipated a shift that has defined the area of West Marin since the 1960s, when it began to attract settlers who turned away from the mainstream to live closer to nature, in tighter communities, leaving a smaller footprint on the earth. They engaged in casual acts of ad hoc creativity, by necessity, every day; making a chair became a "banal" labor of love, both seat and self-expression. Fifty miles up the coast and three years after Blunk had "completed" his house, a similar ethos of self-reliance, creativity and reverence for nature was echoed in the construction of Sea Ranch—a community of timber-framed homes with eaveless shed roofs that were designed by more prominent architects to rest lightly on the land, blending into the wind-bent cypress trees and golden grasses at the edge of granite cliffs.

Whether he was painting, weaving or making ceramics, furniture, jewelry or sculpture (which he often did with the use of a chainsaw) Blunk always approached his work in the same way, a method that stemmed from three formative years in Japan. He had been drafted into the army during the Korean War in his mid-20s and when he was discharged in Tokyo, he stayed in the country, apprenticing with two master potters, Kitaoji Rosanjin and Kaneshige Toyo. Blunk learned to dig and mix clay and make pottery in the local style. He experienced the *mingei*, or folk art, movement, embracing

> "This was like a gallery space. He would rotate his own art with art that he traded with friends."

a balance of serendipity and discipline, spontaneity and rootedness, simplicity and sincerity that he would take home with him to California. He also rejected arbitrary Western distinctions between art, design and craft. "So," Nielsen says, "the way a potter makes a pot is the same way a painter makes a painting."

Kaneshige's house in Imbe, Japan, can be seen as a model for Blunk's: the scale and ceiling height, rustic textures, heavy sliding doors and shoji-like windows. In Blunk's living room, one corner is clad in offcuts from his colossal redwood sculpture, *The Planet* (1968), and incorporates a *tokonoma*, a niche for displaying a beloved object or ikebana, a flower arrangement. In the kitchen, there is another tokonoma with shelves, the bottom one propped up by an oak branch.

"For my father, this was like a gallery space. He would rotate his own art with art that he traded with friends," Nielson says. "It was always changing and really dynamic." In many ways, this is true of the house too, even down to Nielson's childhood dollhouse, for which Blunk carved miniature sculptural chairs, stools and tables. "My father would bring new pieces into the house that he had just finished to look at them and to live with them. He'd stage them in different areas and then, after a month or two, they'd be gone. It was always an evolving space. It was alive."

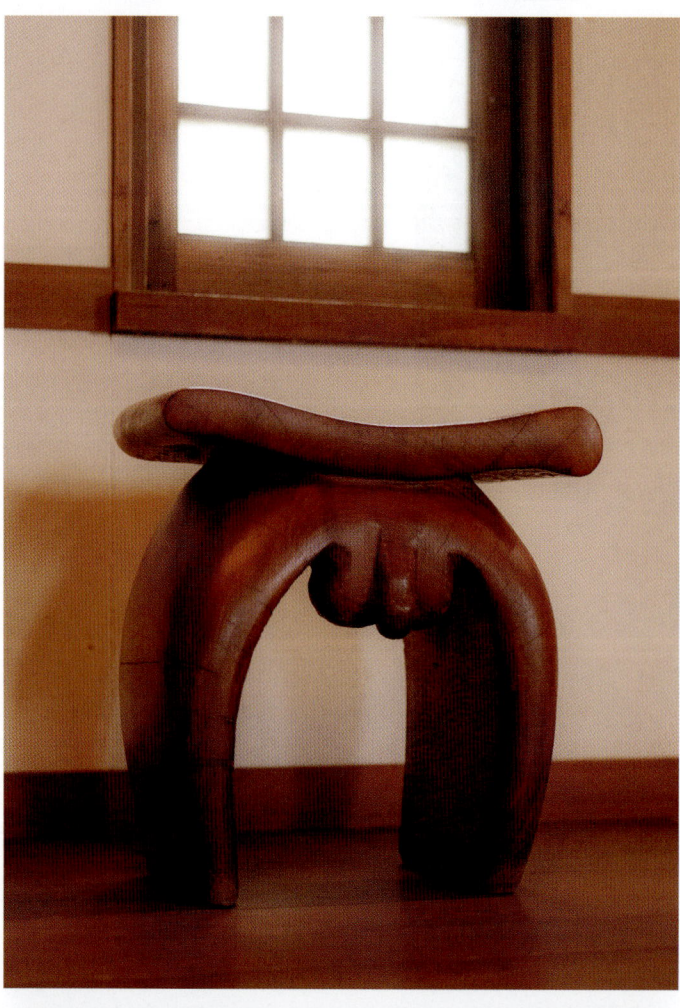

(opposite)
Blunk asked his daughter to "keep the house full of life and creativity." Between 2007 and 2011, the Blunk family hosted an artist residency at the house, and it continues to be a source of inspiration for visiting artists and designers like Adam Pogue and Martino Gamper.

"He had so much in him that he needed to get out through his artwork. It was just what he had to do."

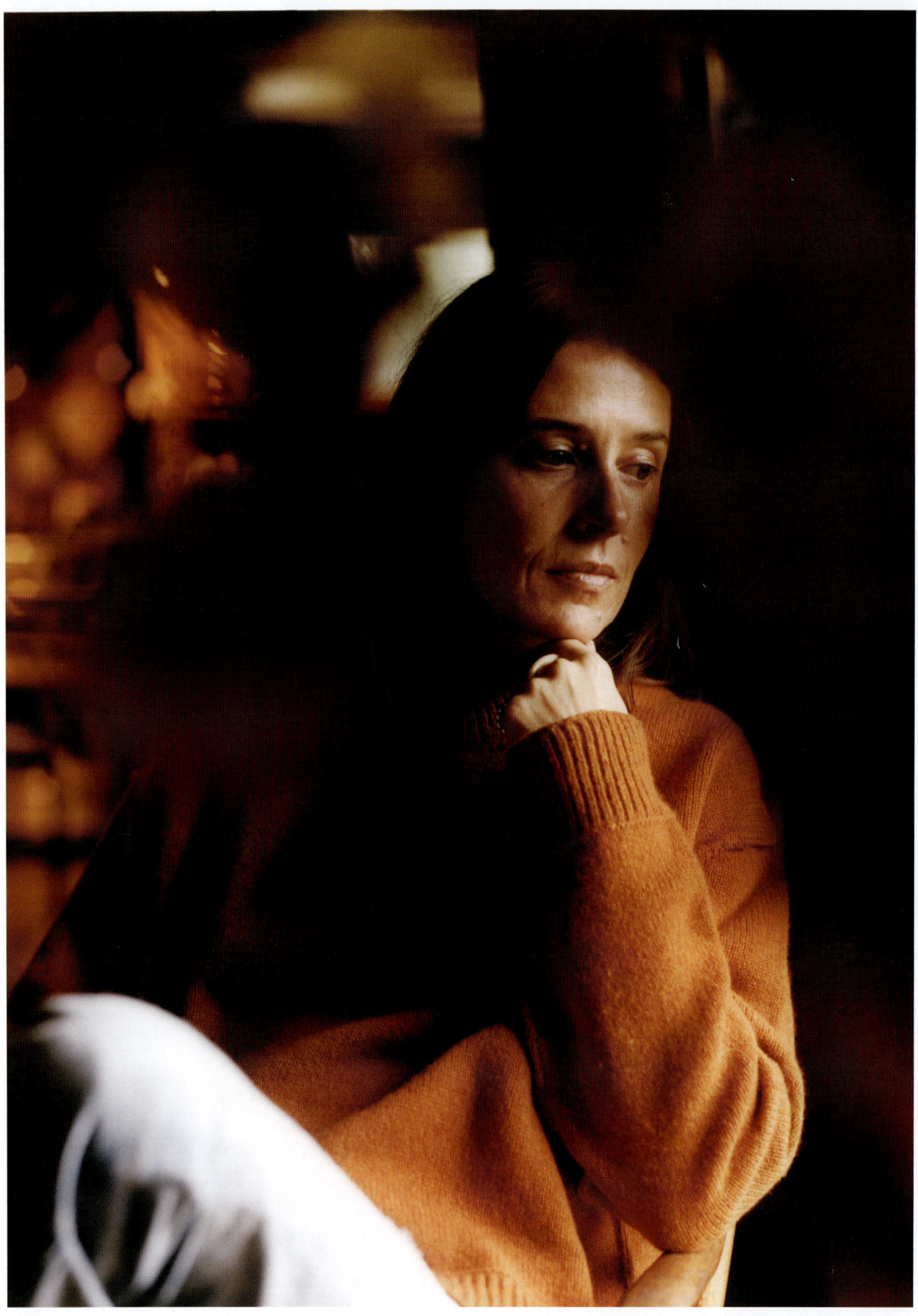

DIRECTORY

162	Field Notes
166	Behind the Scenes
168	Crossword
169	Received Wisdom
172	Seasonal Produce
176	Point of View

FIELD NOTES

Words:
Amanda Thomson

On the lookout for Lepidoptera.

There are about 180,000 different species of butterflies and moths, representing approximately 10% of all described living organisms. Perhaps surprisingly, the vast majority of these are moths: In North America alone there are over 12,000 species of moths and around just 800 species of butterflies.

While in English we distinguish between moths and butterflies, they are both part of the scientific order Lepidoptera and undergo the same life cycle of metamorphosis—egg, larva, pupa, adult. Other languages do not make such a distinction. In French, for example, moths are called "*papillons de nuit*," butterflies of the night—an acknowledgment, perhaps, that moths can be as beautiful as butterflies. After all, just like butterflies, their wings are formed of thousands of tiny, overlapping scales, each of which can be a different color, leading to spectacular patterning.

You're most likely to come across butterflies on warm, dry, windless days—in a garden, or walking through a grassy meadow—but keep an eye out for day-flying moths too. In the US and Canada you might see the stunning black-and-white eight-spotted forester moth, or in Europe, the six-spotted burnet moth, with its striking iridescent turquoise wings with red spots. More intriguing still, the tiny thing hovering by a flower that you might take to be a hummingbird could actually be a hummingbird hawk-moth, as found across Eurasia, or the hummingbird clearwing or the white-winged sphinx if you're in North America.

With a worrying decline in butterfly and moth populations in recent years, it has never been more important to make a welcoming habitat. To increase your chances of encountering Lepidoptera, consider planting butterfly-, moth- and bee-friendly plants, including sweet-scented flowers such as honeysuckle and jasmine. Milkweed is particularly attractive for monarch butterflies, and asters, goldenrods and evening primrose will attract the painted lady, sphinx and a variety of skippers. Buddleia, with its beautiful spears of tightly packed purple, pink or white flowers, is often called the butterfly bush and is equally loved by moths. In addition to enticing important pollinators into your garden, you will be directly supporting the wider ecosystem—butterflies and moths are the primary food source for many birds and other critters, and their numbers are vital indicators of how healthy these ecosystems are.

POWER TOOL

As Told To: Emily May

British dancer and choreographer JULES CUNNINGHAM on their intimate relationship with their feet.

What I love about dance is that it's just you and your body in space. My body is my instrument—I have to keep it in a condition where it can *do* the dancing. My feet are particularly important. They are as articulate as my hands. I know them intimately.

During my training at Rambert School in London and my first contract at Theater Koblenz in Germany, I did a lot of ballet and pointe work as well as contemporary dance, so my feet got used to going in and out of pointe shoes. I've always found pointe shoes problematic—they're designed to create an illusion of lightness and femininity. That doesn't sit well with me.

Later, in New York as a dancer with the Merce Cunningham Company, I danced almost exclusively barefoot. My feet spread out and toughened up. Taping them was a company ritual, especially on tour. We'd burn pieces of tape to make it more pliable and stick them to our feet for protection and to create better surfaces for turning.

Merce's technique is extremely demanding on the feet. You're almost always on relevé—the balls of your feet—or jumping. It builds incredible strength but also leads to injury. I once tore the ligaments in my foot during a performance. Adrenaline kept me dancing; I didn't realize the extent of what had happened until I came offstage.

My choreography can also be quite foot-intensive. This is true of my latest pieces, *Pigeons* and *CROW*, which premiered at Sadler's Wells in London in March. *Pigeons* is rhythmical and relentless, exploring how the titular birds move together, shifting direction with quick, syncopated steps. The music we dance to is *Gay Guerrilla* by Julius Eastman, a Black, gay composer who worked in the 1970s and '80s. A lot of his music has been lost. I resonate with the fact he was somewhat of an outsider. Knowing he lived in New York feels meaningful too—I like imagining what he might have experienced as he walked along the same streets I have.

ON THE SHELF

Words:
Rhian Sasseen

SHEILA HETI on why writing is like a relationship.

The Canadian writer Sheila Heti approaches writing as though it were a puzzle: scattered pieces of plot, dialogue or image that possess their own internal logic, and that come together, under her guiding hand, to create something deliberate and wholly its own. Over the course of her 20-year writing career, she has written about the death of a parent (*Pure Colour*), a woman's decision to have children (*Motherhood*) and the existential problem of how an artist should live their life (*How Should a Person Be?*). Her most recent book, *Alphabetical Diaries*, creates a kind of surrealist parlor game out of her personal diaries, rearranging their sentences alphabetically so that they form their own exquisite sense.

RHIAN SASSEEN: Many of your books are organized around constraints—there are the coin flips in *Motherhood*, and the diary entries in *Alphabetical Diaries*. Does the form of the book come before you know what the book is about, or vice versa?

SHELIA HETI: I guess the form comes first. With *Motherhood*, I was flipping and asking questions of those coins for a few years before I thought, I want to write a book about motherhood. I liked what was happening when I was doing it. I liked the way it would push my mind in new directions. I've always tried to write for as long as possible without knowing what the book is about, until an inflection point where I start to need to know.

RS: Is the inflection point different in each book?

SH: At a certain point, I become a little impatient with the feeling of not having an idea or a form or a vision. It's different for every book, but it's still the same sort of feeling—like, now I'm just wandering. For a while, it feels fun and exciting, and like I'm discovering, and then it feels like I'm walking in place.

RS: Does physically walking ever become a part of the process for you, or is it more metaphorical?

SH: I think it's more metaphorical! I walk a lot because I have a dog, and I like thinking while walking, but I don't think I take walks to think. The different stages feel different in my body, metabolically. When you're excited, and when you have a form in mind and you're working towards an end, you feel like a different creature than you do when you're just completely wide open and exploring. I've been doing this for so long now that I'm starting to have a little more patience. I know that each phase is a phase. I used to get more worried or frustrated with myself when I was in the early stages, like, *Am I ever going to figure out what the book is about?* I understand better now that this is just the necessary place for it to be... It's like a relationship: There's infatuation, and then there's arguing and fighting, and trying to actually adjust to it. And then there's some kind of peace. You start to see the way these things repeat across relationships, and it's the same thing with books.

RS: Was it emotional to go back and read through your diaries for *Alphabetical Diaries*?

SH: Not really, because I never went back through them. When I started the project, the first thing I did was alphabetize them, so I never read them over. There would be sentences that would make me remember whole scenes, but I don't think I'm very emotional. I never really feel a lot of emotion when I'm writing, apart from excitement. *Alphabetical Diaries* wasn't really like writing. It was editing. I never felt inside of it, in the way that you do when you're creating something from scratch. With editing, you feel a little detached from it when you're doing it. You're sort of evaluating; you're not really lost.

RS: How do you approach editing versus writing? In an essay on the artist Sara Cwynar, you once compared shopping and writing to "selecting." Is editing also selecting?

SH: Writing is selecting, but on a more unconscious level and on a much deeper level, whereas editing is more deliberate. With writing, you're trying to be a little looser and *less* deliberate—more open to what happens or what surprises you. I think with editing, you have an idea of what you want, and you're trying to get there.

RS: Is there always an element of chance in the writing process?

SH: I don't know if it's chance, or if it's more that you don't know why things come up for you. It's like dreaming, but they are dreams that are being brought to you for reasons that you're not quite certain about. I think it's more like that than chance. You don't know what's generating the images that you come up with.

BEHIND THE SCENES

Words:
Rosalind Jana

Print designer HARRIET COX on the art of the pattern.

Harriet Cox is a senior print and textile designer at London-based brand KNWLS and consults for other labels, having previously worked at McQueen and JW Anderson. She sees herself as someone in the business of creating "purposeful artworks"—not abstracted pieces to hang on a wall, but images and patterns destined for being lived in. Her designs, whether spectral florals or watery, charred-looking plaids, are intricate, audacious and avowedly modern.

ROSALIND JANA: What drew you to print design?

HARRIET COX: I grew up looking at John Galliano, Martine Sitbon and designers working for Alexander McQueen (Simon Ungless, Fleet Bigwood). I loved how print could serve as a bold form of artistic expression and convey the story of a collection. McQueen's "Plato's Atlantis" and his final collection were released while I was a student and completely blew me away—I was in awe of the kaleidoscopic imagery of butterflies and snakes. It felt like a jolt of electricity.

RJ: What makes printmaking a separate discipline to other aspects of design?

HC: It's a specialized field that requires adaptability in artistic techniques, while also ensuring the designs work effectively on the garments—whether it's digitally printed, screen printed, hand-painted or a placement or engineered print.[1] It's quite rare for a creative director to have both the fashion design expertise and the skills needed for the application of print and textile design, which is why this aspect is often outsourced.

RJ: You work with various labels. What is your relationship with the creative director?

HC: You want this dynamic relationship where they say a word or phrase, and you really react to that. Then you present a lot of research along that theme. That can come from the V&A [Museum] archives, or from what I see on the street.
—

Photo: Alixe Lay

166　　　　　　　　　　DIRECTORY

RJ: What are some of the techniques you use?

HC: There's bleach, which is extremely DIY. When I was first started to work with KNWLS, I was doing these plaids [using] my dad's shirt. We literally took it off his back. Using found materials and playing with them is key. I also use wax for relief, and stencil cutting is a big thing, as well as a lot of printmaking.

RJ: How cognizant are you of how it will look on the body when you're starting to create the artwork?

HC: Now it's quite natural to me. If I'm designing an artwork, I will already be thinking about the scale of it.... Maybe I'll already know the direction to repeat it. There's almost an engineering aspect to any placement—I love being experimental in the artwork to begin with, [but] the end point is mathematical. The trick is to make a repeat that no one can tell is a repeat.

RJ: You recently worked with Dilara Fındıkoğlu, which is a very different label to KNWLS: different silhouettes, different atmospheres. Do you enjoy shifting your own vision?

HC: I love it. It's like being an avid observer—drawing from the past to envision the future. Over the years, working with Charlotte Knowles and Alex Arsenault [at KNWLS] we've really cultivated a language of prints and a deep appreciation for the process and techniques involved. It's quite rare to find that kind of symbiosis. Prints are often among the most discarded items in charity shops. I want to create something people will treasure and grow with over time.

(1) Unlike repeat prints, where a seamless repeat of a pattern is printed on the fabric, placement and engineered prints involve precisely scaling and aligning the design on the garment while considering seams, darts, and other structural elements.

KINFOLK

I LOVE LA
Enjoy this visit to La La Land.

Mark Halpin

ACROSS

1. Uploaded pic, often
5. Oceanic predator
9. Content
14. Folk singer Guthrie
15. Greenish blue
16. Delete
17. Stunning revelation
19. Defeats or outperforms
20. Experimental maze-runner that's been over-indulged?
22. Alternatives
23. It might be green or black
24. Big name in records
27. Kerfuffles
30. Hindu festival of colors
31. "That hurts!"
32. Wagnerian work about the Shampooing of the Gods?
36. Let off some steam
37. Joe of many a mob movie
38. Ambience
39. Slice of a geometric solid that uses very few words?
42. "Hail, Caesar!"
43. Common blood type: abbr.
44. Bugs
45. "For sure," for short
46. "Puppy paws" roll, in dice
47. Acquire
49. Number in *The Little Mermaid* in which Sebastian cleans his home?
56. Love
58. Stupidity
59. An area's flora and fauna
60. Albacore and the like
61. Twice-monthly tide type
62. Christmas song
63. Baby salamanders
64. Big flightless birds

DOWN

1. Roundhouse follow-ups
2. Onstage item
3. Ticklish Sesame Street resident
4. Arid Mongolian expanse
5. Last choice on a list, frequently
6. Some orchestra members
7. Don't raise or fold
8. Simultaneously
9. Like the Dead Sea Scrolls, linguistically
10. Realm
11. Choux-maker?
12. Winter hours in Calif.
13. Thumbs-up
18. Act like liquid in a bucket
21. Related to a certain Germanic tribe or European country
25. Eyes in emojis, often
26. Overwhelmed
27. Taking _____ of absence
28. Murder site in a chart-topping song
29. Man's name that's a homophone of 50-Down
30. Protracted warning from a cobra
33. Source of a lifesaving shot
34. Obscure; hard to understand
35. Old Norse giant
36. Wallachian "Impaler" said to have inspired Dracula
40. Quick learner
41. Church offering
47. Bestow
48. Lab burners named for a volcano
50. Vehicle that's a homophone of 29-Down
51. Sufficient, slangily
52. Suffix similar to -trix
53. Appear to be
54. Biblical twin
55. Poisonous snakes
56. Epitome of simplicity
57. Soccer star Hamm

RECEIVED WISDOM

As Told To: Benjamin Dane

Furniture designer NIELS GAMMELGAARD on patience, plastic chairs and why the best ideas stand the test of time.

I've never had a job—not in the traditional sense, anyway. I grew up in a home of academics—both my parents were doctors—and my father insisted that we never be a burden on society. He financed my education himself, and I lived at home until I was 24 and got married.

My career didn't follow a conventional path, and in many ways, I was just placed where I was supposed to be. Looking back, I think my mother knew exactly what she was doing. I had always been good with my hands—able to draw, to build things. My mother saw the artistic streak in me and enrolled me at the Royal Danish Academy of Fine Arts. I wasn't accepted at first, but after training briefly as a carpenter and spending a few months sketching at the National Gallery of Denmark, I was admitted and ended up studying industrial design. I never questioned it. It felt like the natural progression.

My collaboration with IKEA started in the most unorthodox way. After an early project of mine failed commercially, I got in my car and drove to meet Ingvar Kamprad, the founder of IKEA. He was living in Denmark at

the time and had moved the company head office to Humlebæk, north of Copenhagen. I didn't know him; I just called and asked if I could visit. He told me, "Niels, I won't buy your furniture, but I can see you understand chairs. Could you design one in plastic and metal?" I said yes, went home, built a prototype out of electrical tubing and cardboard, and drove back. That prototype became the Folke chair, which millions would eventually sit on.

I'm proud that the furniture I designed for IKEA in the '70s and '80s is now part of design history. Back then, we weren't thinking about creating pieces that would end up at auctions or in museums, we were just trying to do good work. Yet, here we are. I've been told that my furniture is now even trending on TikTok.[1]

The renewed interest in my designs is surprising but also deeply satisfying. It proves that we made something timeless that still resonates decades later. I think they have endured because we started from scratch—we weren't copying past traditions. Danish furniture had always been rooted in fine carpentry, but we approached it differently, blending art, functionality and mass production.

The best advice I ever received came late in life, from my wife: Do your best, or don't bother. It's a philosophy I've passed on to my children, too. If you're going to do something, you should do it with everything you have.

I have softened over the years. My friends say I was a real hothead in my younger days—blunt, stubborn—but time changes you. I used to be the kind of person who would get worked up over the smallest things, but I've come to appreciate patience, the ability to let things be. The other day, I watched a TV program on road rage and realized: That used to be me.

Honestly, I never had a master plan. I just kept working, solving problems, designing things that made sense. Even now, at 80, I'm still designing. I don't believe in retiring—my father was forced to retire at 70, and he was gone two years later. That won't happen to me. As long as I have ideas, I'll keep creating.

(1) The popularity of Gammelgaard's designs from the 1970s and '80s has led IKEA to re-release models like the steel-mesh Järpen chair and the Guide shelving unit, dramatically undercutting the resale price of the vintage products in the process.

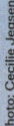
Photo: Cecilie Jegsen

TOP TIP

As Told To:
Ali Morris

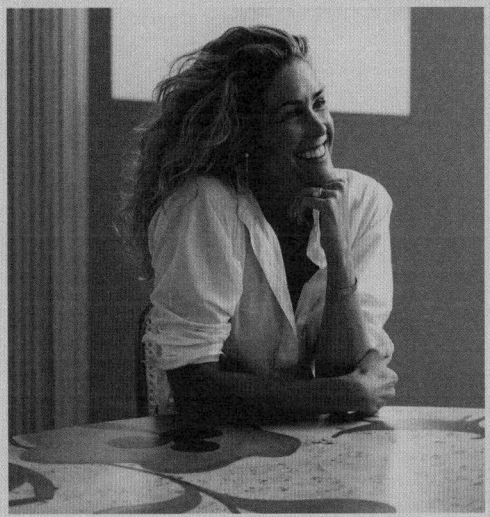

Interior designer JULIETTE ARENT on creating a low-tox home.

Six years ago, I fell ill and was diagnosed with various immune conditions. But even as I tried different treatments, I just wasn't getting better—in fact, I was getting worse. It wasn't until early 2023 that a holistic practitioner here in Sydney suggested it might be related to topical steroid addiction, a serious condition that's not widely recognized.

I ended up moving to Bangkok for six months to get specialized treatment, and it was during that time that I dove deep into understanding how my living environment was impacting my health. If you're looking to support your health and well-being, it's crucial to take a close look at your living environment. The spaces we inhabit can have a profound impact on both our physical and mental health, and making some strategic changes can make a big difference.

One of the most important factors is air quality. Humidity levels above 60% can lead to mold growth, which is a major irritant for many people. Investing in a good quality dehumidifier, especially in damp areas like bathrooms and basements, can help keep humidity in check. Proper ventilation is also key, so be mindful of airflow, especially in closets and wardrobes.

Chemicals are another big concern. Conventional cleaning products, air fresheners and some building materials can off-gas volatile organic compounds (VOCs)—harmful chemicals that can cause respiratory issues, headaches and even long-term health problems. In my own home, I opt for natural, fragrance-free cleaners and I advise my clients to choose low-VOC or VOC-free paints and furnishings, avoiding anything that's been treated with stain-resistant or flame-retardant chemicals.

The lighting in your home is also worth considering. Blue-rich LED lights can disrupt your circadian rhythms and melatonin production, so try to use warmer, dimmer lighting in the evenings.

Making changes like this can seem inconvenient, but the difference it can make for your health is immense. Our homes should be safe havens, not a source of toxicity and stress. I hope that by talking about it, I can inspire others to take a closer look at their living environments and make changes that support their well-being. It's not about being perfect, but about taking small steps toward a healthier home.

—

SEASONAL PRODUCE

Words:
Brandon Jew

Chef and founder of San Francisco's MISTER JIU'S shares a recipe for a bright summer dish.

At the beginning of the summer, when corn is sweetest and most tender, I prefer it barely cooked; later in the season I will cook it longer to ensure the starches convert to sweetness. Here it accentuates the sweetness of the Dungeness crab, a local delicacy in the Bay Area and something I encourage our cooks to take pride in.

Vibrancy is key when sourcing any ingredient. I look for color (it should be eye-catching), texture (like it just got plucked from the ground), shape (consistency but not uniformity), and how it smells (it should spark curiosity). That's why it's interesting to compare the different varieties of corn that are locally available in the summer, whether it's white, yellow or bi-color.

This recipe is really born out of a love for the light gravy texture and how it can coat noodles in a very luxurious way. It's a classic Cantonese combination and technique that we enjoy serving at Mister Jiu's.

GLASS NOODLES WITH CORN, CRAB AND CILANTRO
(Serves 4)

¾ pound Chongqing-style glass noodles or any sweet potato starch noodles
2 tablespoons grapeseed oil (or similar)

For the dressing:
1 tablespoon minced garlic
2 tablespoons minced ginger
3 ounces yellow chives, cut into ¼-inch squares (or garlic chives or the light green parts of scallions)
1 tablespoon toasted sesame seeds
⅓ cup peanut oil
3½ tablespoons toasted sesame seed oil
1½ teaspoons white soy
¾ teaspoon sugar
1 tablespoon ground white pepper

For the crab:
1 whole live Dungeness crab, approximately 3 pounds or 1 (8-ounce) container picked crab meat
2 tablespoons crab oil made from shells (see Note) or fragrant chili oil
⅓ cup fresh corn kernels
¾ ounce chopped cilantro stems
1¼ ounces picked cilantro leaves

For the broth:
2 cups clam stock
¼ cup cornstarch
3 egg whites

Boil the noodles according to the instructions on the package (generally cooking for two to three minutes in boiling water). Drain and rinse in cold water, stir in grapeseed oil to keep the noodles from sticking to each other, and set aside.

To prepare the dressing, place the garlic, ginger, yellow chives and sesame seeds in a small bowl. In a small skillet, over medium heat, heat the peanut oil until it's shimmering and pour over the bowl to "sizzle" them. Stir in the sesame oil, white soy, sugar and white pepper and set aside.

If you are preparing the crab yourself, fill a bowl with ice water. Steam the crab in a bamboo steamer for around six minutes, cut off the legs and claws and plunge them into the ice water. Clean the gills, remove the head and discard, and then steam the body for another two minutes before placing in the ice bath. Once the crab has cooled, use scissors to clean out the meat, keeping the claw and body meat separate.

To prepare the broth, in a small pot, bring the clam stock to a simmer over low heat. Meanwhile, combine the cornstarch with ¼ cup water to make a slurry. When the stock is simmering, stir in ¼ cup of the cornstarch slurry. The mixture should be thick enough to coat the back of a spoon. Stir the mixture to create a whirlpool and slowly pour in the egg whites, add the corn and bring back to simmer, then add the crab body meat and mix, before adding the claw meat. Add more cornstarch slurry as needed to keep the broth thick.

In a large cast-iron skillet or a wok over medium heat, add the yellow chive dressing followed immediately by the noodles. Mix thoroughly for two to four minutes to heat up the noodles before ladling the broth, corn and crab over the noodles to coat.

To serve, garnish with crab oil, cilantro stems and leaves.

Note: To prepare the crab oil, preheat the oven to 375°F (190°C). On a baking sheet, roast the crab shells for 15 minutes. Place the roasted shells in a large pot and cover with 3 cups neutral oil. Slowly bring up to a simmer and cook over low heat for 2 hours. Let the oil come to room temperature for 2 hours, and then strain.

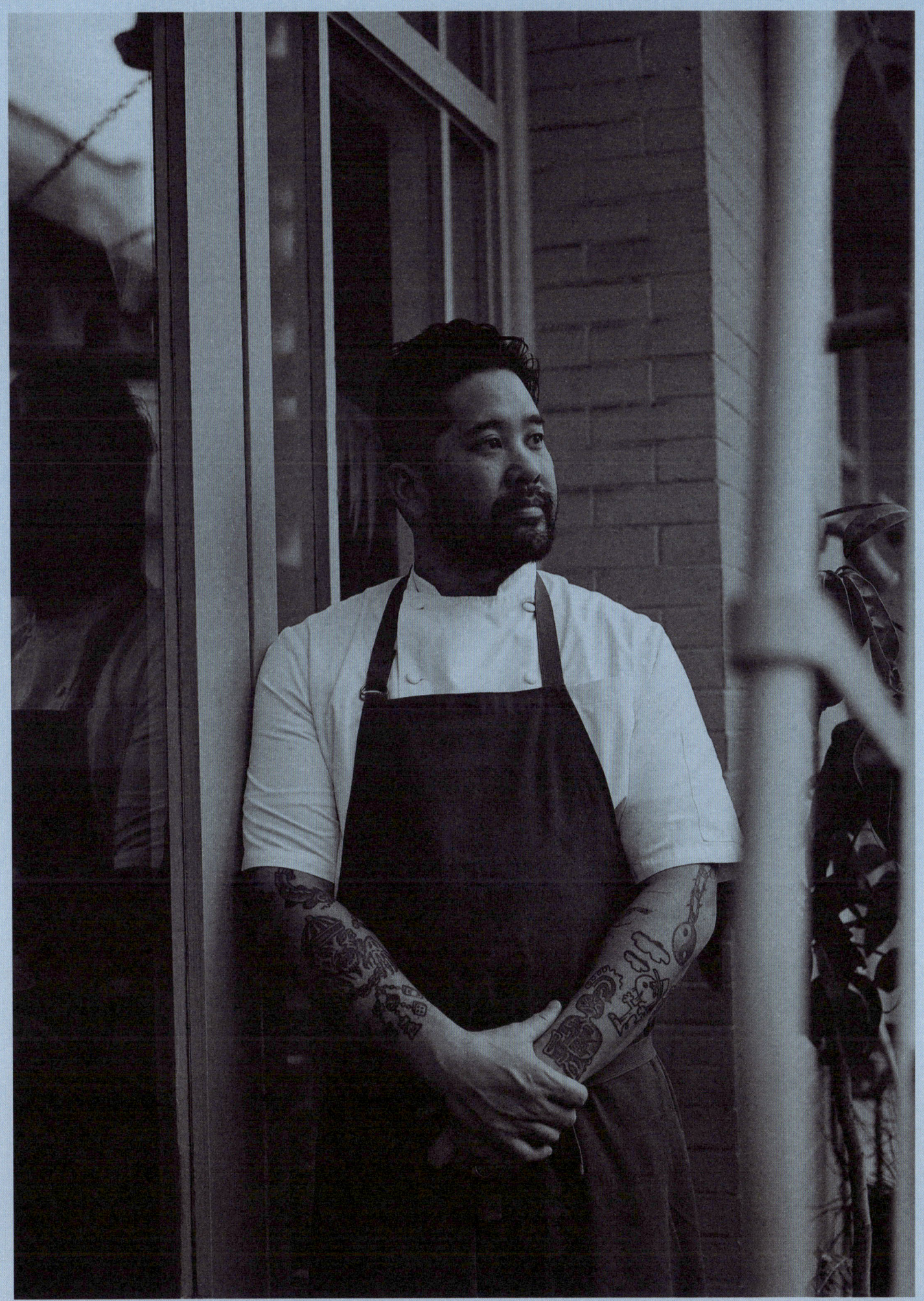

CREDITS

CALIFORNIA COVER:	PHOTOGRAPHER STYLIST MODEL HAIR MAKEUP PRODUCER	Daria Kobayashi Ritch Gemma Ferri Moriah Star at That Agency Maranda Widlund Gia Harris Asli Akal
		Moriah wears a top by TIGRA TIGRA and a skirt by VETTESE.
WIM WENDERS COVER:	PHOTOGRAPHER STYLIST SET DESIGN GROOMING PRODUCER	Katie McCurdy Ashley Abtahie Elaine Winter Dana Boyer Veronica Leone
WIM WENDERS:	PHOTOGRAPHY ASSISTANT STUDIO POST PRODUCTION	Drew Wilson 16 Beaver Studio, New York Abby Harrison
TREE HUGGING:	PHOTO ASSISTANT STYLING ASSISTANT PRODUCTION COMPANY PRODUCTION ASSISTANT	Michael Irwin Hannah Loewen YY Prod Lee Atyas
RAED KHAWAJA:	PHOTO ASSISTANT PAGE 98	Austin Calvello Khawaja wears a shirt and trousers by HOMME PLISSÉ ISSEY MIYAKE.
SPECIAL THANKS:		Daybreak Studio Nick Dierl Emma McKee Michiko Miyazaki Gaulier Aliya Mohamed Di'ara Reid Karen Rudolph Nikki Spilka

STOCKISTS:
A — Z

A	A.P.C.	apcstore.com
	ACNE STUDIOS	acnestudios.com
	ANTHROPIC	anthropic.com
B	BALMAIN	balmain.com
C	CONVERSE	converse.com
D	DIOR	dior.com
	DOLLS KILL	dollskill.com
E	ENTIRE STUDIOS	entirestudios.com
F	FRITZ HANSEN	fritzhansen.com
H	HOUSE OF FINN JUHL	finnjuhl.com
I	INTODUSK	intodusk.com
	iS CLINICAL	isclinical.com
	ISSEY MIYAKE HOMME PLISSÉ	isseymiyake.com
K	KENZO	kenzo.com
L	LARA KOLEJI	@larakoleji
	LONDYN KYLE	@londynkyle
M	MAISON MARGIELA	maisonmargiela.com
N	NAHMIAS	nahmias.com
O	ODDLI	oddli.com
	OMEGA	omegawatches.com
	ORIGINAL BTC	originalbtc.com
R	RICHARD MILLE	richardmille.com
	ROLEX	rolex.com
S	STRING FURNITURE	stringfurniture.com
T	THIRD WAY	athirdway.co
	TIGRA TIGRA	tigratigra.com
	TINA FREY	tf.design
U	UNIQLO	uniqlo.com
V	VERSACE	versace.com
	VETTESE	vettese.net
Y	YOHJI YAMAMOTO	yohjiyamamoto.co.jp
Z	ZADIG & VOLTAIRE	zadig-et-voltaire.com

KINFOLK

POINT OF VIEW

As Told To: Precious Adesina

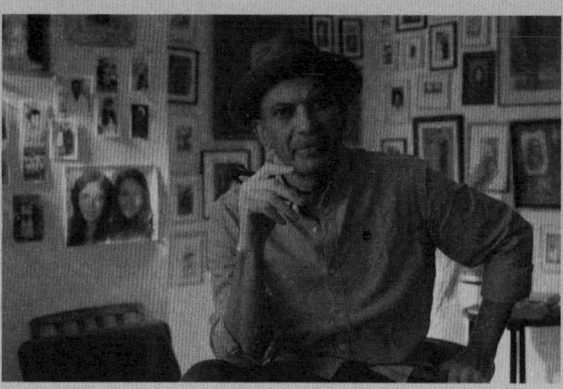

Artist SALAH ELMUR reflects on a corner of his Cairo studio.

I like sitting in cafés and museums, but my favorite spot is in my studio in Cairo, in a space I've made for relaxation. I will work for hours without stopping, then I sit here, drink tea or coffee, look at the photographs on the walls, and I immediately feel at ease.

I wanted this corner to feel homey, to be a place where I could rest. My studio is full of different collections: I have maquettes of rabbits, antique pots women once used to store eyeliner, various rubber stamps. Here, however, there are only photographs—a small selection from a collection of more than 20,000 black-and-white photos from Sudan, Egypt, Ghana, Kenya, Mexico and beyond. I especially love those from the '50s, '60s and '70s—before digital cameras—because they feel like a miracle to me. They fix a moment in time, recording life as it was.

When I'm on a break, I sit and look through them one by one, studying people's features, imagining their stories. Two girls, a man, children sitting and playing—each photo sparks something in me. I even have a photo of my father and mother on their wedding day, but I keep family photos in an album.

My father had a photo studio before I was born, and when I was young, I found boxes full of negatives and pictures in our home. Even though his studio was only open for a year in 1964, that discovery changed my life. At the time, my father was a university student, and the Sudanese government required everyone to have an ID card. That meant every Sudanese person needed a photograph. My father was already a member of the university's photography society and had a camera, and he saw the opportunity to open a small studio to earn money. Seeing the images transported me to another world. I didn't know who the people were, but I imagined their lives and why they had gone to the studio at that time.

When I paint, all kinds of images come to mind but old photographs are a big part of my visual memory. In my work, you often see figures that feel like they are posing for a photograph—the people always face the camera, even when they're in motion. That comes from these old photos; the people getting ready, presenting themselves for the camera.

I had to leave Sudan in the 1990s but I've never stopped going back. Sudan gives me energy. I used to go back every two or three months, but for the past two years I haven't been able to return because of the war. I miss it so much. Today, I finished a painting about the country—it shows burning trees, people and animals being killed.

I can't fully express how much pain I feel seeing what is happening there, how people are being killed every day. Many have had to flee their homes and leave everything behind, their memories, their belongings. Now, the houses are empty. When they return, the things they had a connection with—their chairs, their beds, their photos—all of it will be gone.